D1571478

FreedmanDamiani

REC

BOB RECINE

ALCHEMY *of* BEAUTY

Essay *by* Rene Ricard

Special thanks to MARIO SORRENTI & ROBBIE FIMMANO

A WIG
by LEONARDO *da* VINCI

In the Queen's collection at Windsor, amid a numberless trove of Leonardo's drawings (eight hundred something, in fact), there is a little head with an elaborate coiffure of braids with two chignons à la Princess Leia. It appears to be a study for the head of Leda from the lost or never executed painting known only in copies. What makes this little drawing germane to our subject is the little notation in Leonardo's famous Tuscan dialect hat translates, more or less as, "Can be removed". When the dust of debates settles around the Master's intention in this cryptic phrase it would seem to mean that the drawing is for a wig. Leonardo's duties at the Sforza court in Milan extended far beyond the casting of a colossal bronze horse or the designs for fortifications and churches, but to the creation of costumes for balls, masques, and other aristocratic diversions, where there is a notable lackof distinction in heroic terms between an equestrian monument or a mistress' hairdo. Their status was about equal as far as Leonardo's participation was concerned. So the principle that the great artist could lend his hand to a French twist, I suppose, can be inverted, without too many constraints, to a great hairdresser lending his hand to a work of art. But the categorical hierarchies through time and history do a little gavotte around the notions of higher and lower. Each one specific to its time and place. Remember the descending order of subject matter during eighteenth century painting: starting with historic down to Portraits; then, because of Chardin, allowed in at the bottom was Still Life. I think landscape painters (near the bottom themselves) had to add little figures of Hebe or Jebe -no, I made her up; but painters did add figures - staffage - often by another hand, so the painting could be titled the Sacrifice of Something rather than just view of Someplace to get accepted as art at all.

Bob Recine's place at the top of his field began in a chance meeting, when he was very young. He sort of fell into hairdressing and in the way of smart young people, went from genius to genius absorbing from them what he could; giggling at what was absurd; but ending up with a proficiency that is nothing short of astounding. When you are on a Vogue shoot the exigencies of the circumstance demand flawless results in five minutes and twenty of them in an afternoon. For an artist - the tremendous concentration required to do a job that is only appreciated as part of an ensemble and, except a few exceptions, discarded with the next issue - must be frustrating and probably infuriating after a while. The need for a personal monument, validation for a life's work, something a little permanent, was not too much for Recine to ask. Of course, his photographs are beautiful. What can you expect? He is daily surrounded by beauty. His choices are beautiful. He finds beauty and that's the trick; because beauty found is always anomalous, and in that anomaly is what, I suppose, we could call: Style. And after all, we live in a time of photographs, or should I say, "We have lived through the time of photography". For example; with cell phones, now, well, photos are ... well, ubiquitous. Photography is our language, the way paintings have become our church. Sculpture is the noblest art. It is not a stretch to state that what Bob Recine has always done with hair is a form of sculpture. That's not just formally true. Hair as a material would enter his consciousness without an act of will. The transforming of cut-up hair or commercially available hairpieces he could so easily deconstruct and re-create as sculpture. Leonardo, obviously, was making a hair sculpture for the fancy dress of the Ducal mistress in her Leda costume for the ball. RENE RICARD, *New York, 2011*

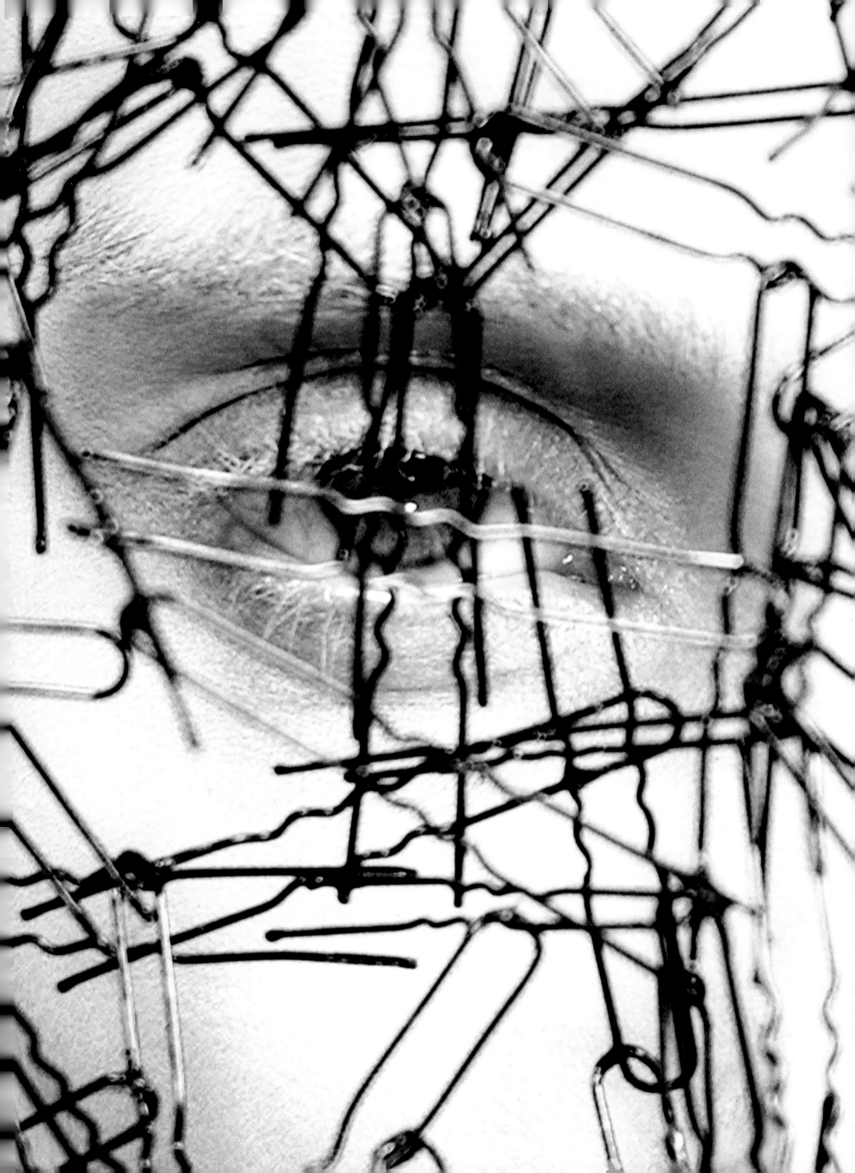

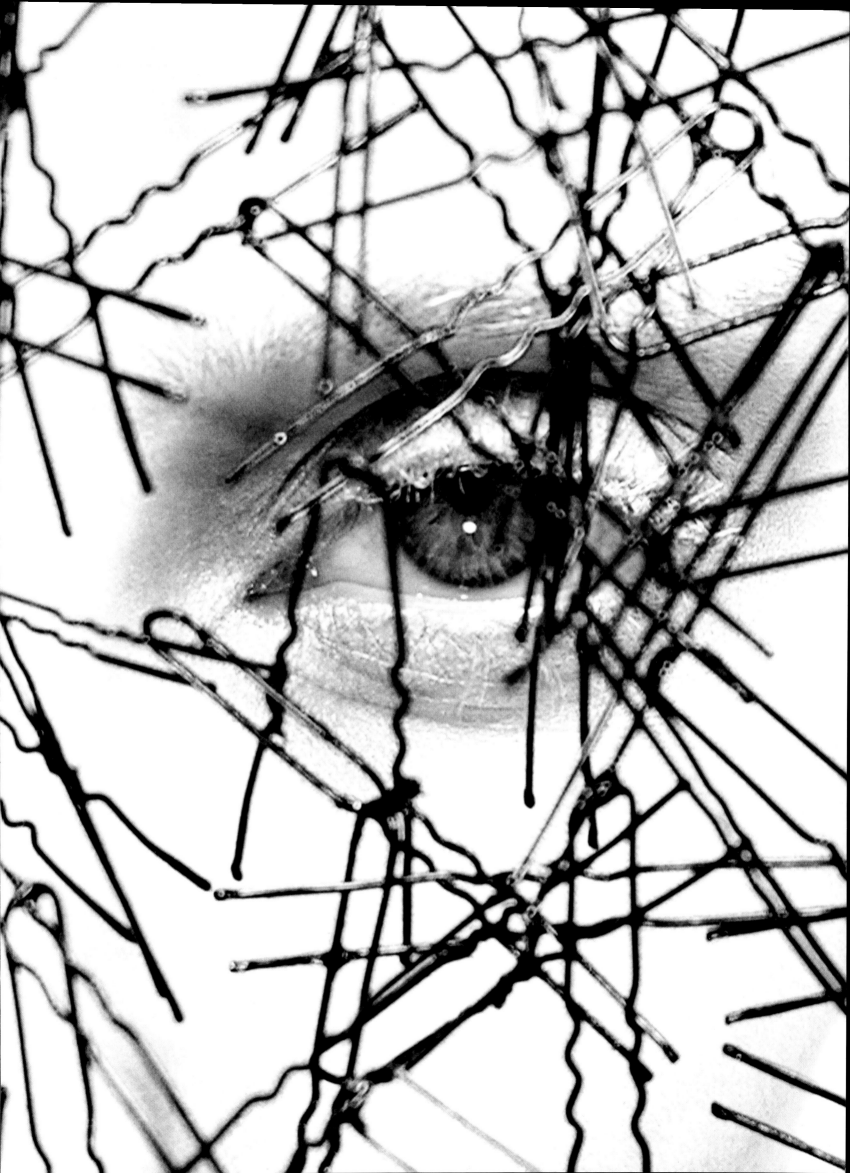

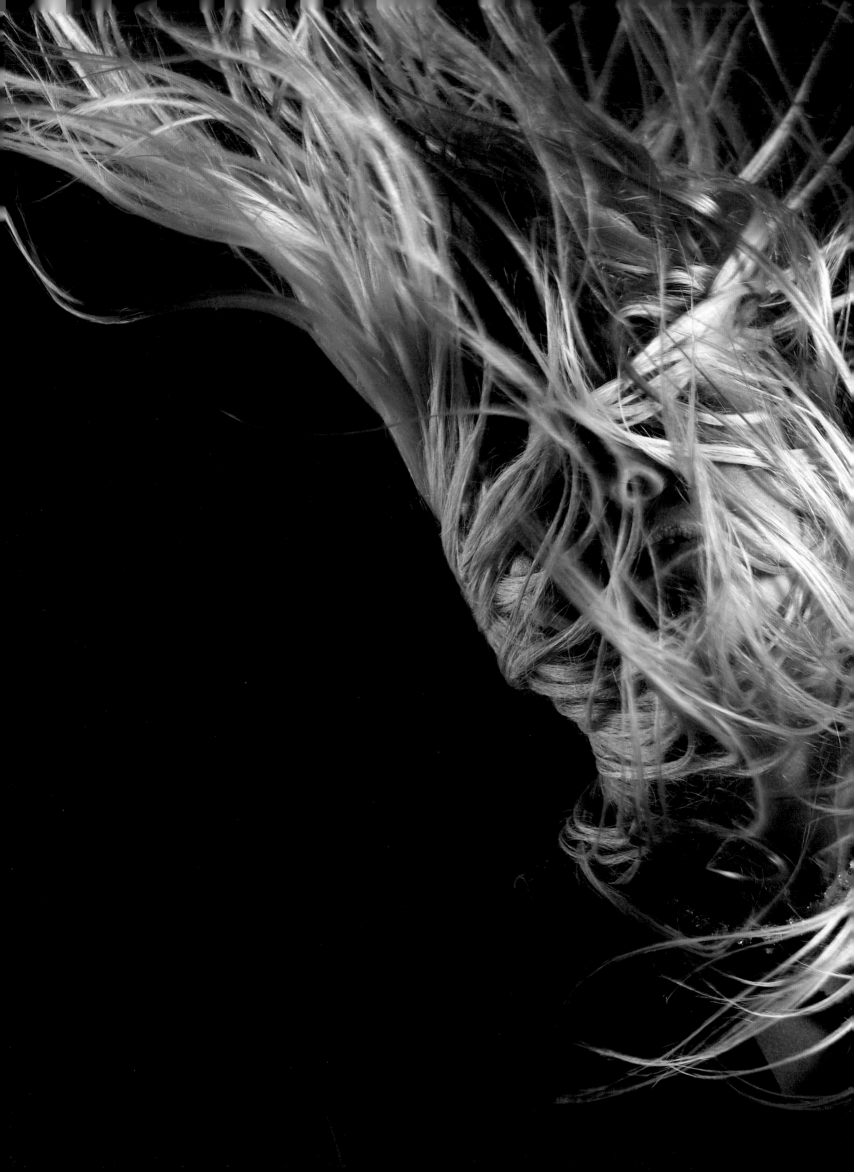

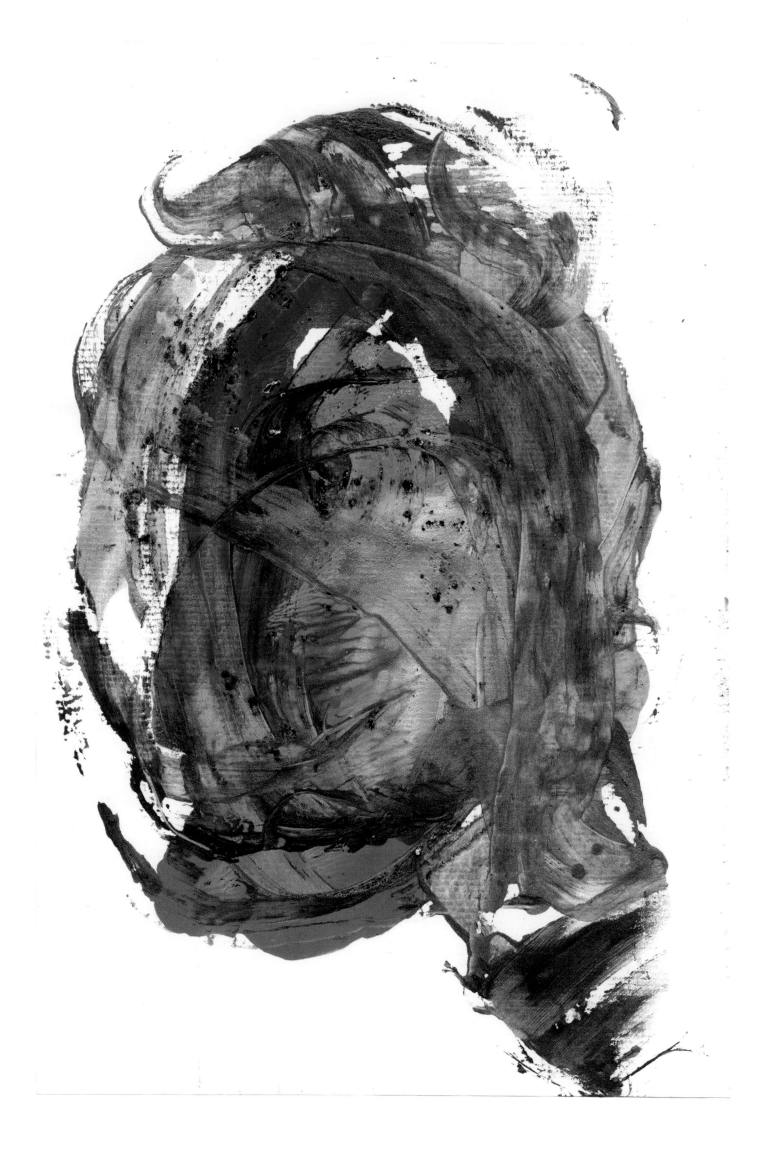

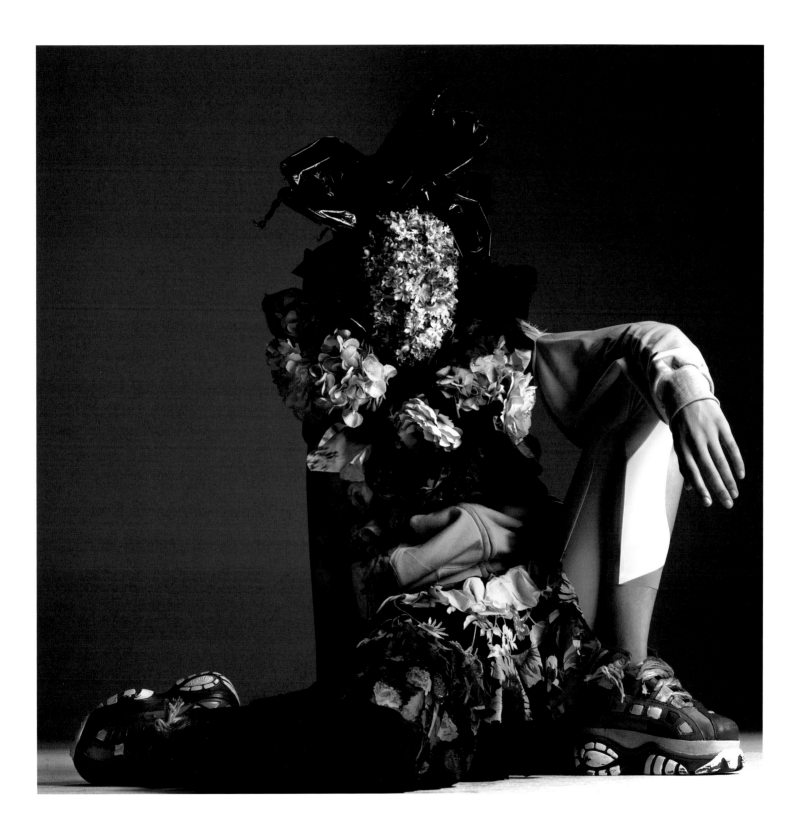

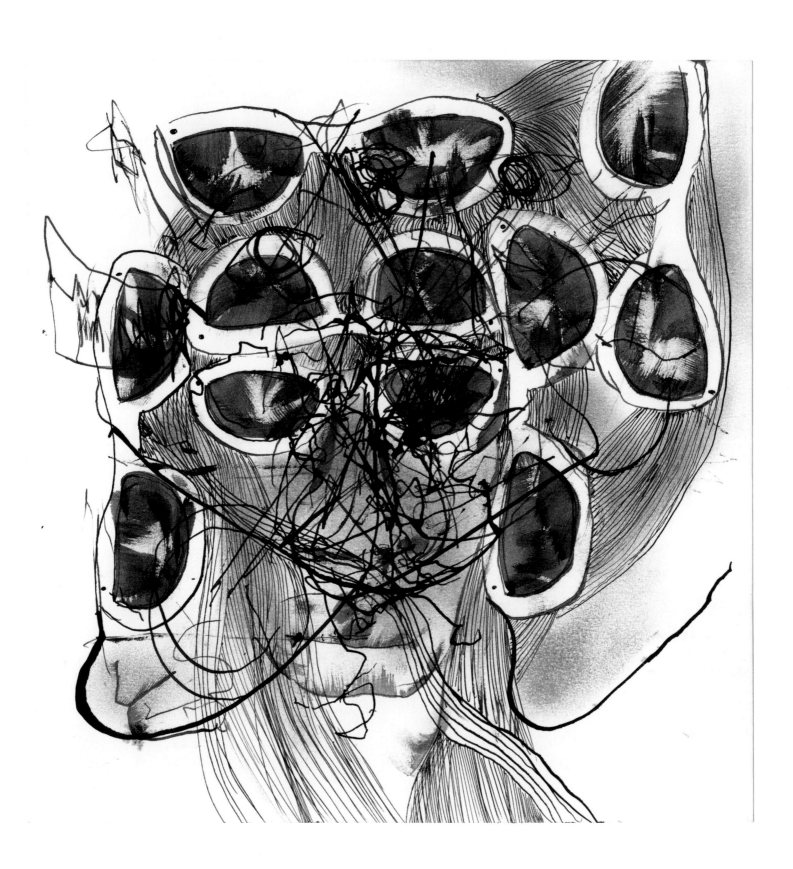

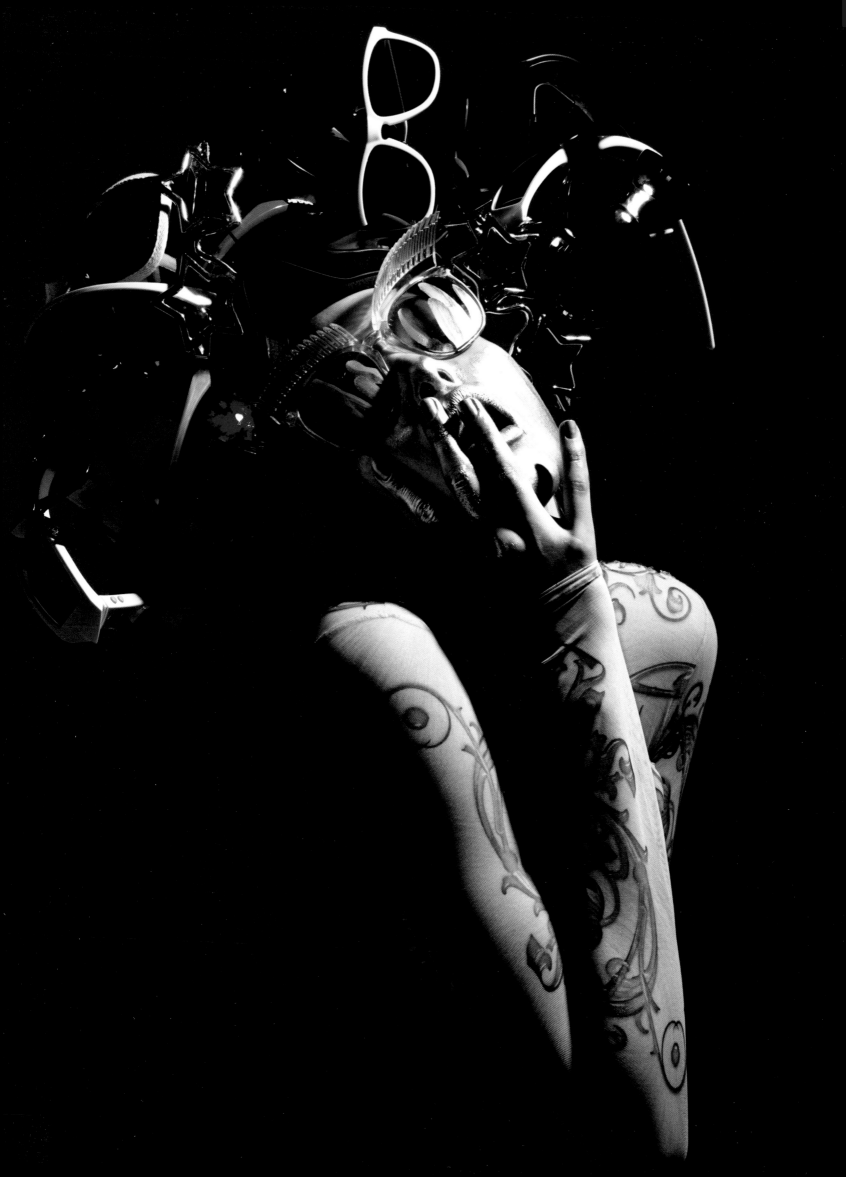

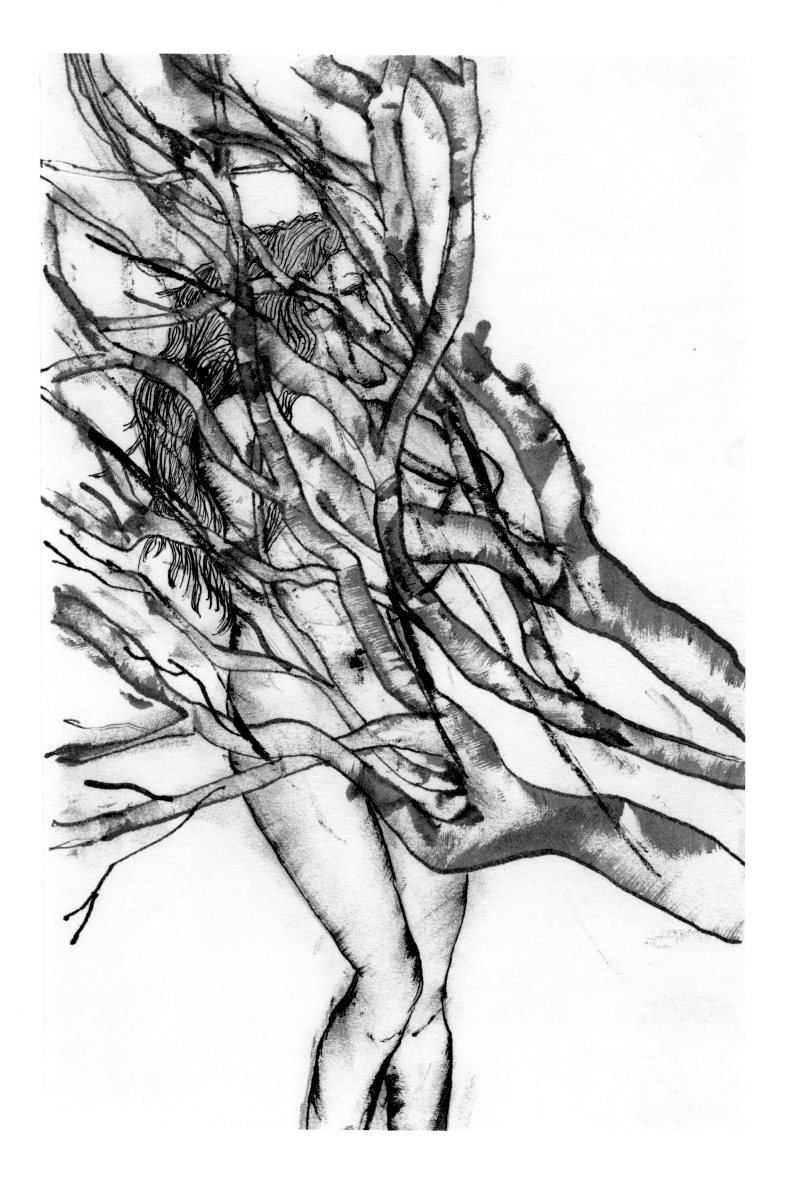

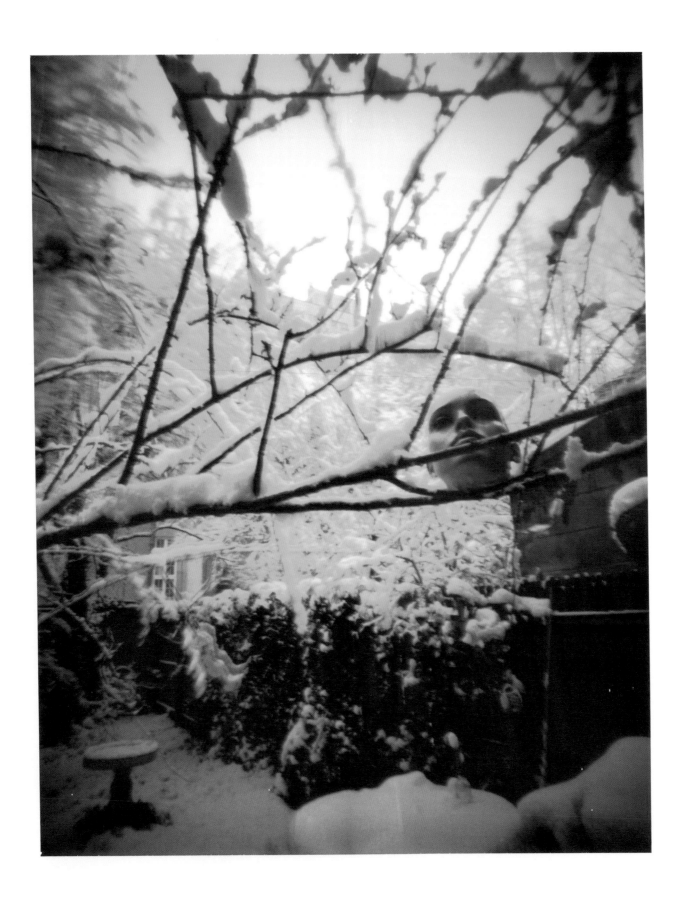

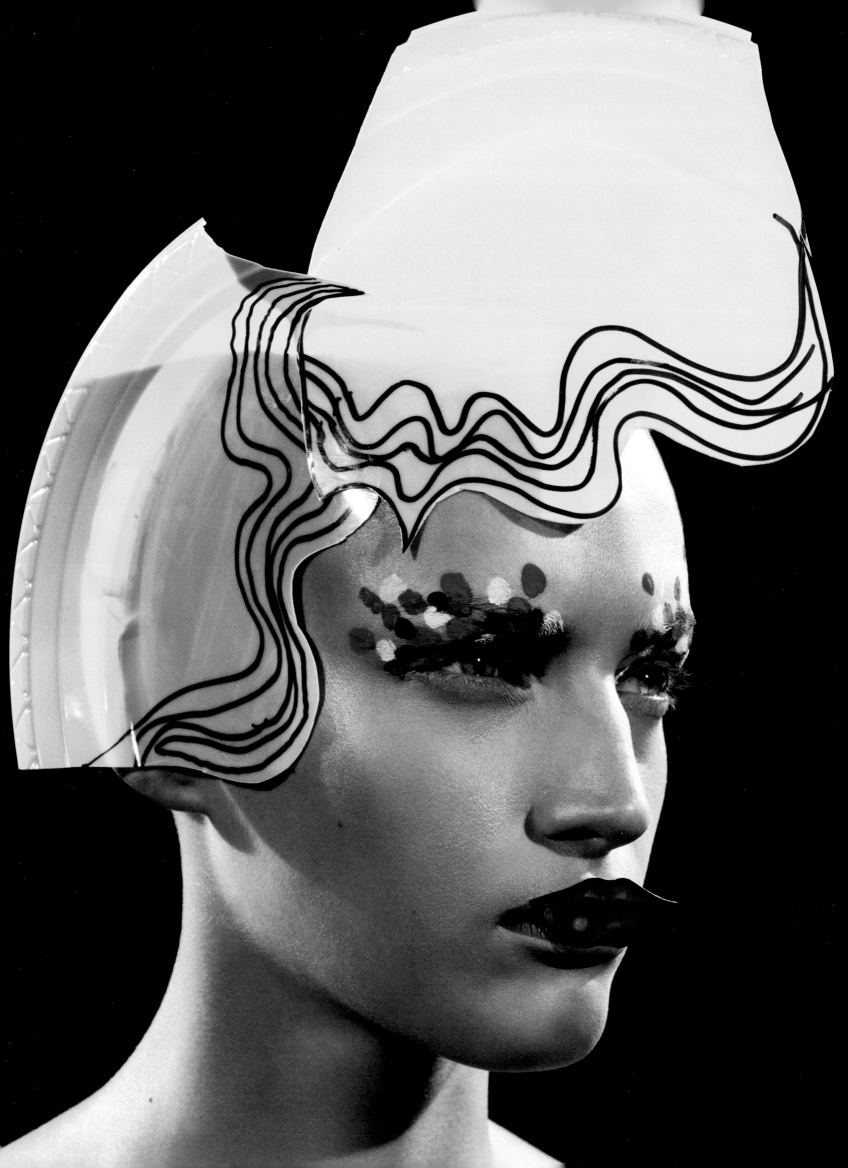

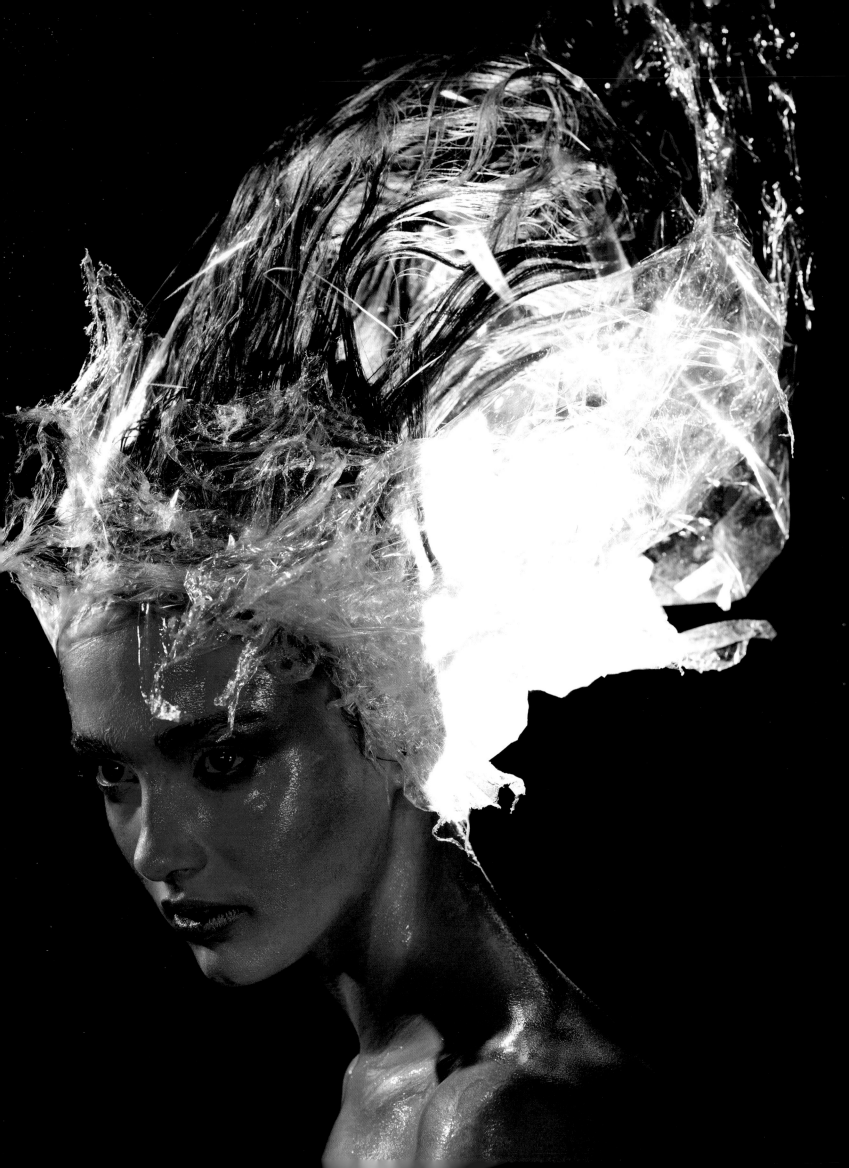

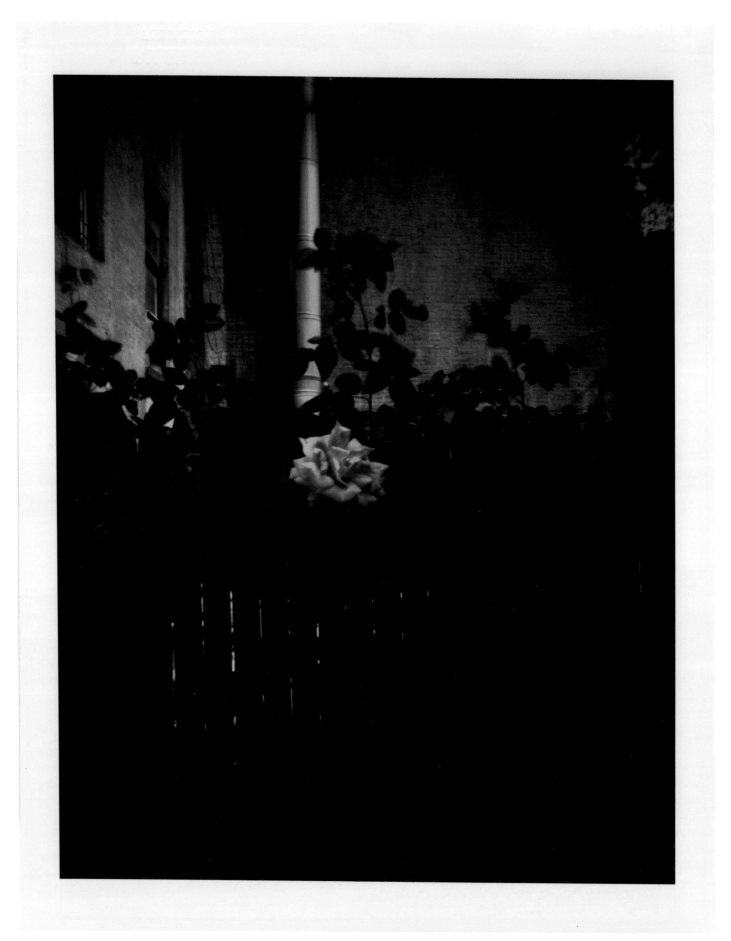

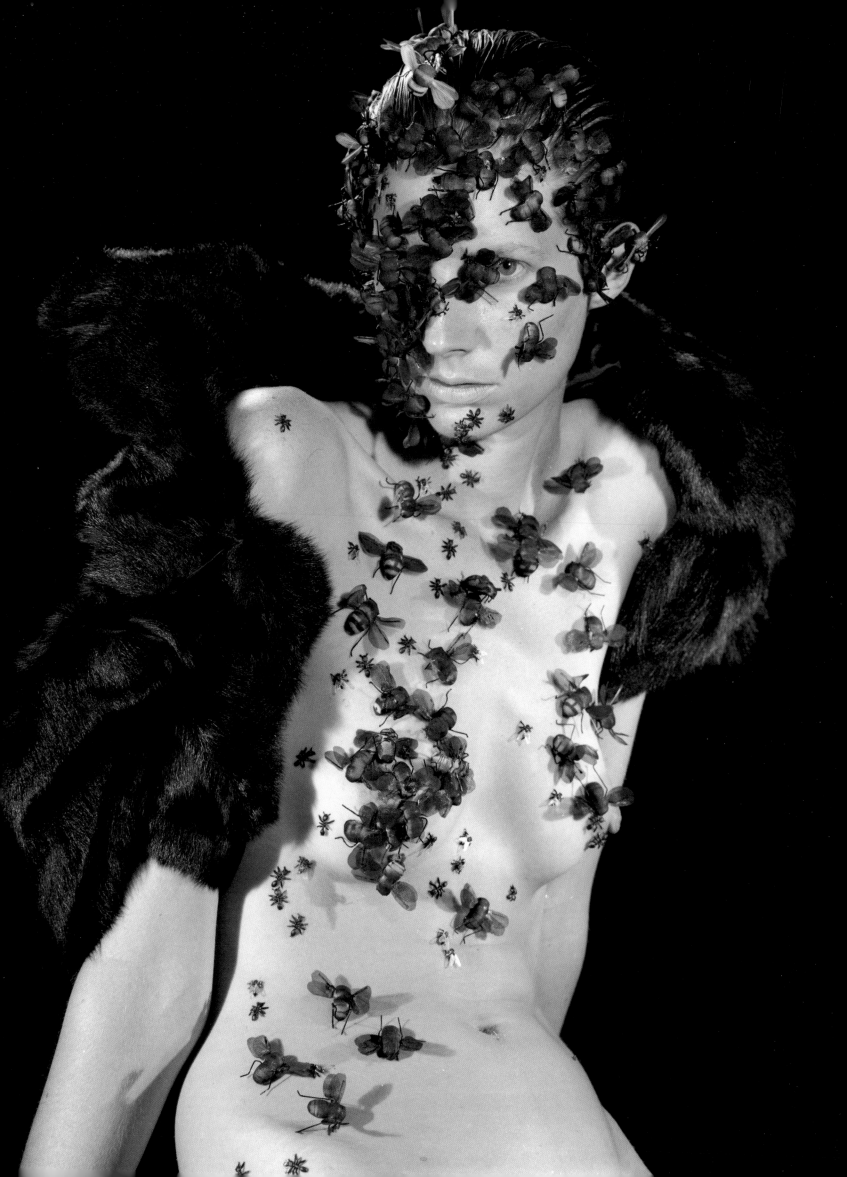

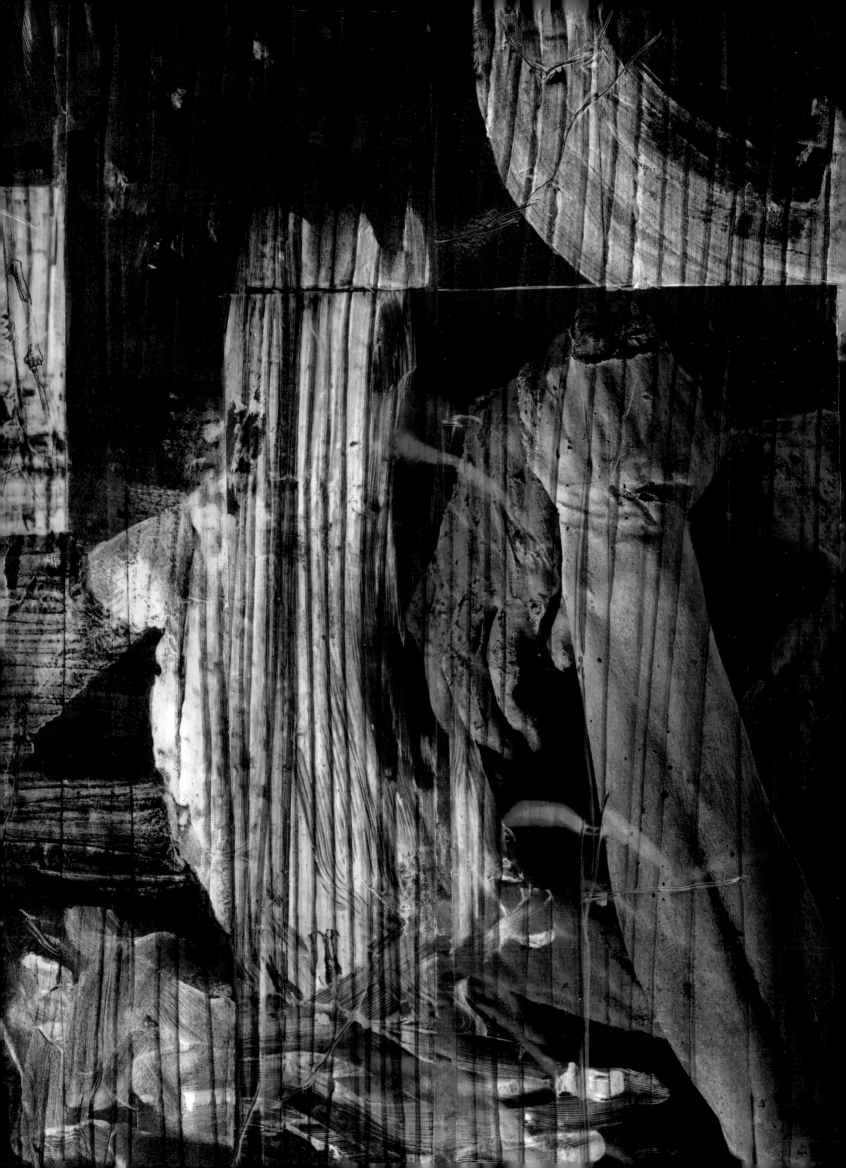

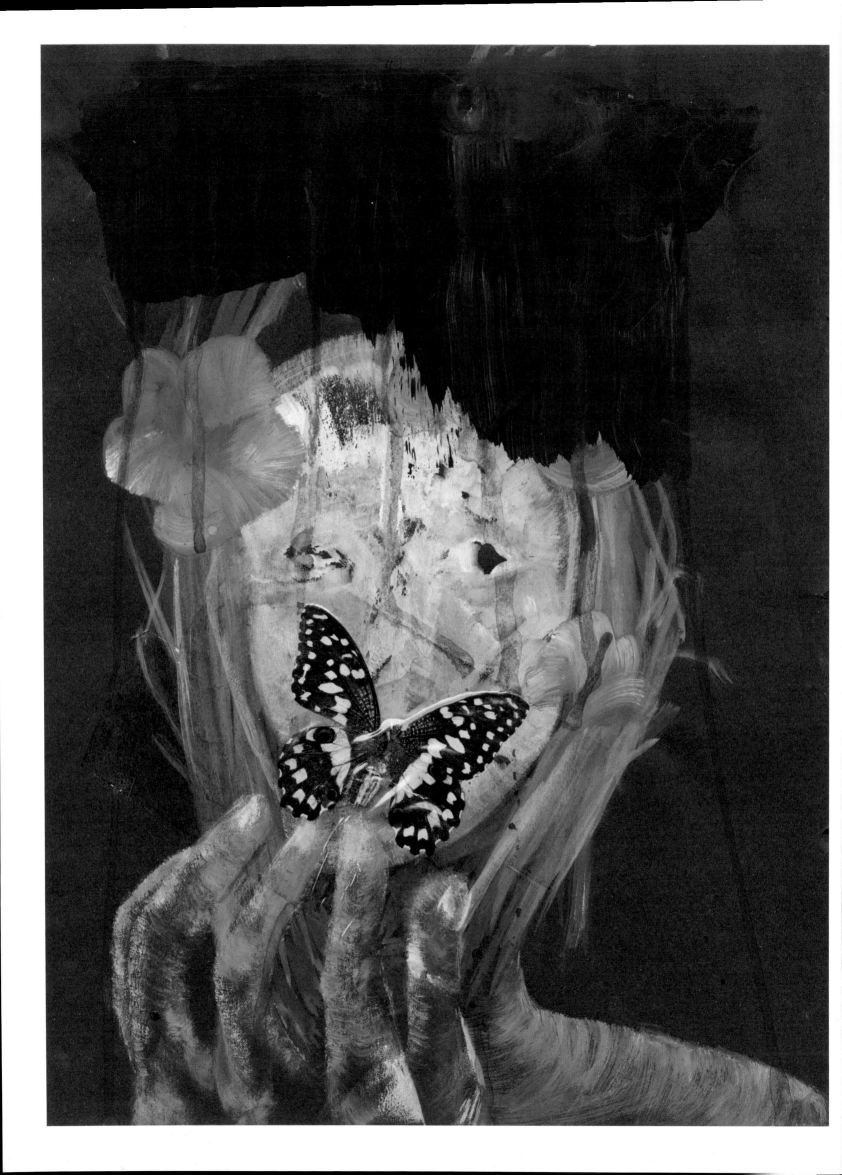

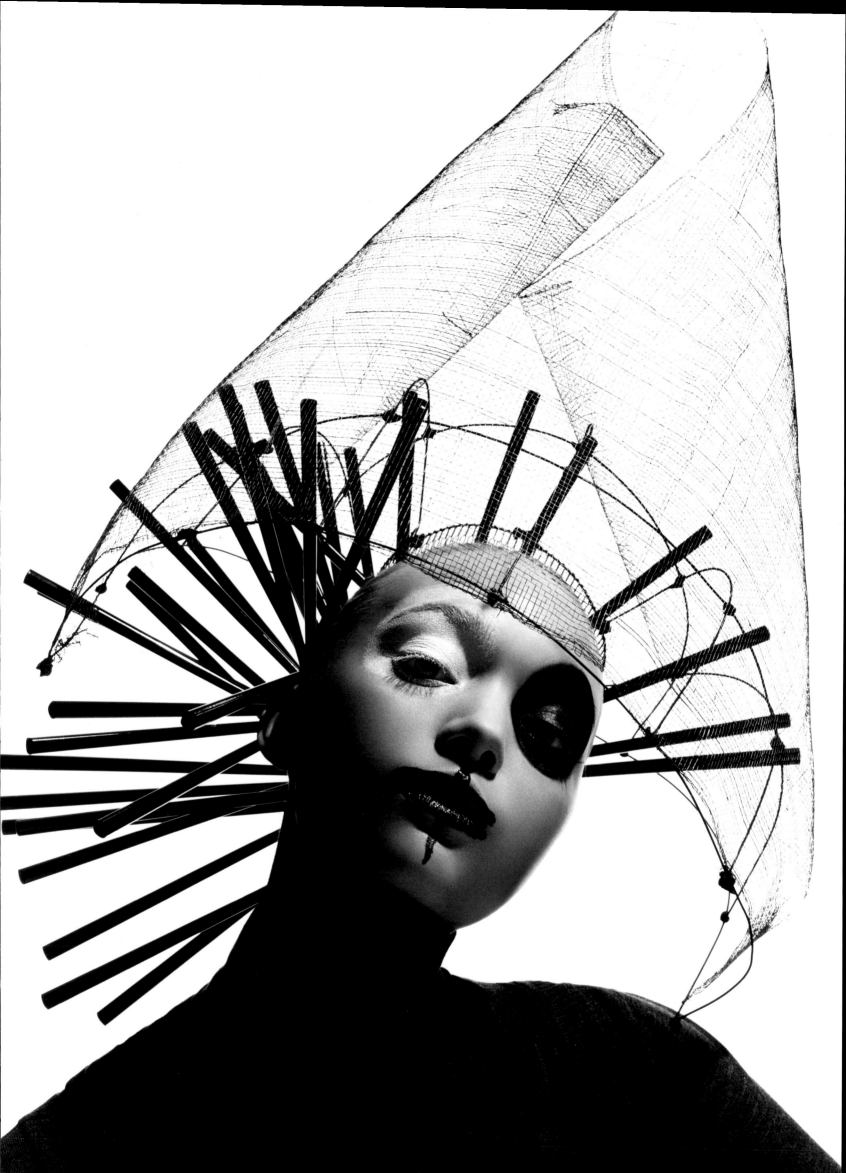

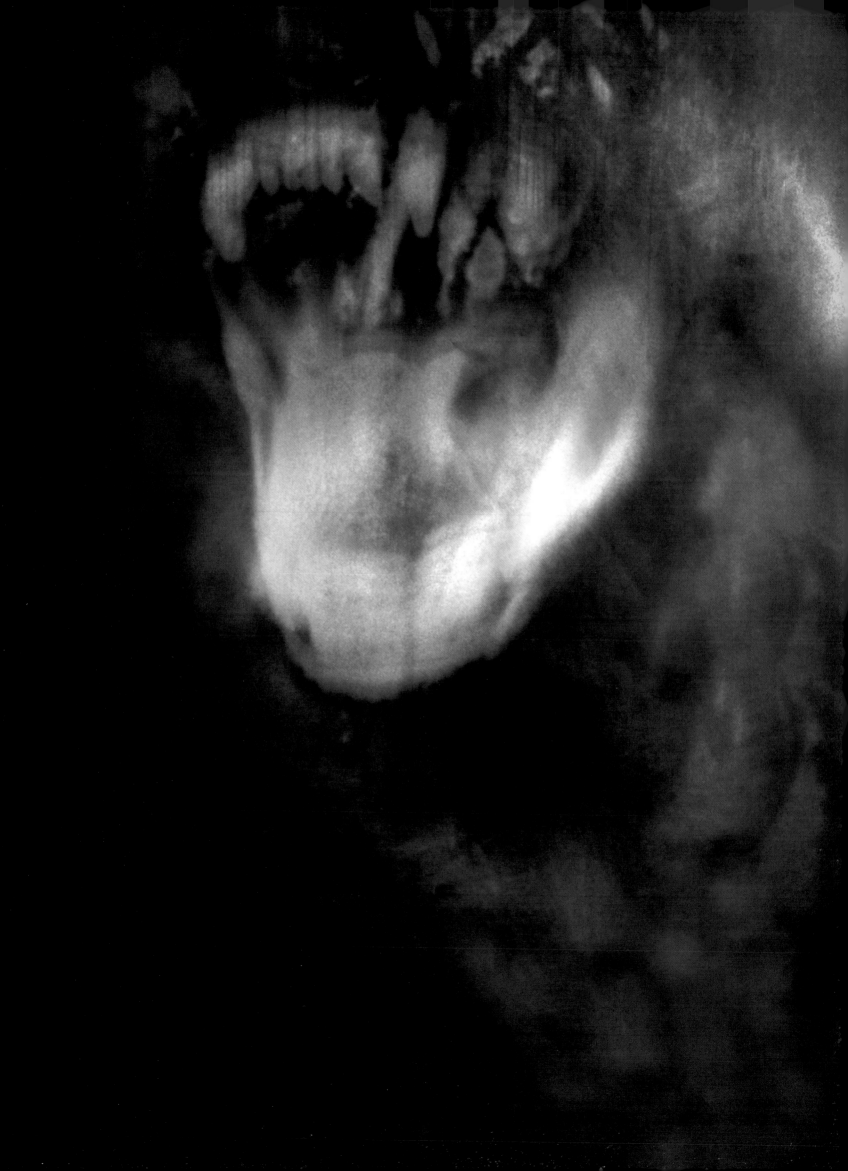

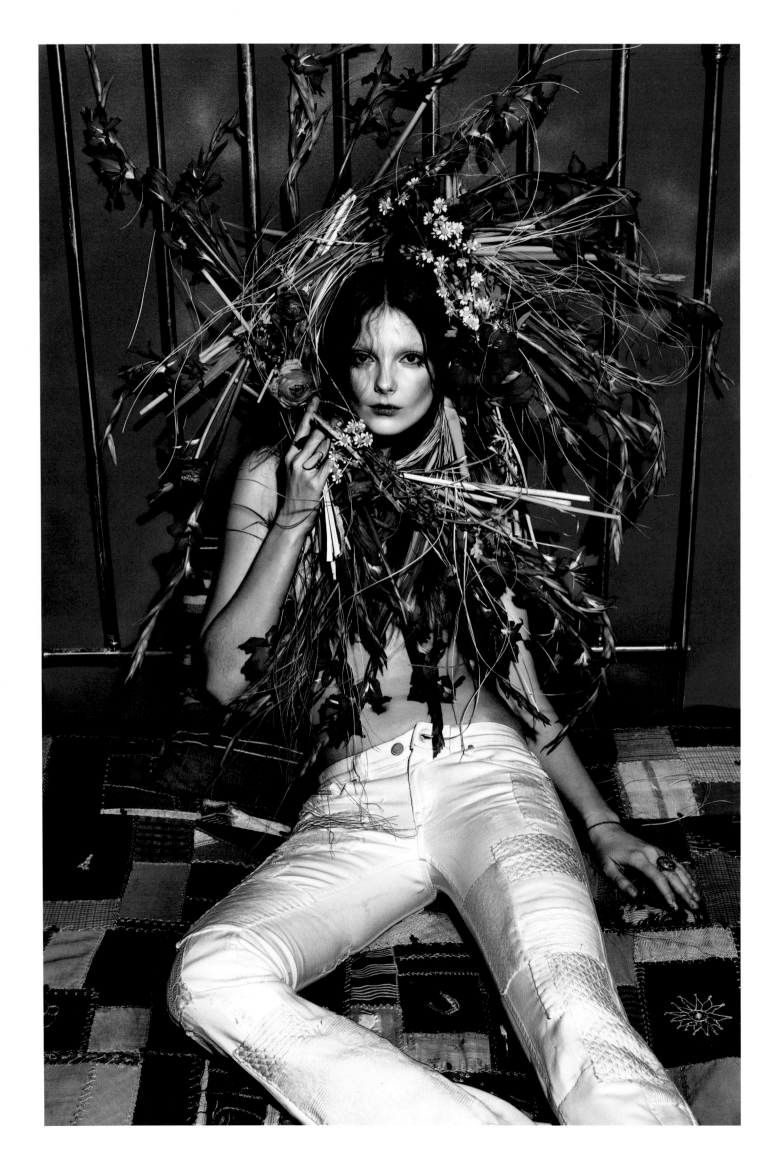

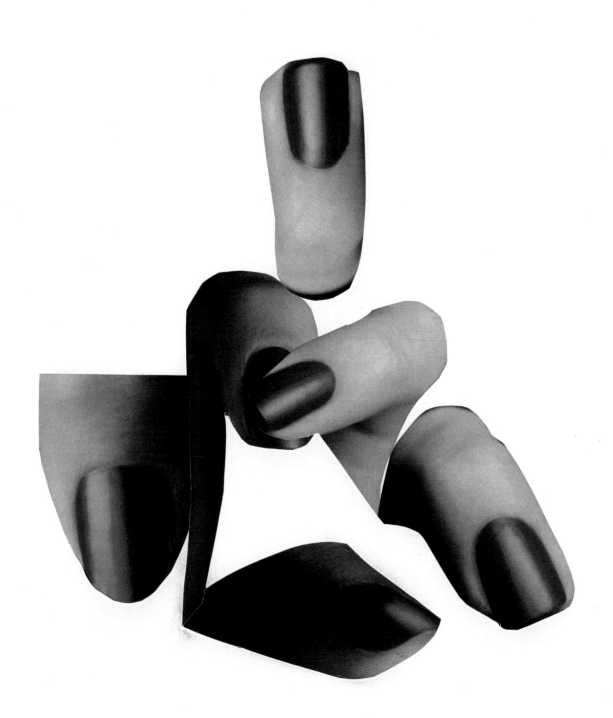

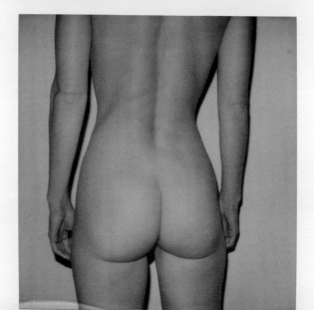

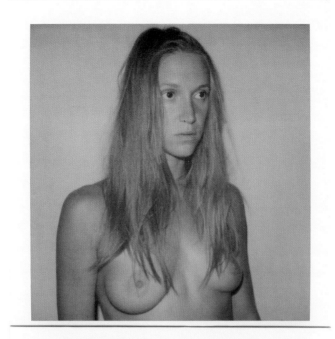
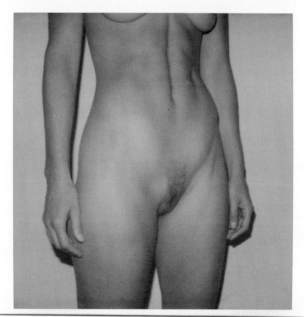

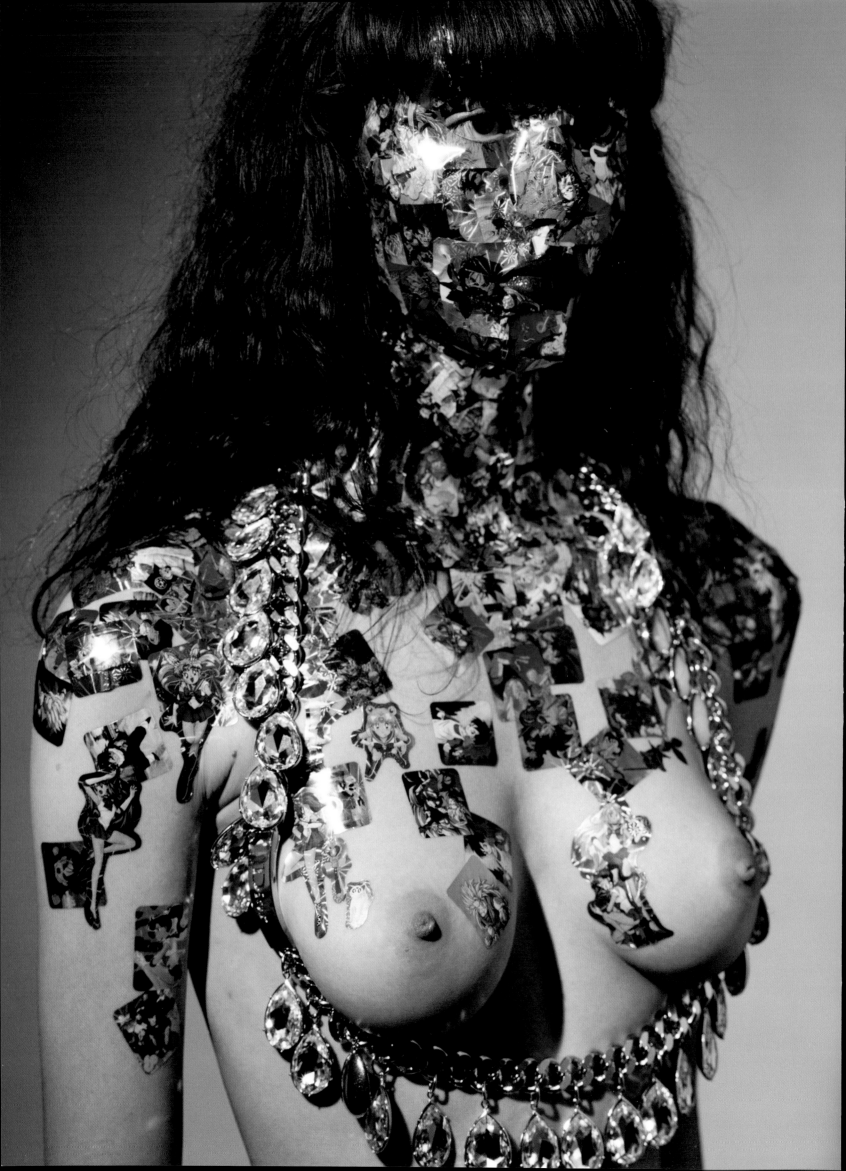

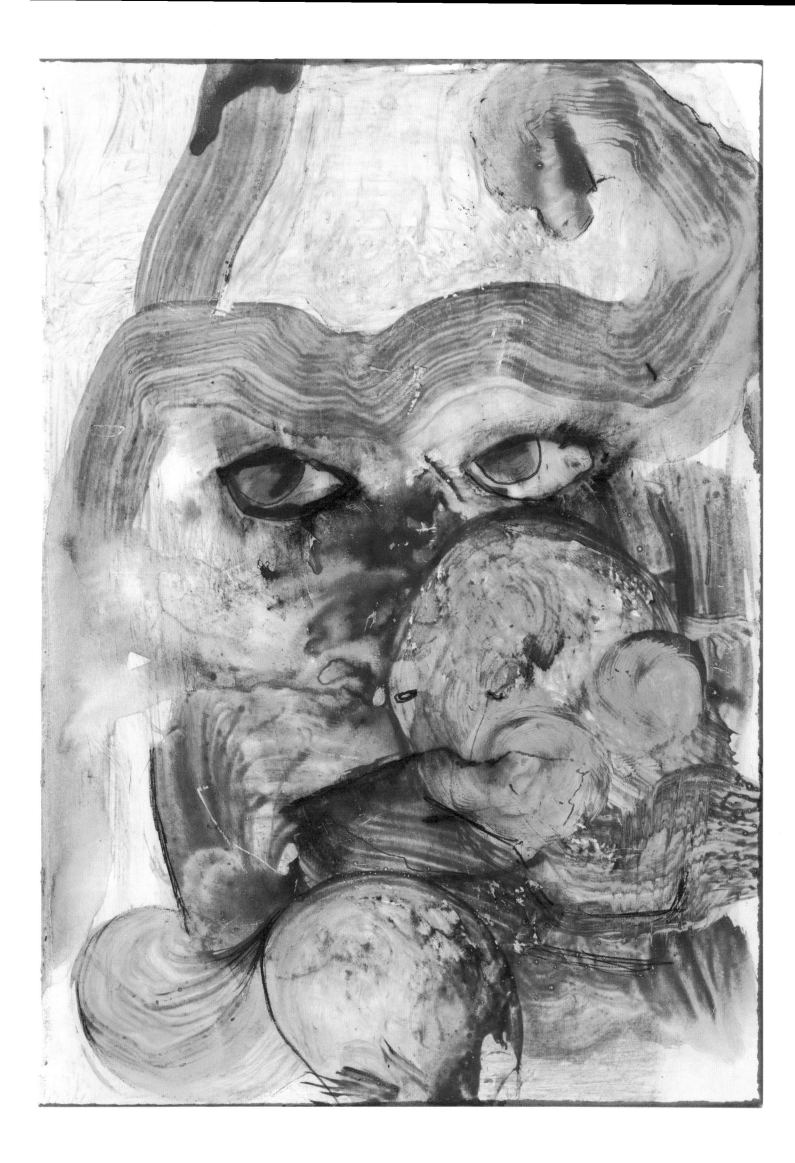

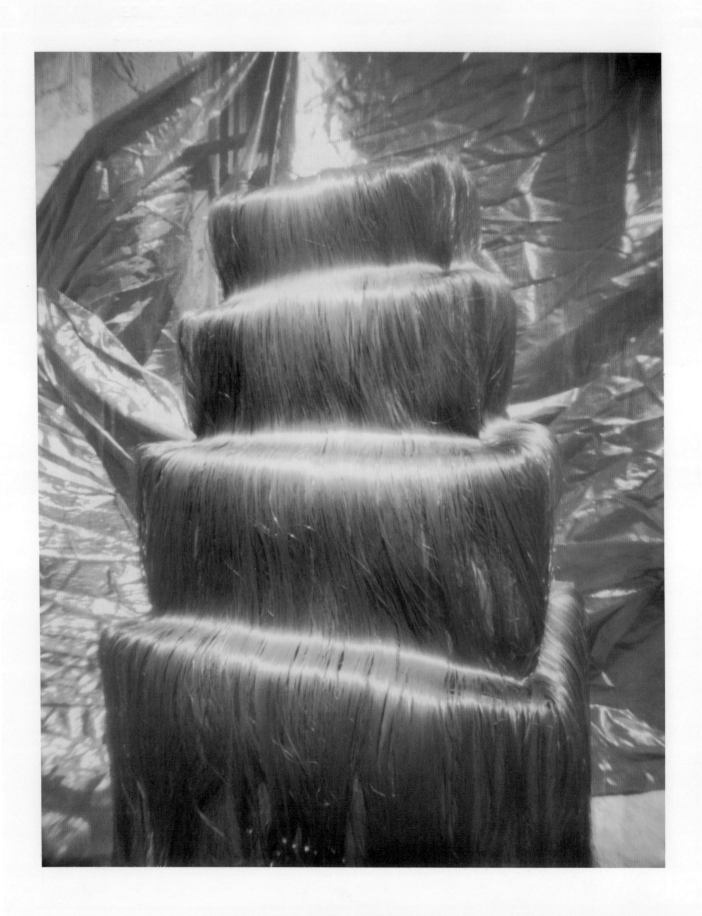

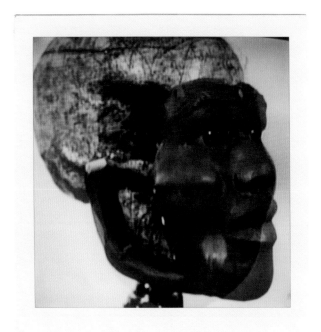

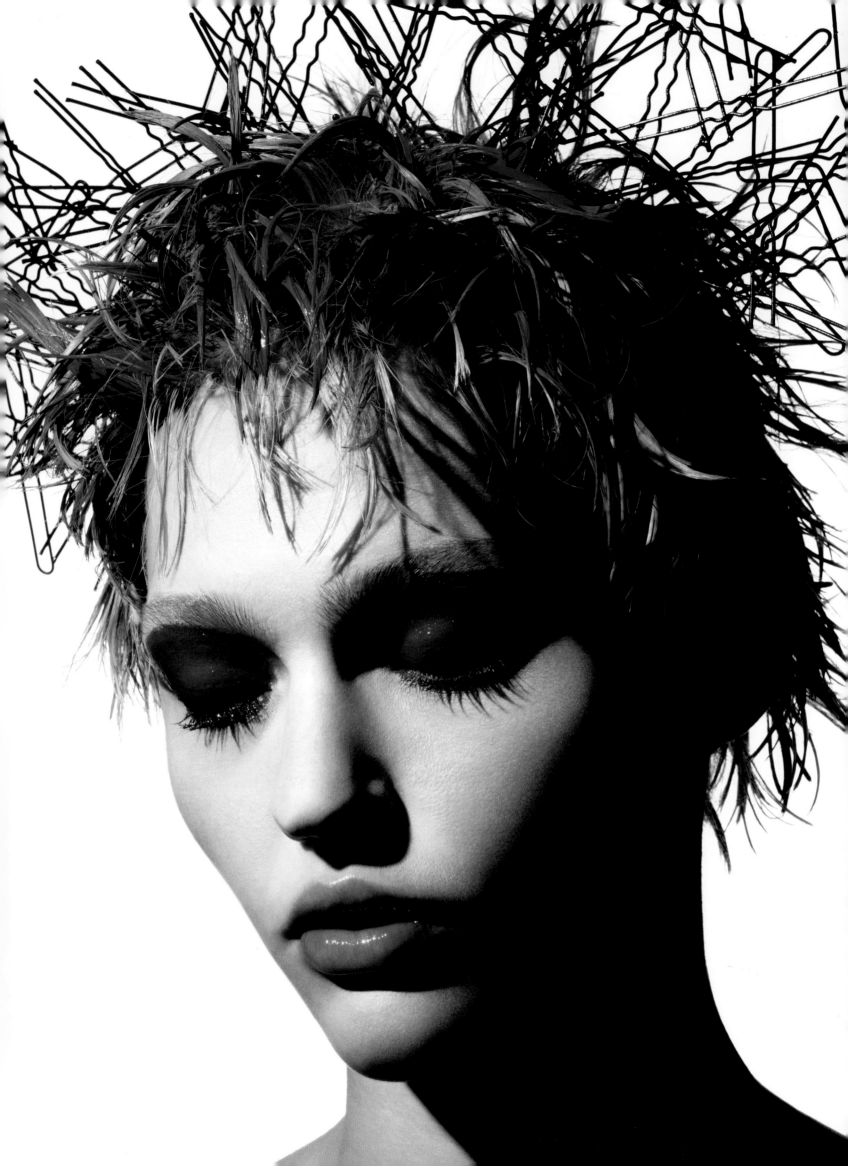

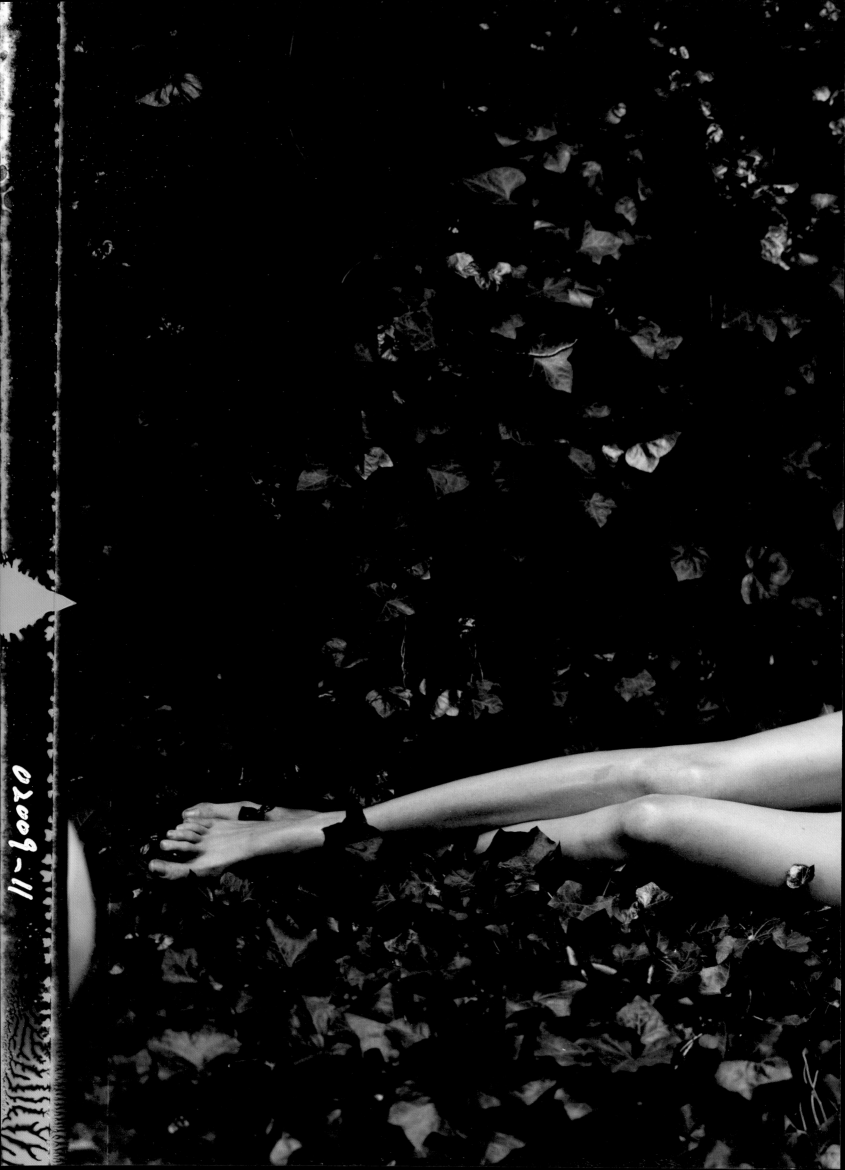

0808-11

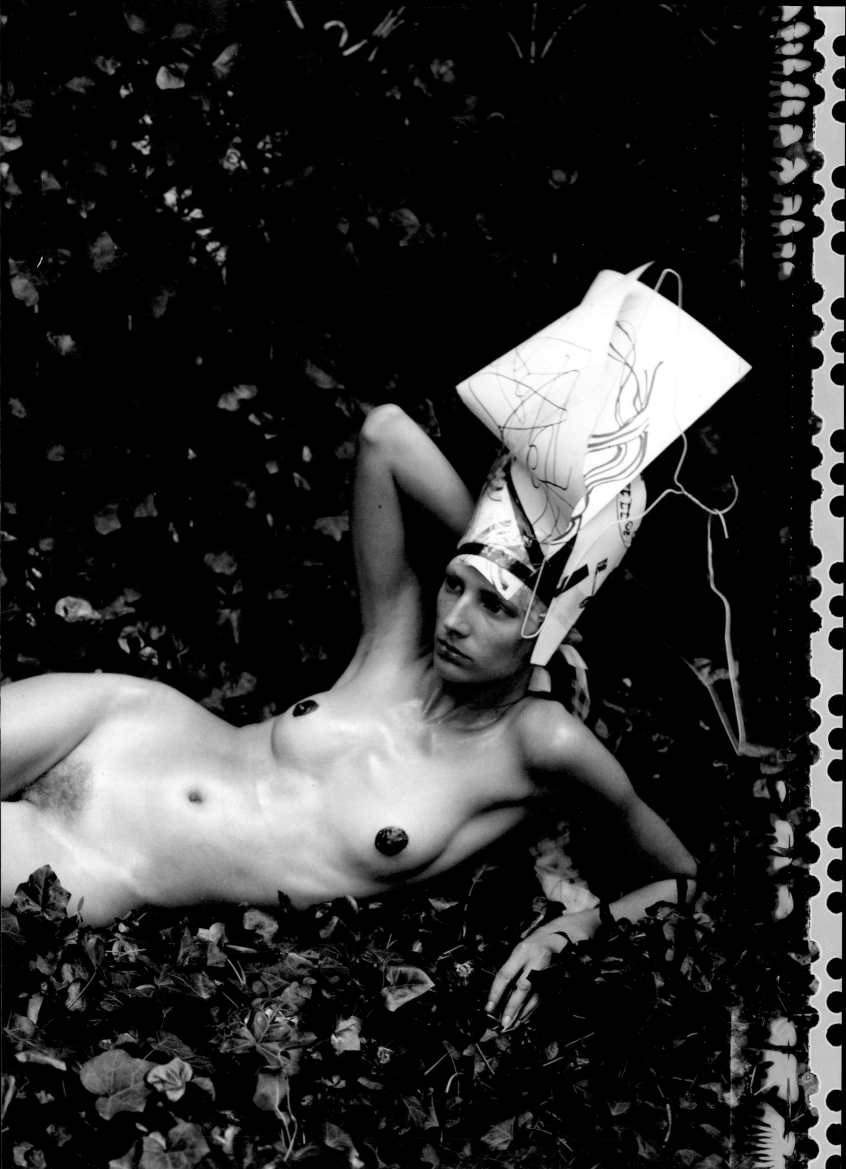

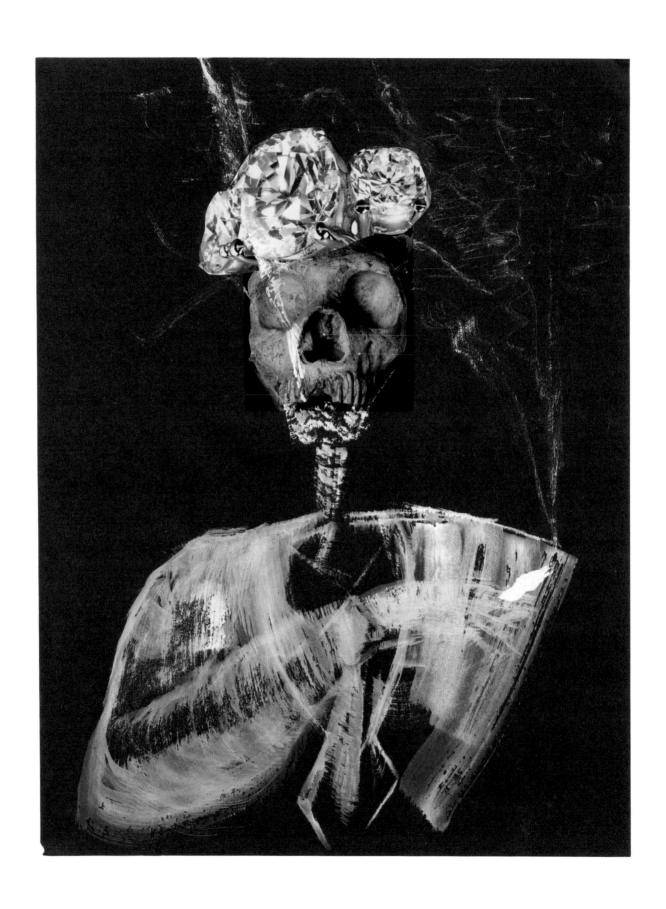

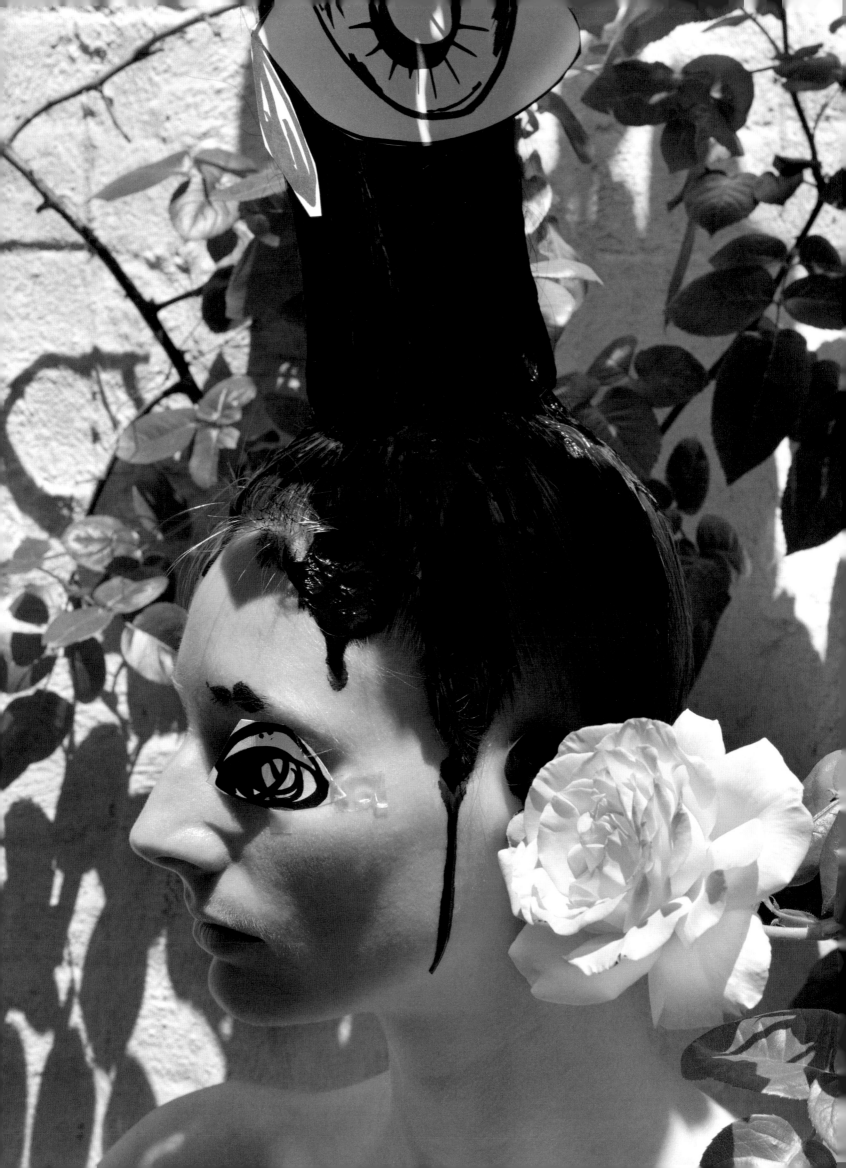

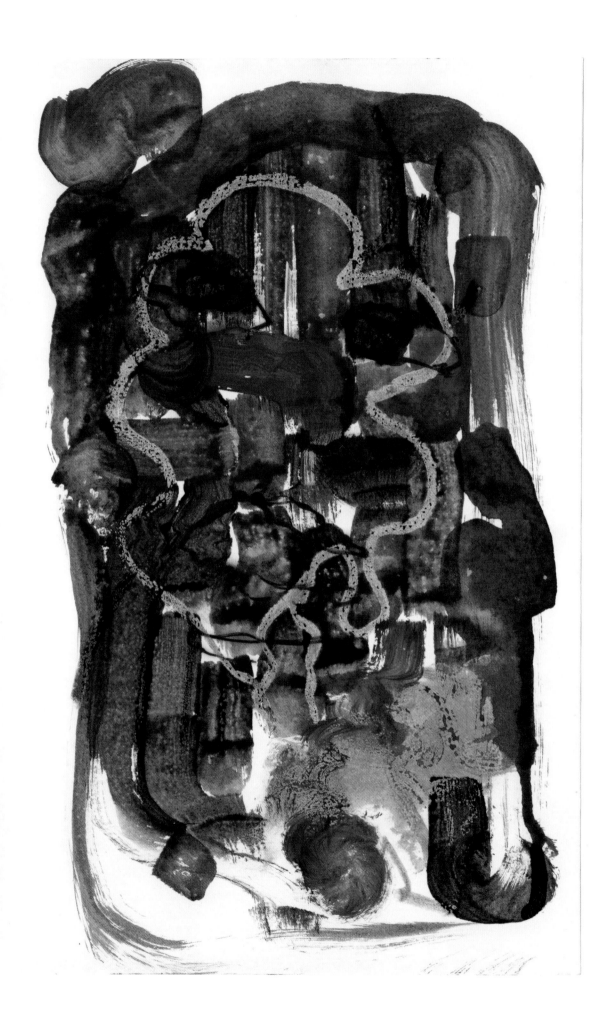

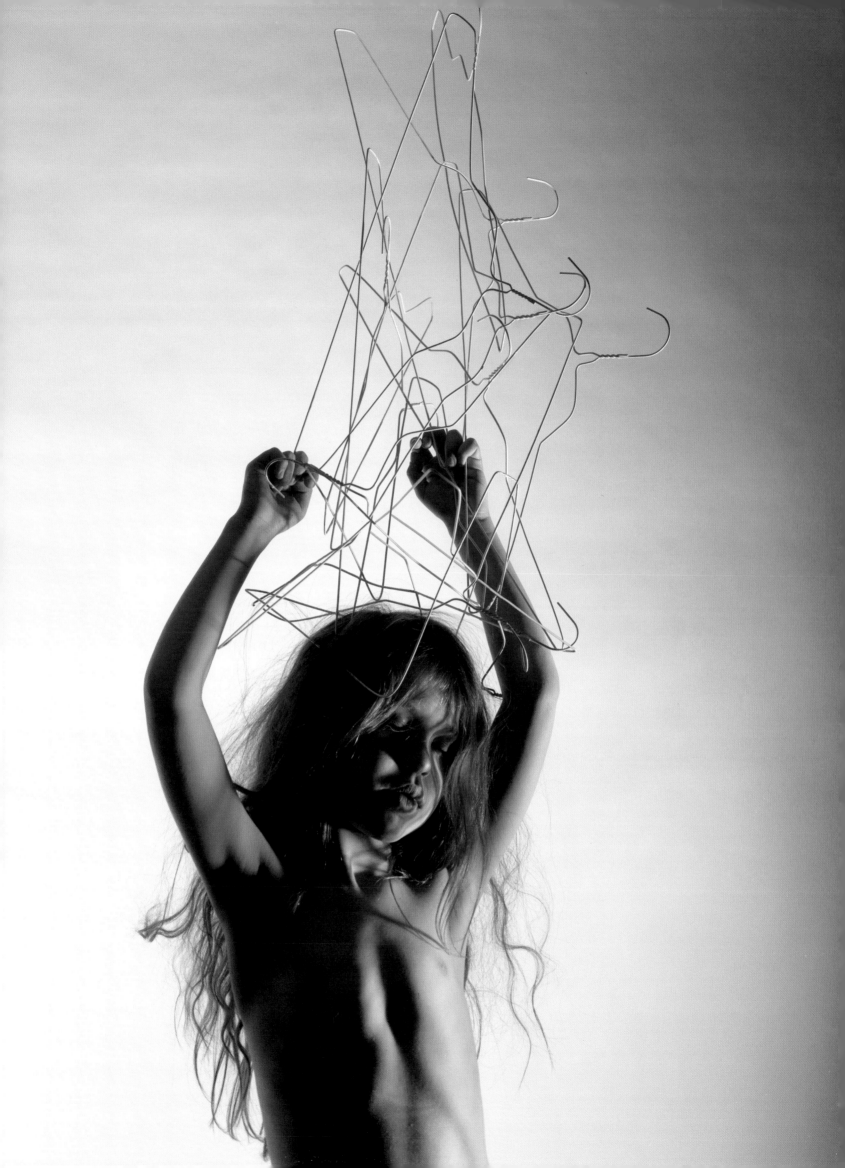

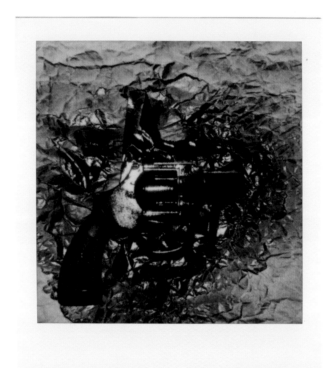

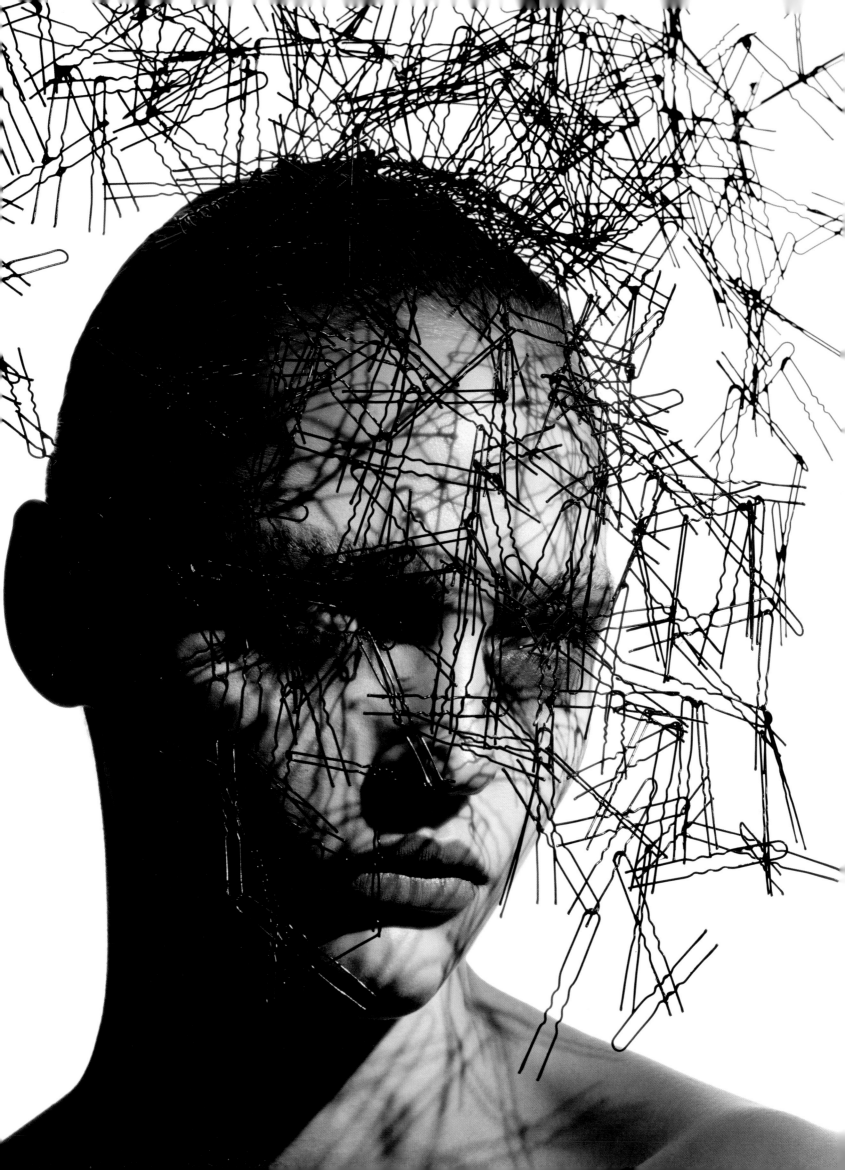

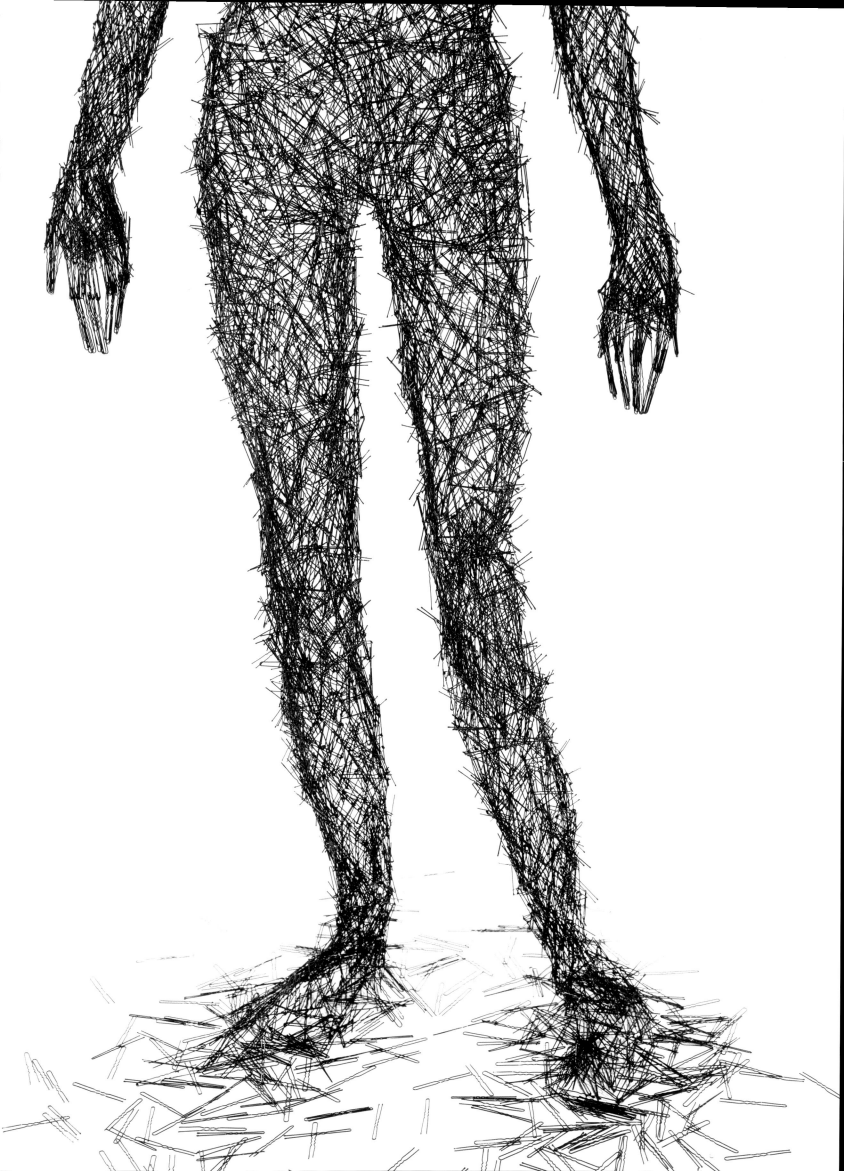

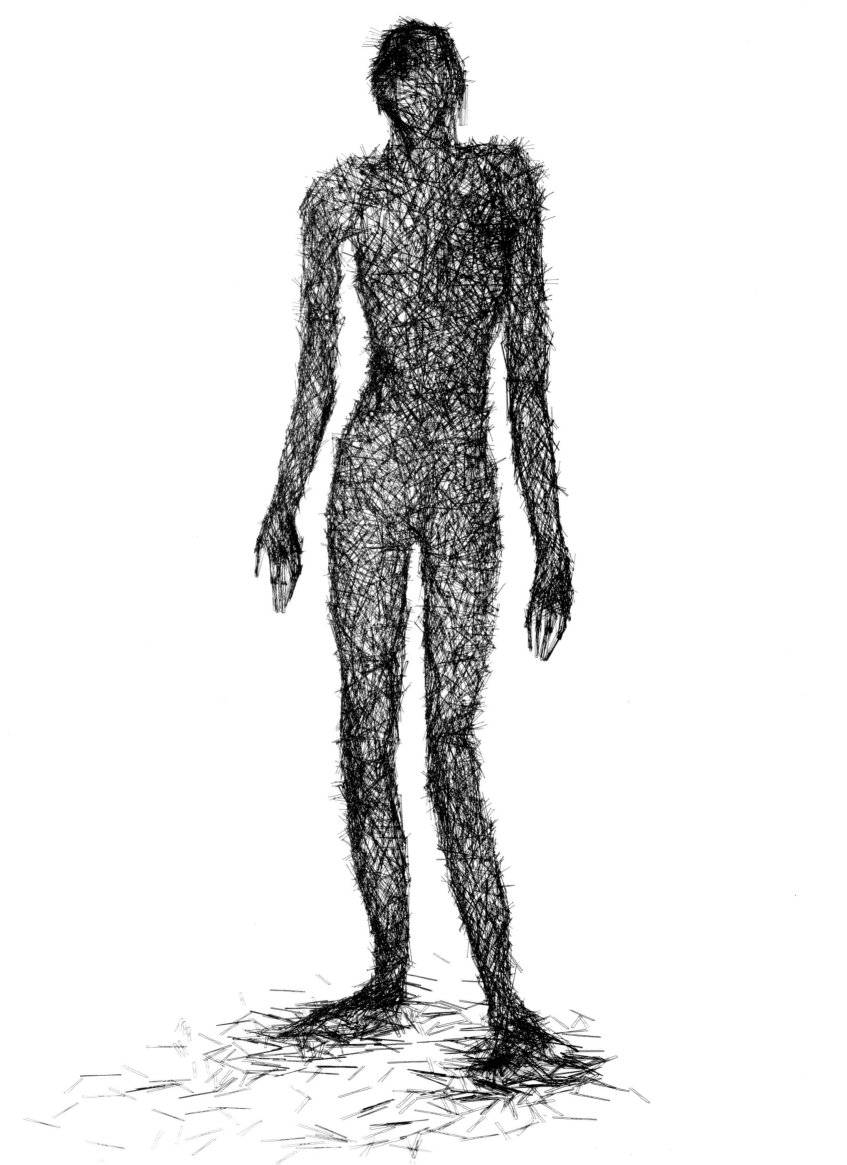

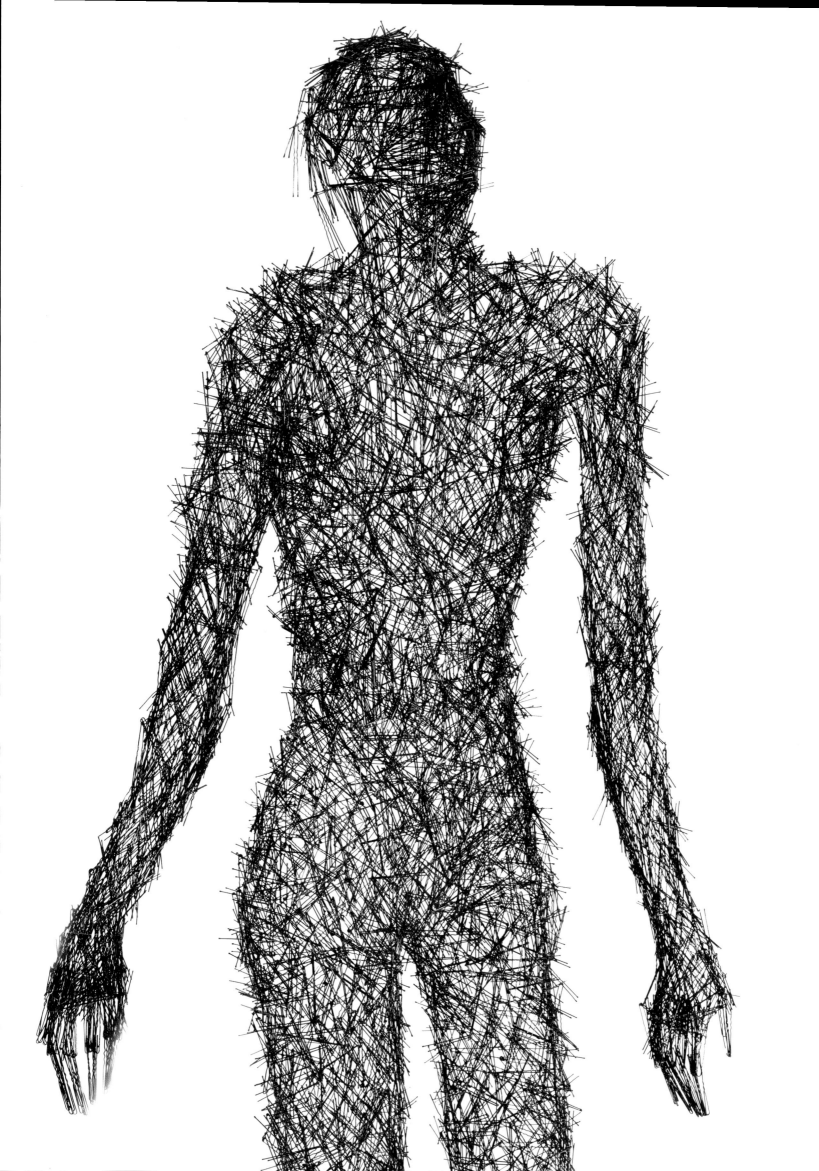

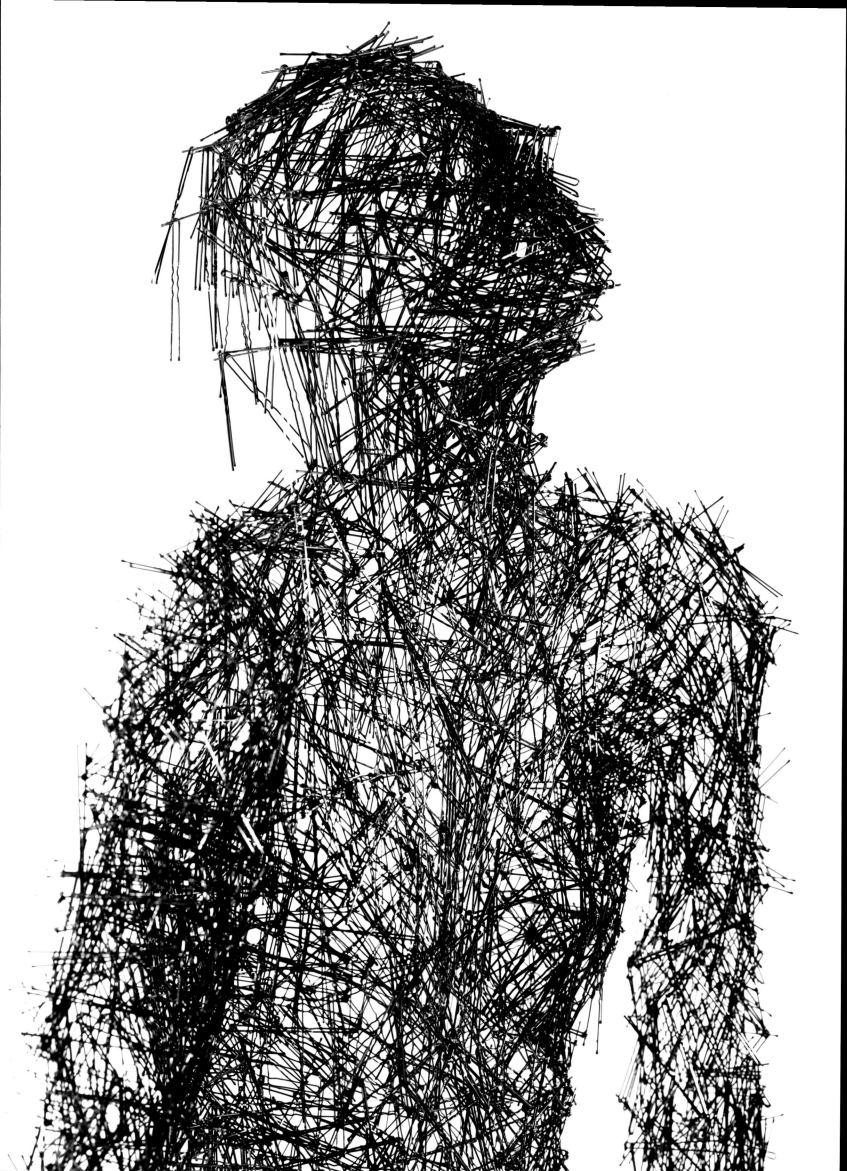

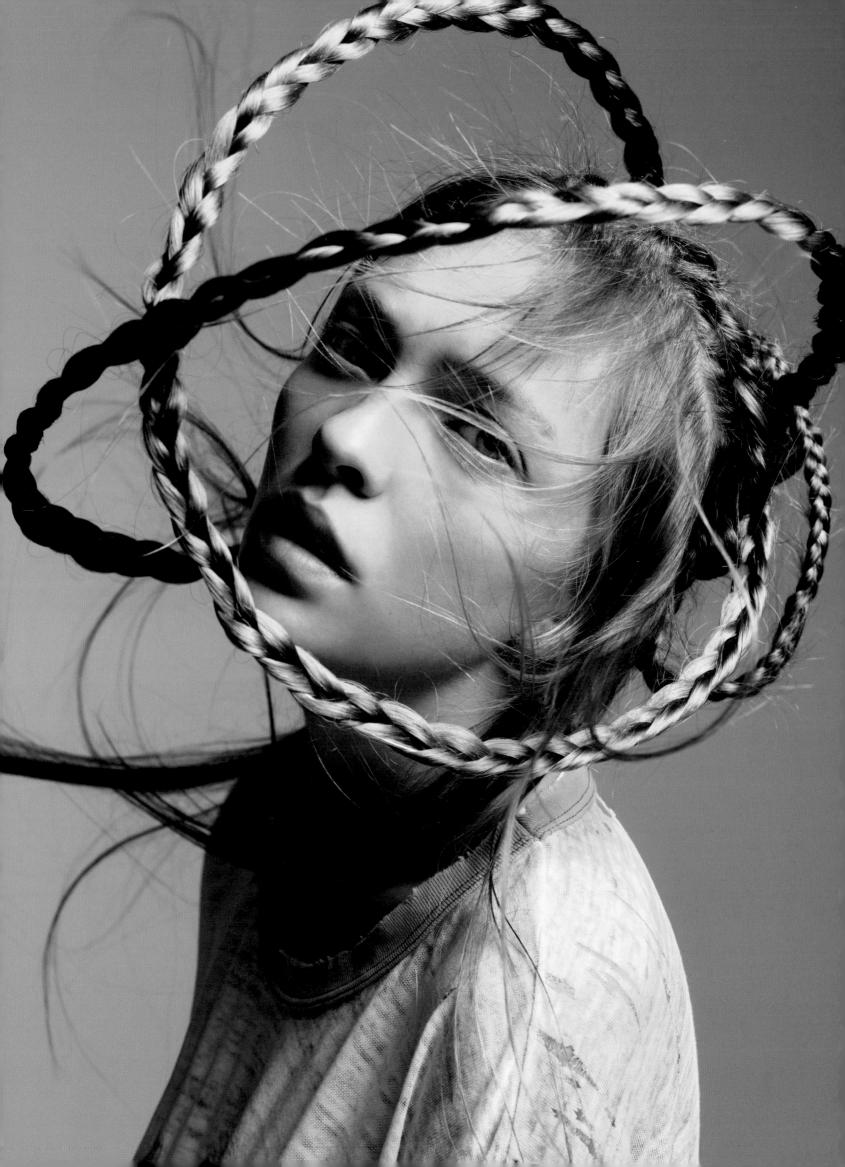

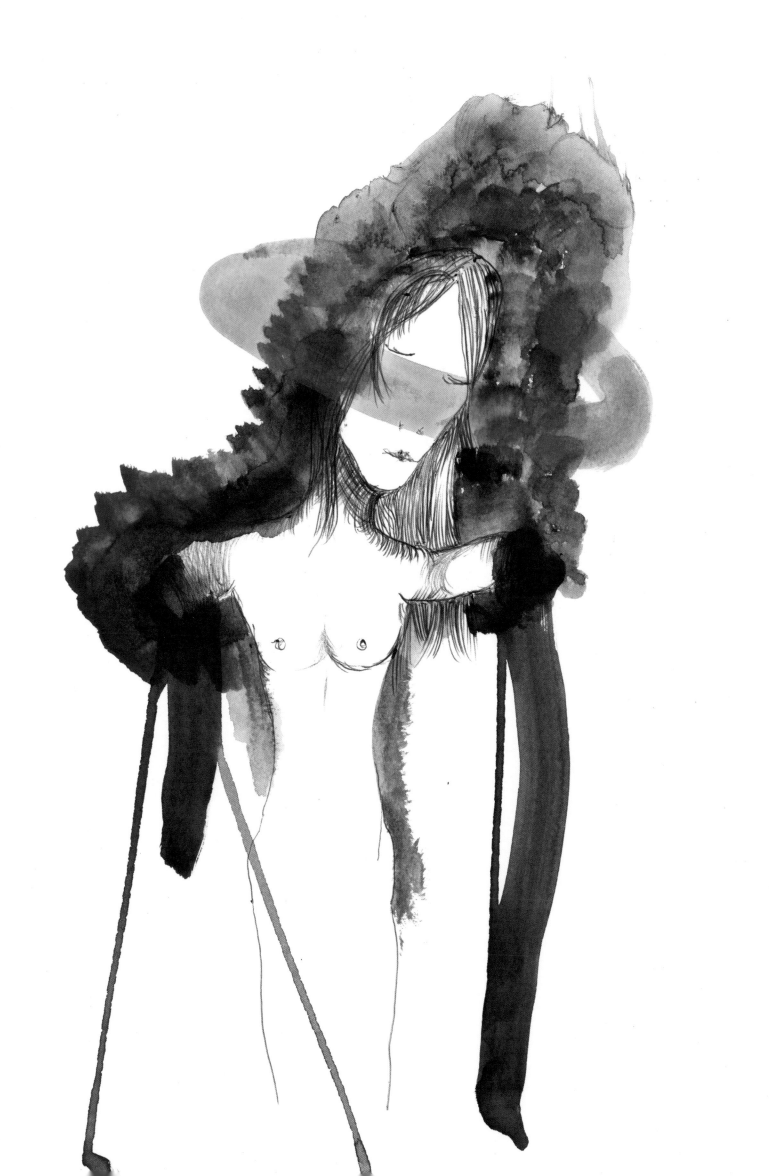

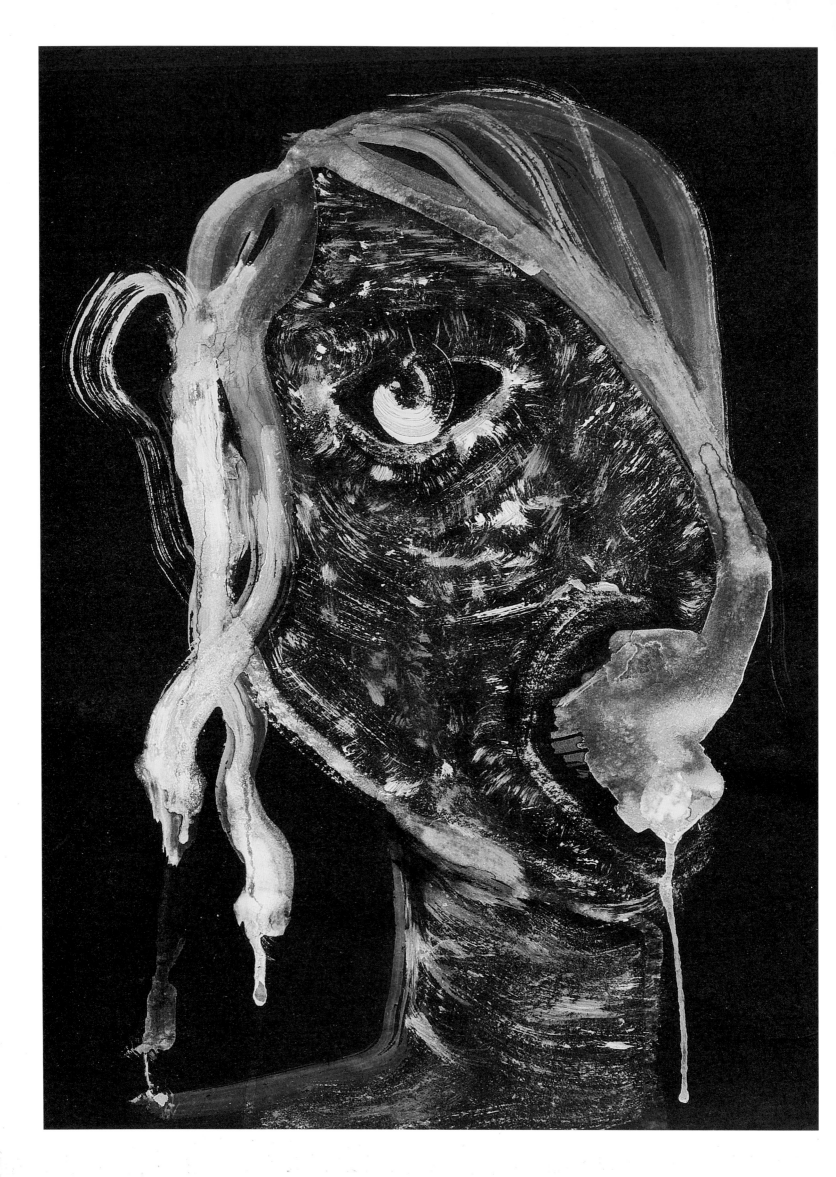

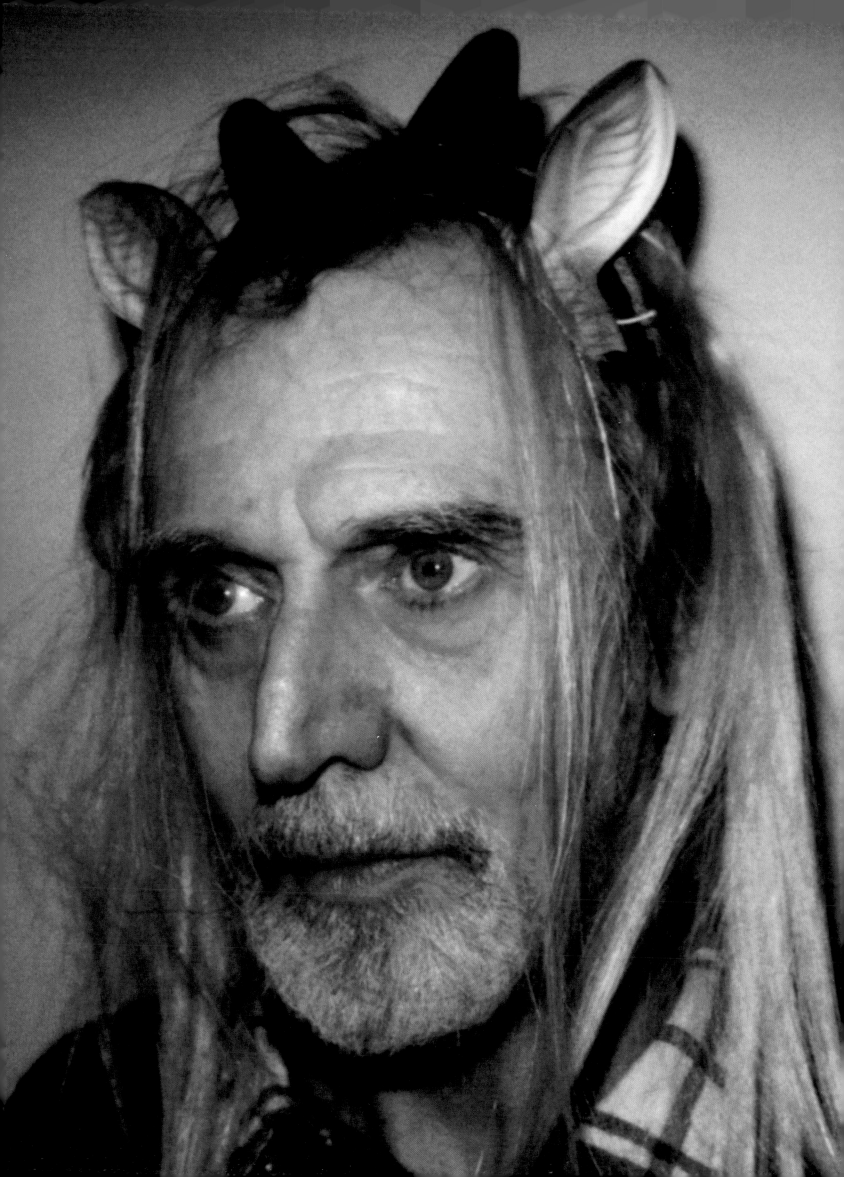

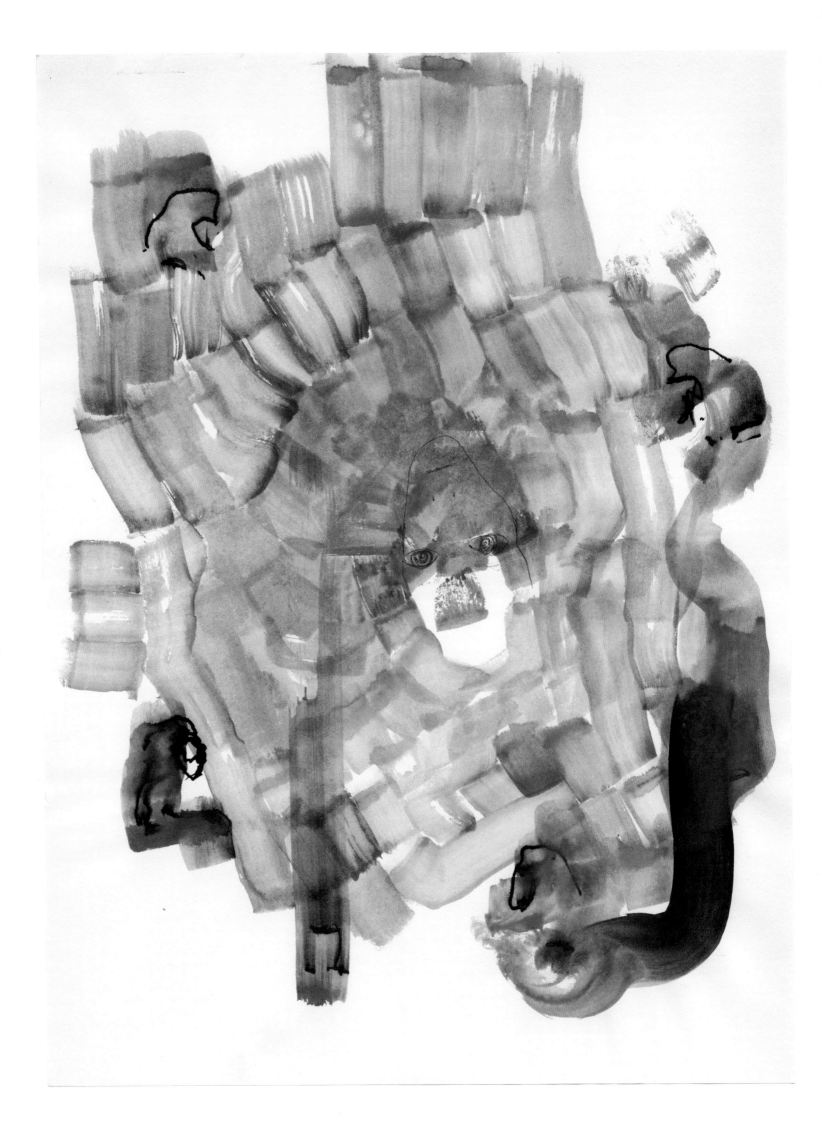

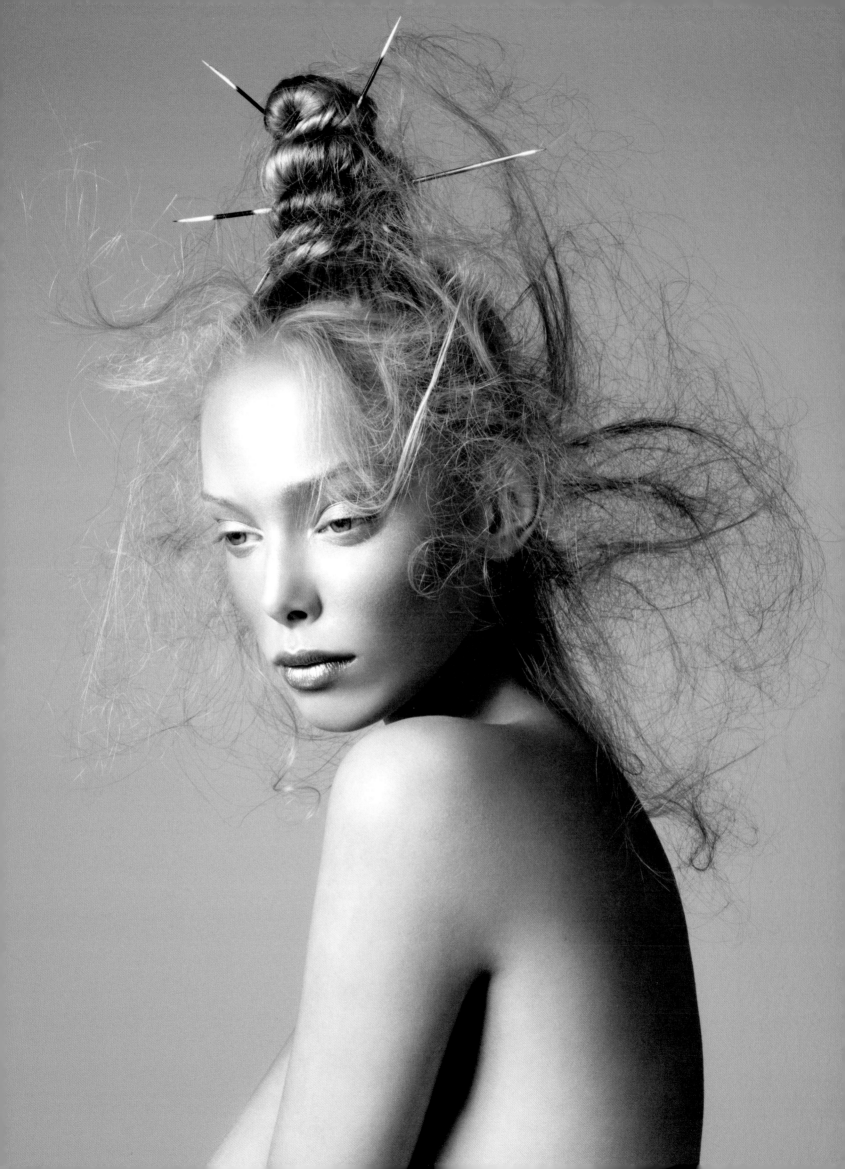

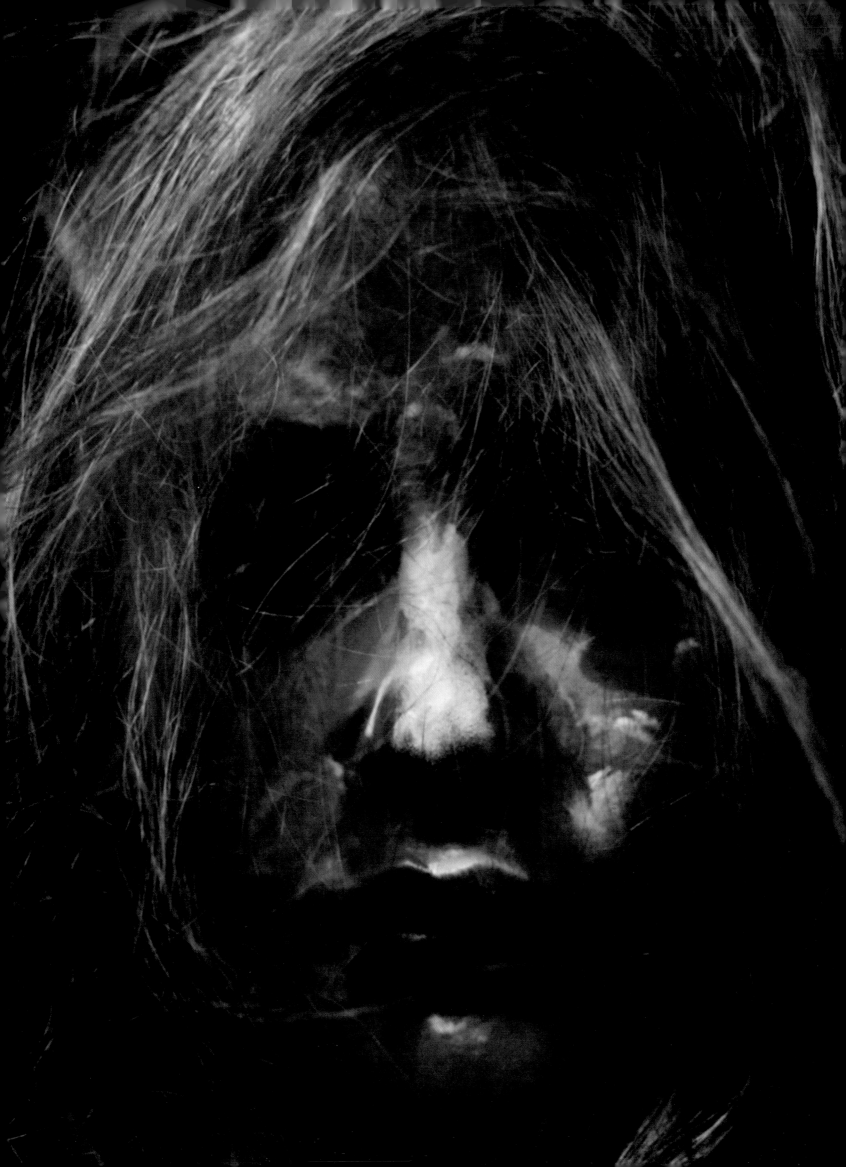

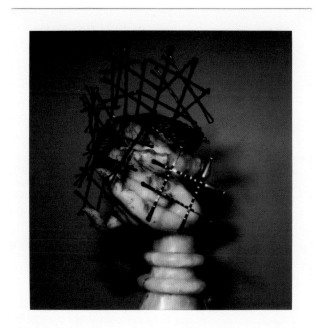

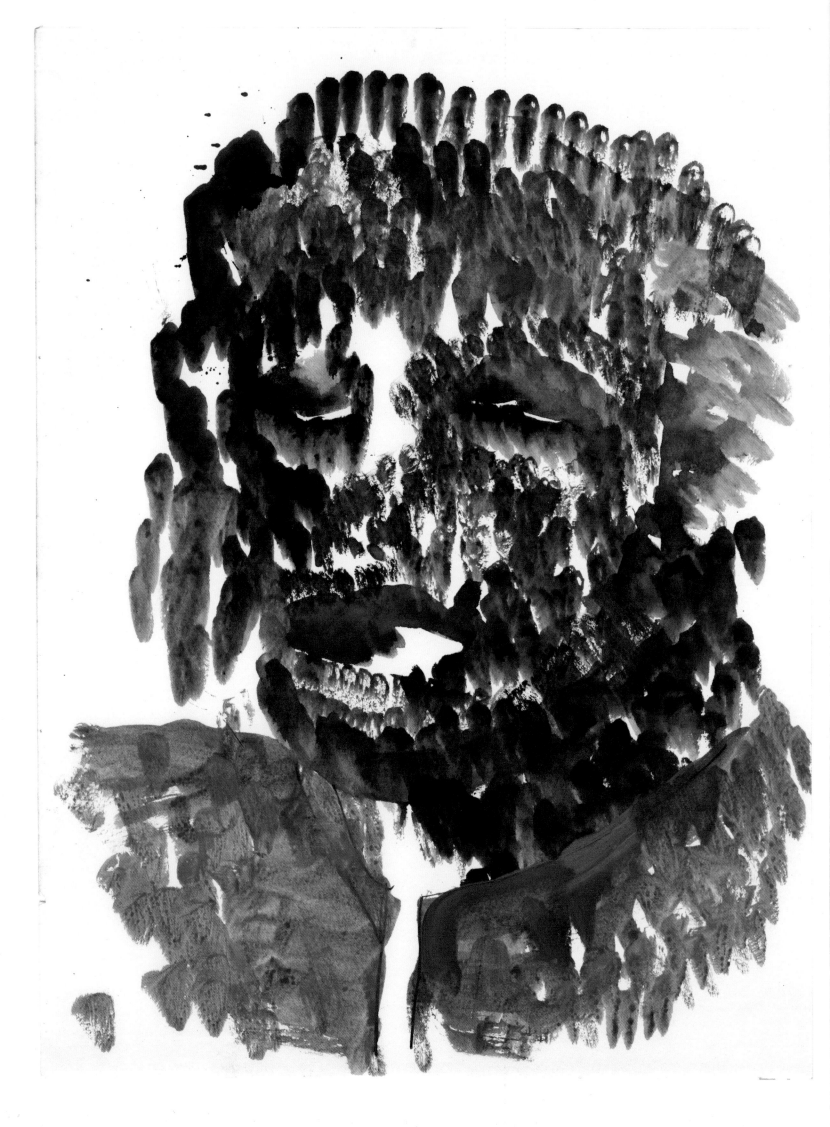

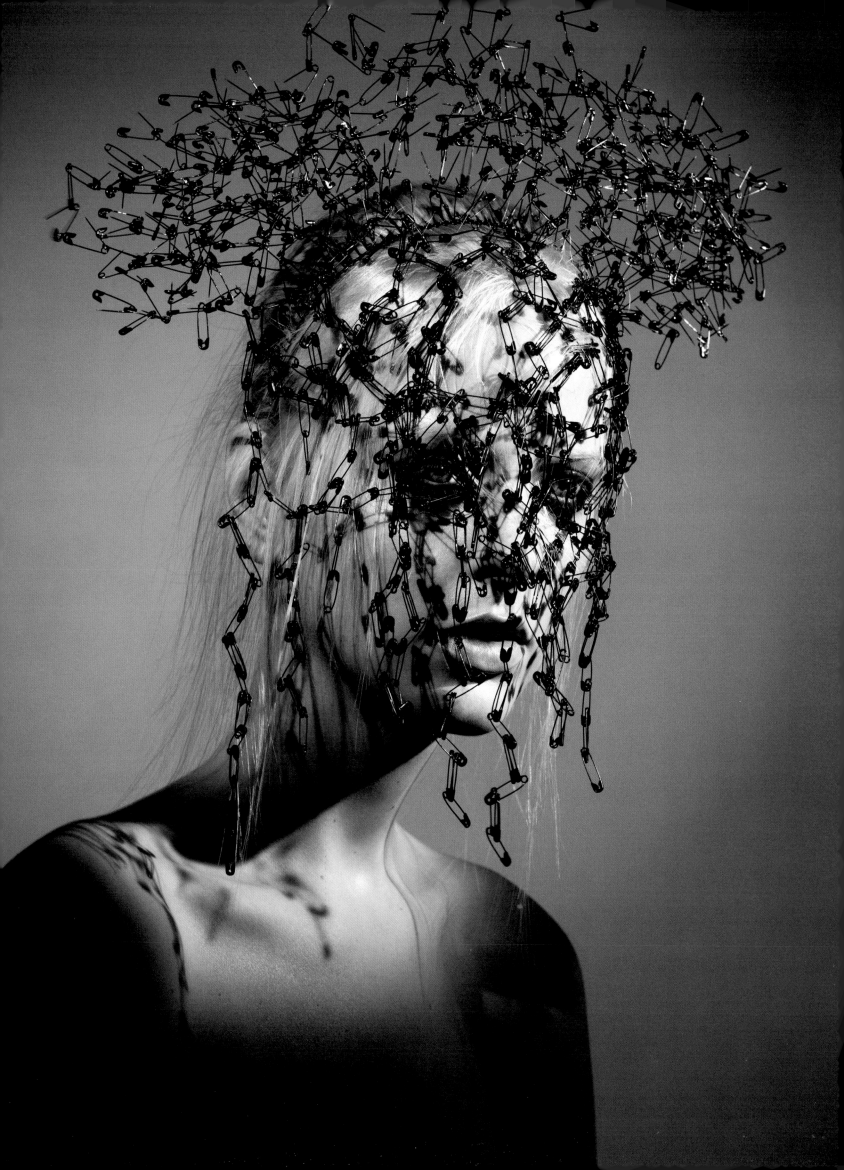

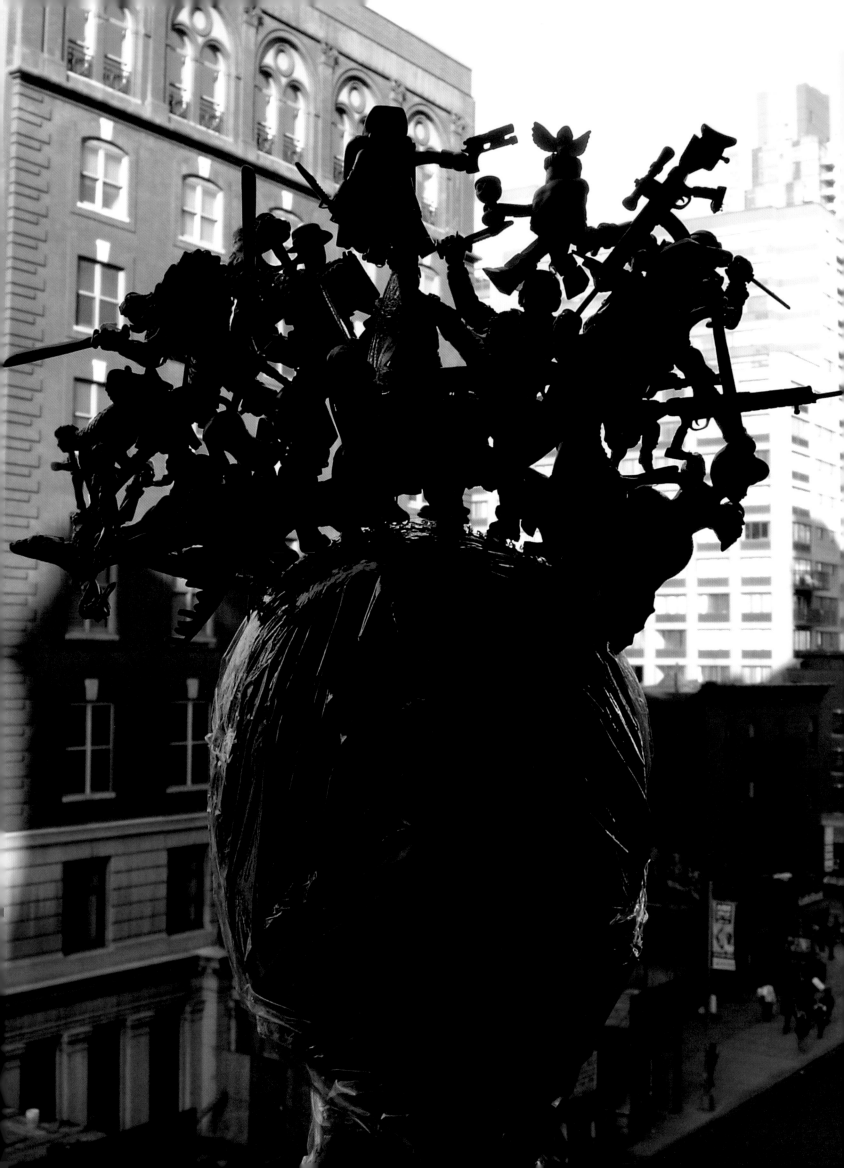

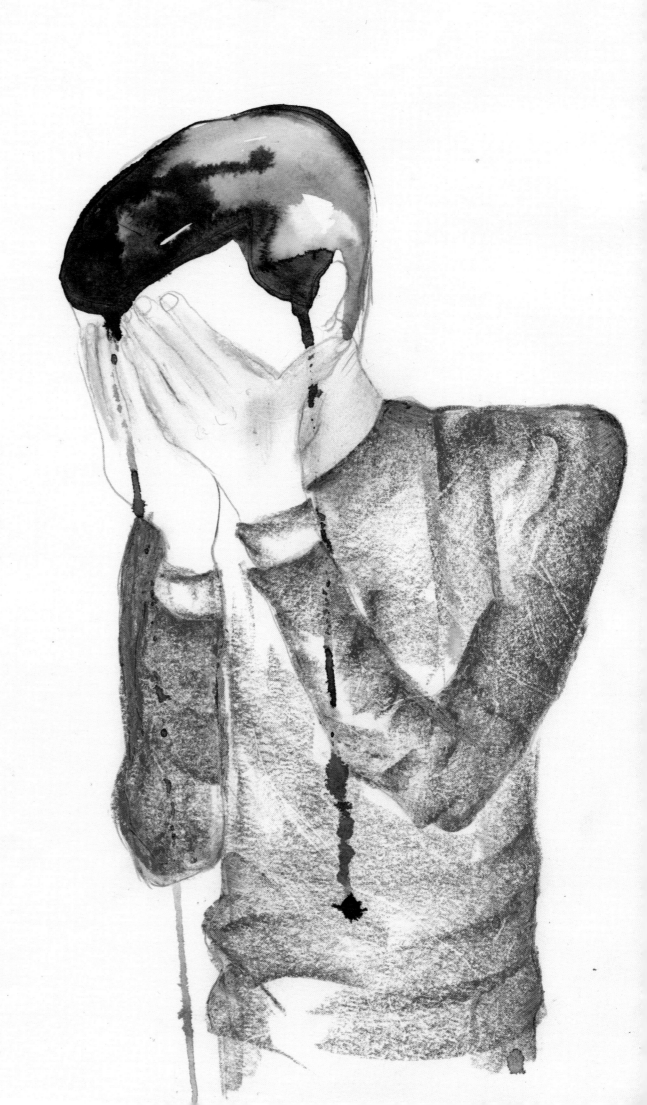

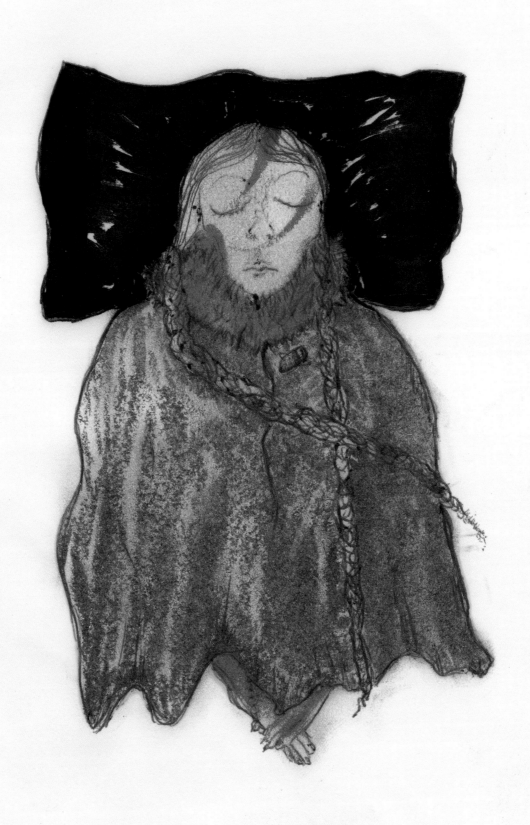

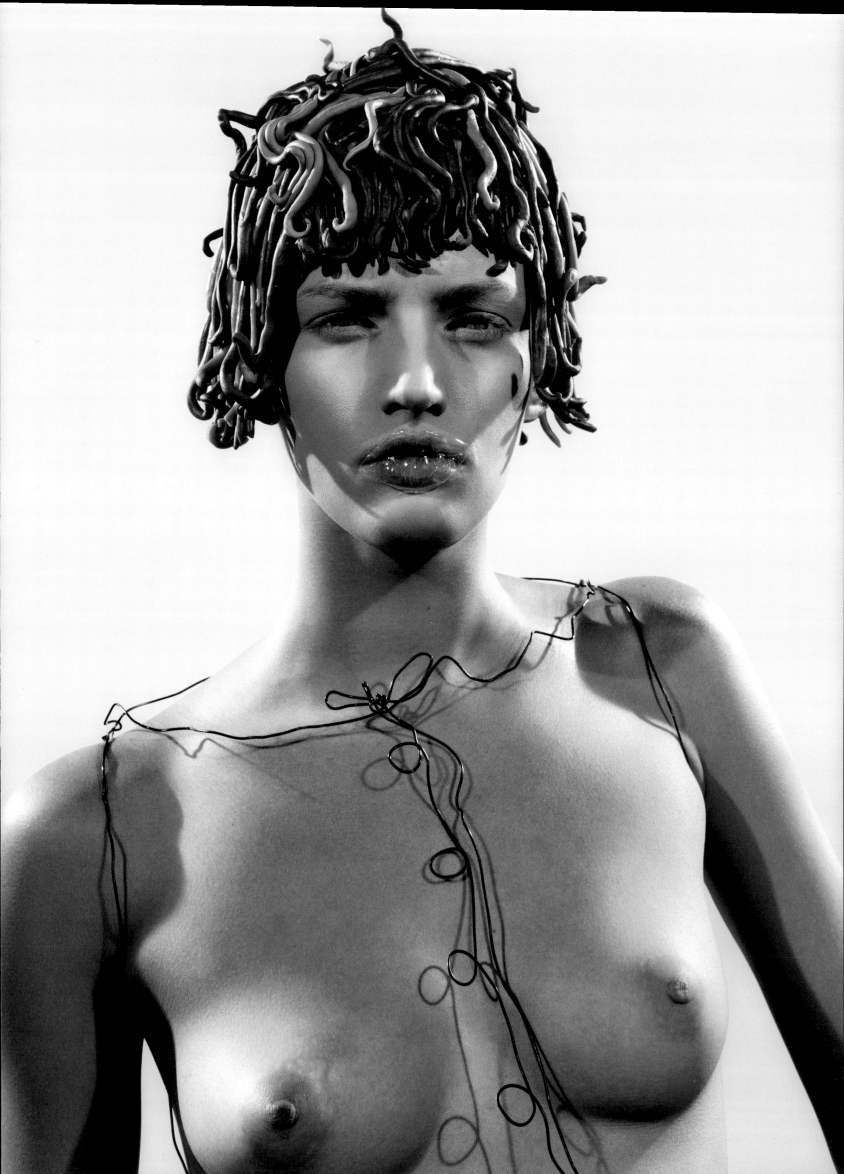

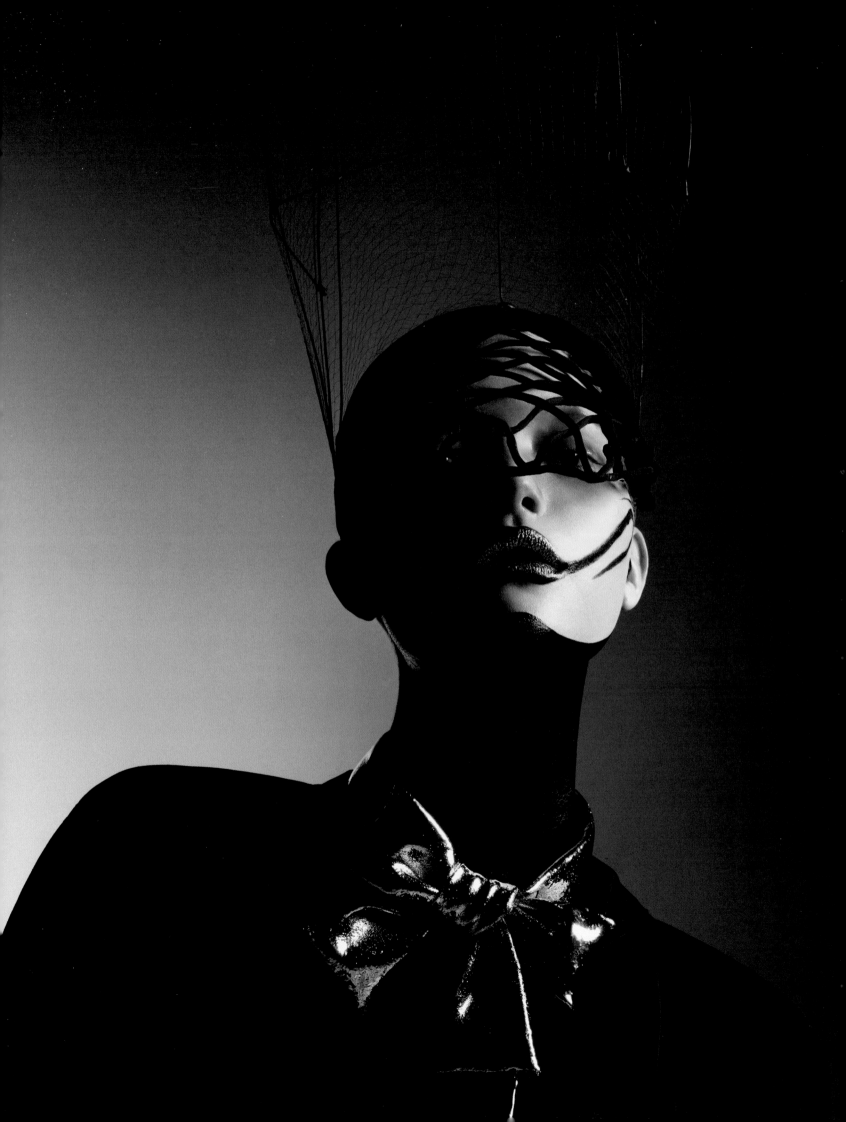

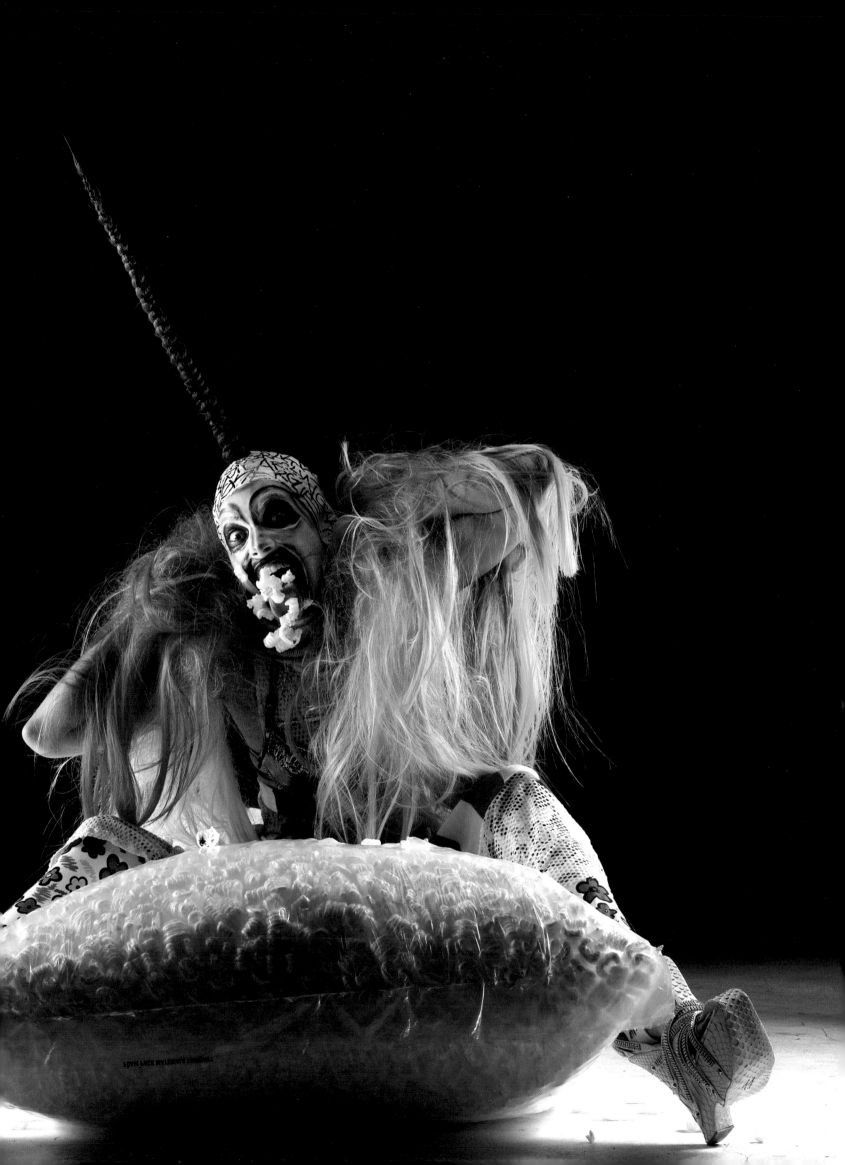

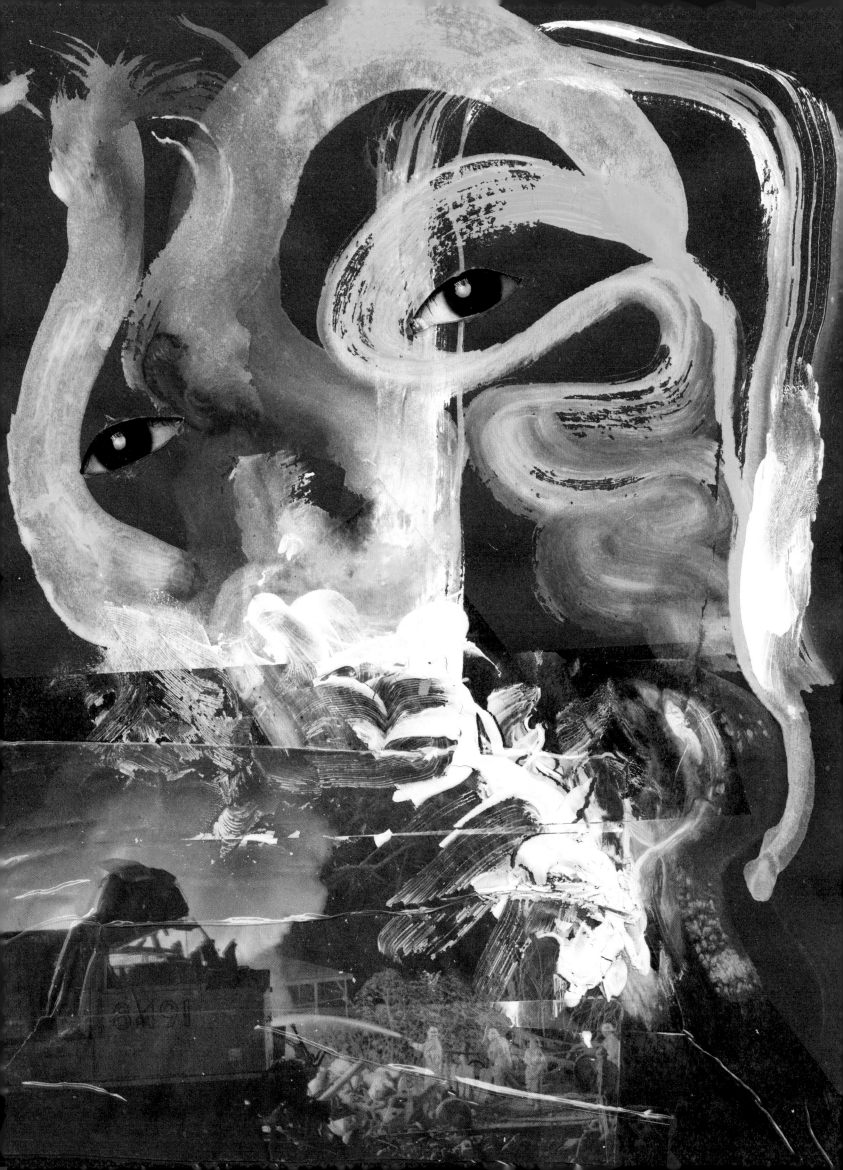

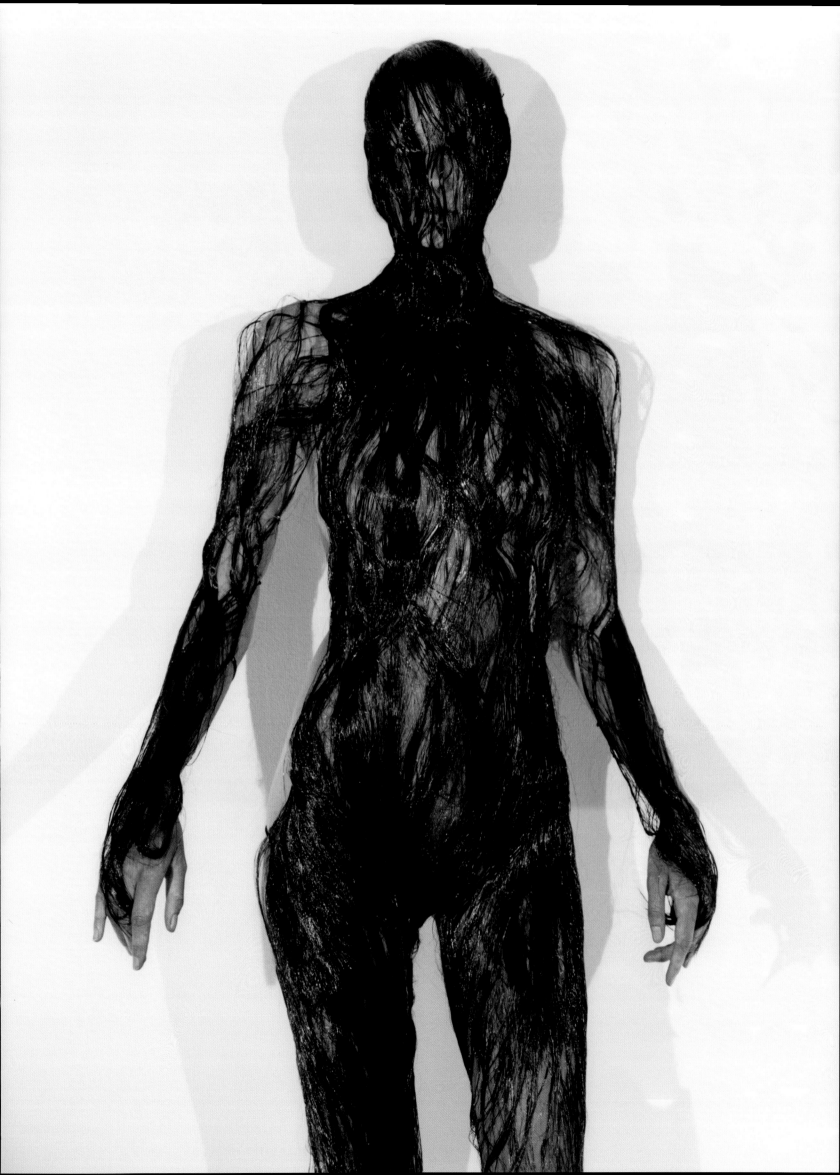

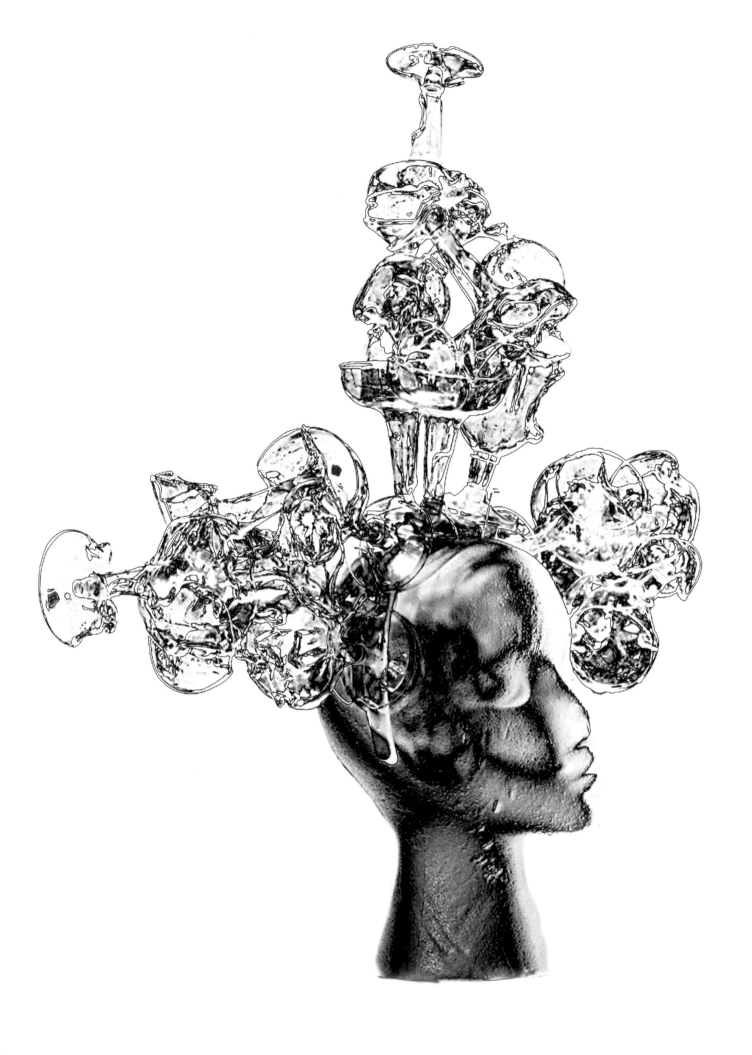

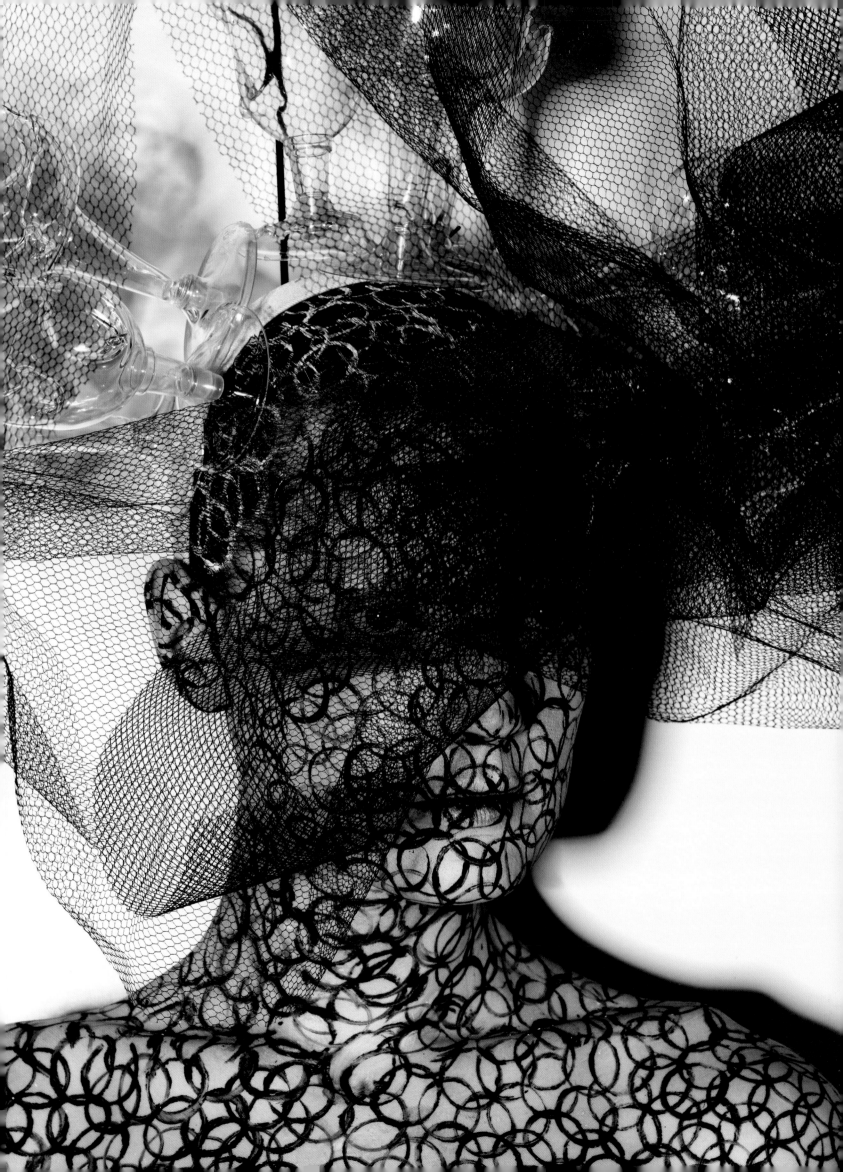

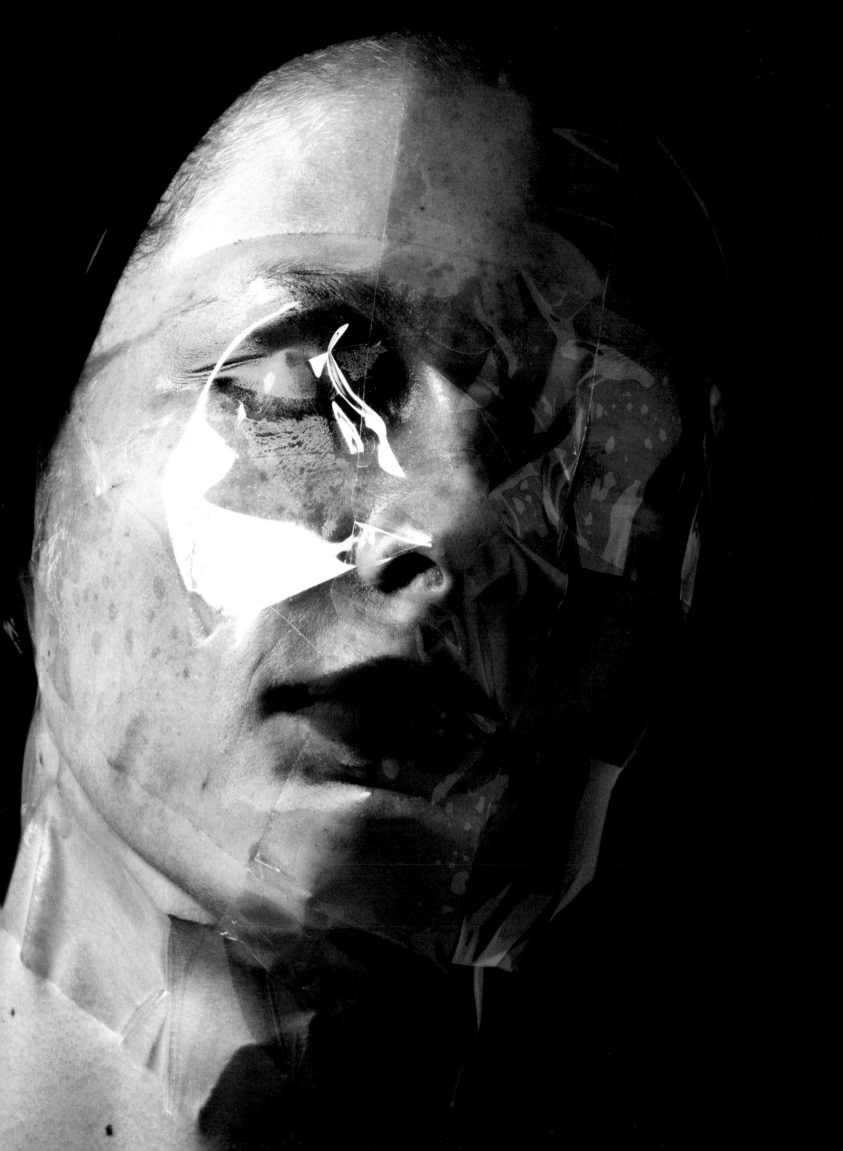

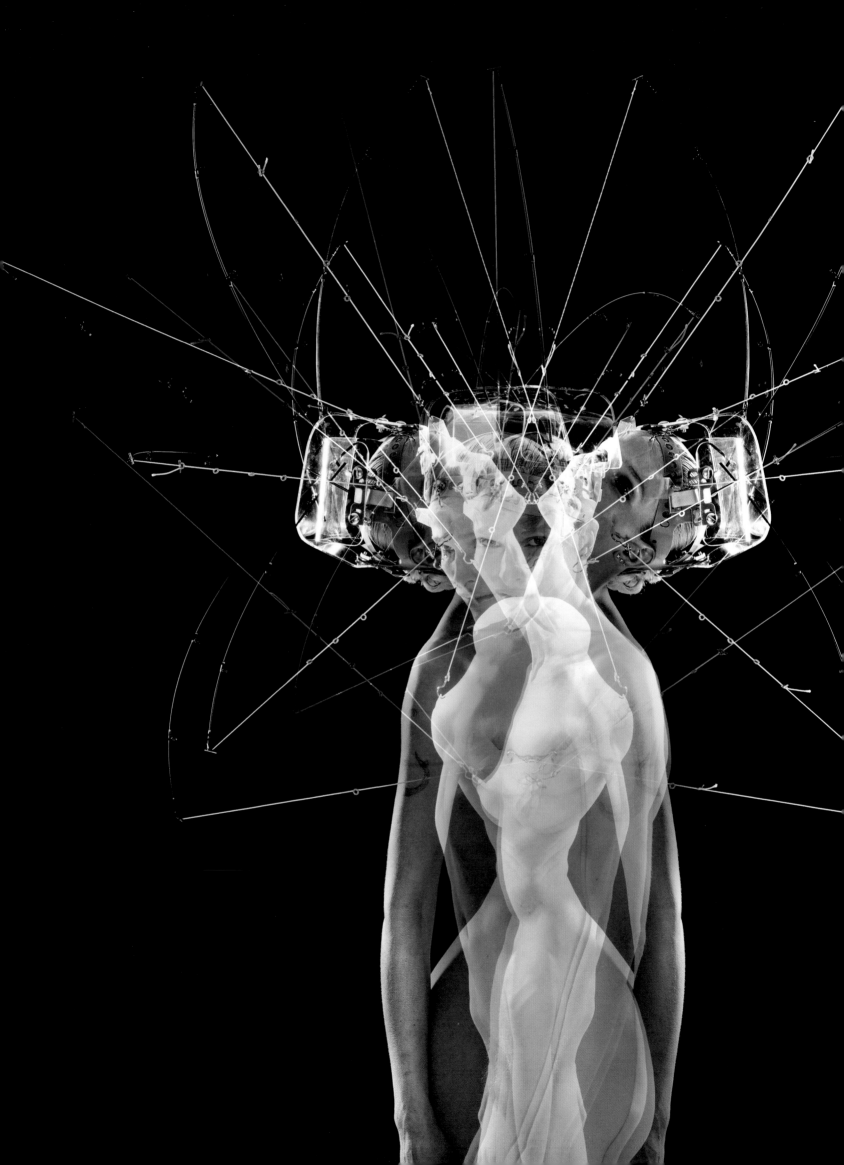

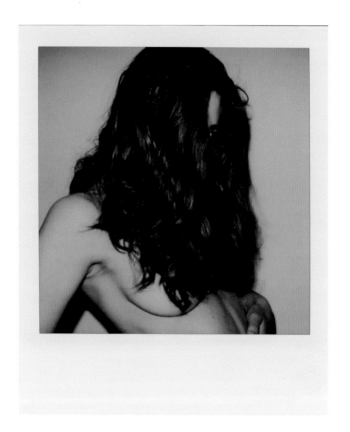

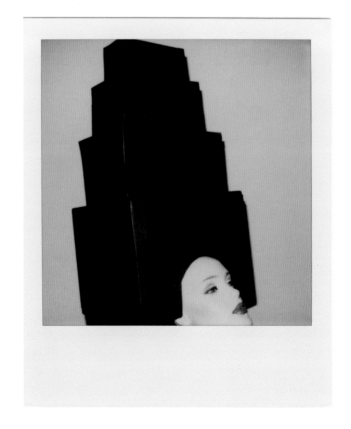

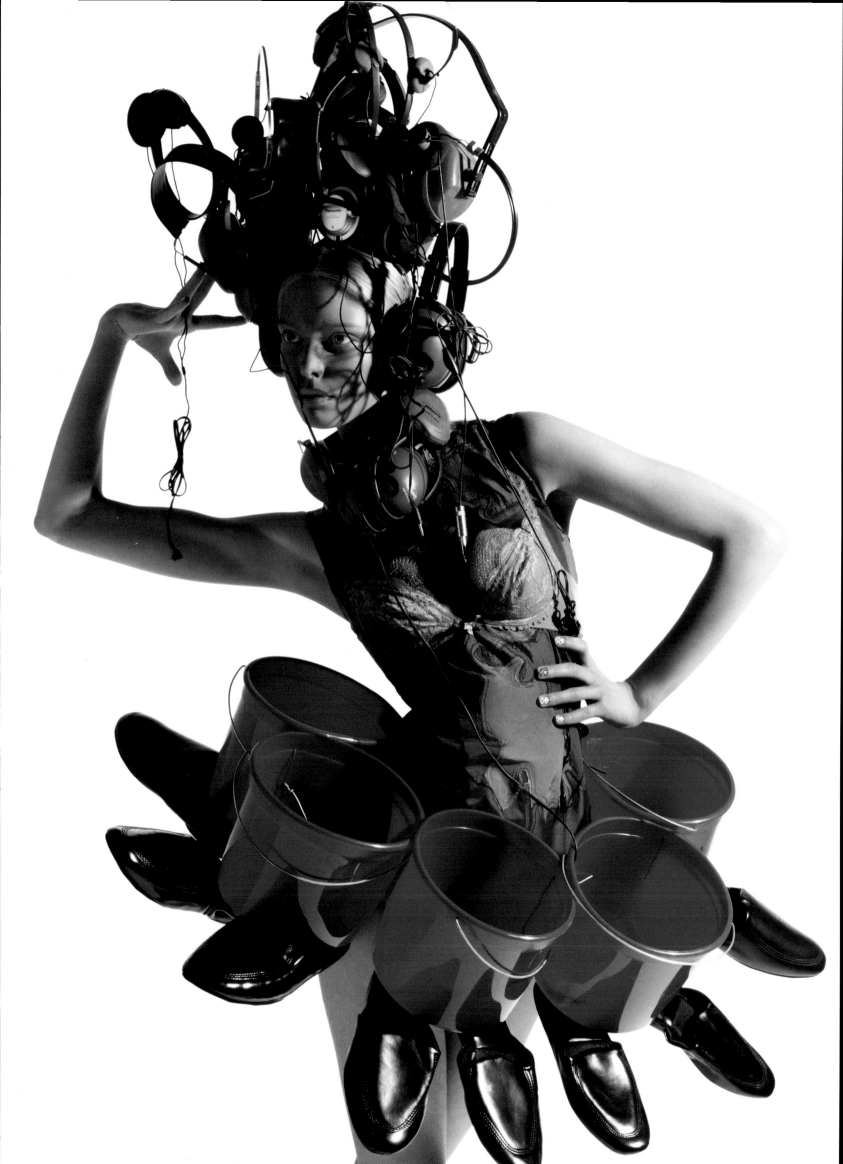

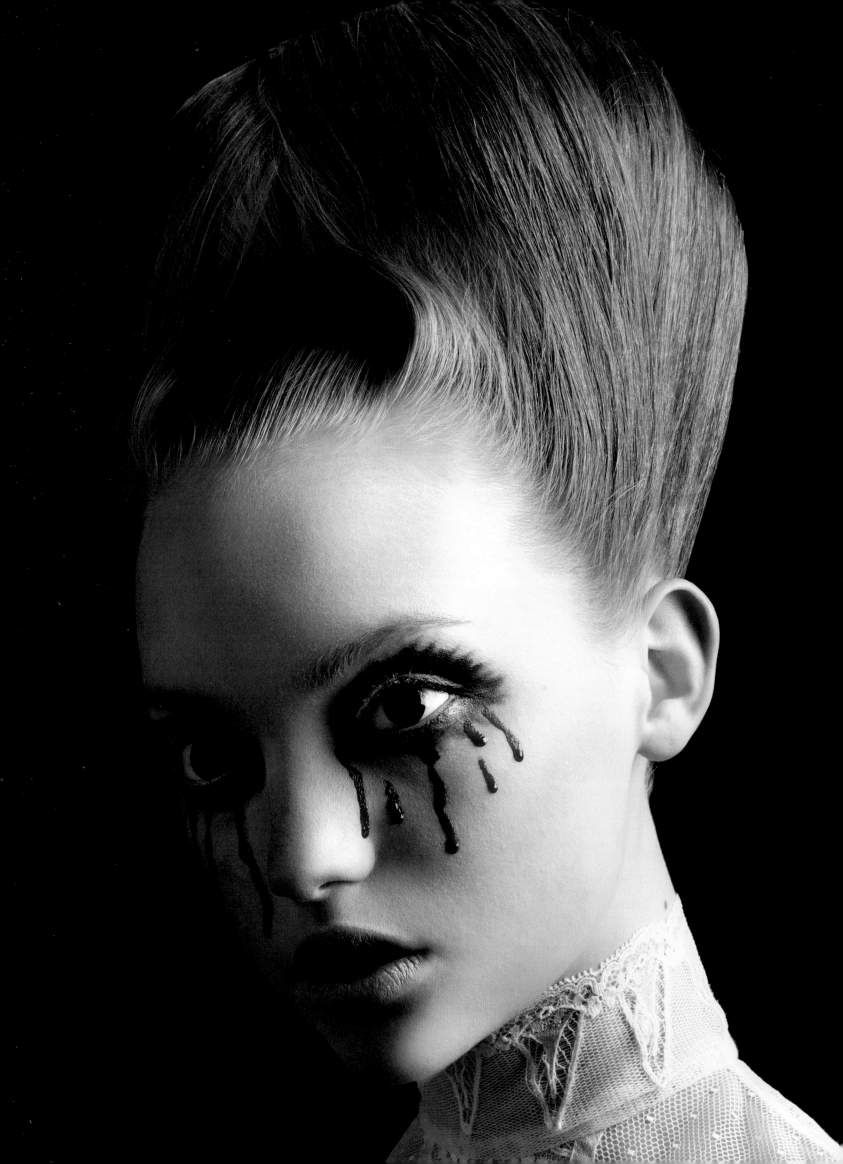

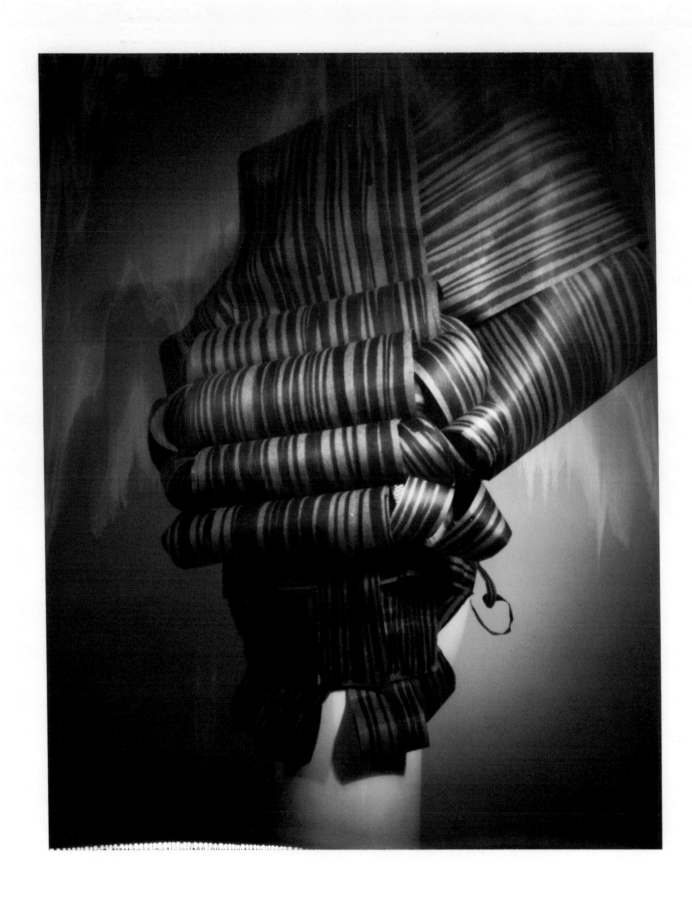

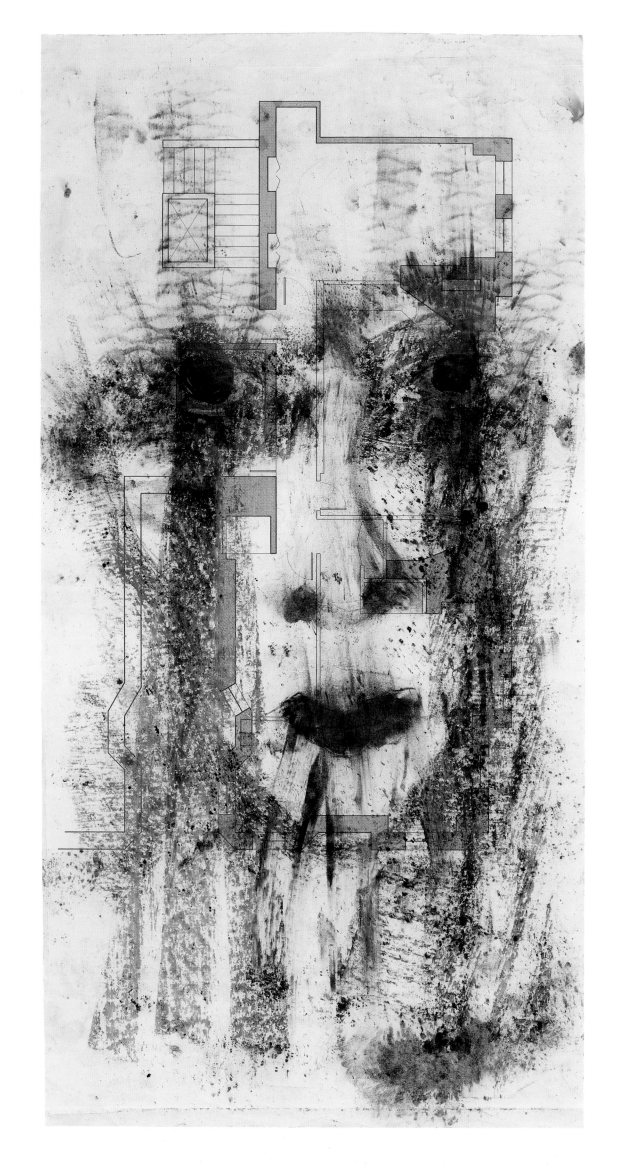

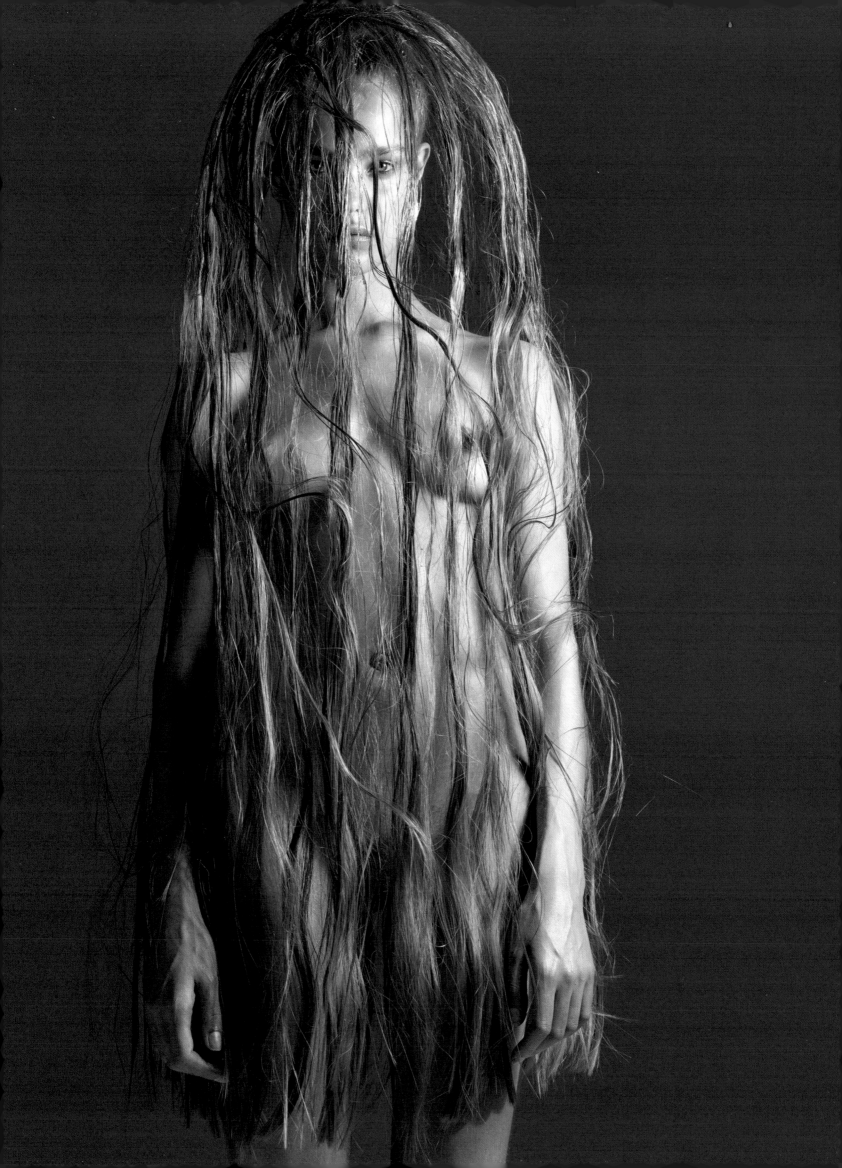

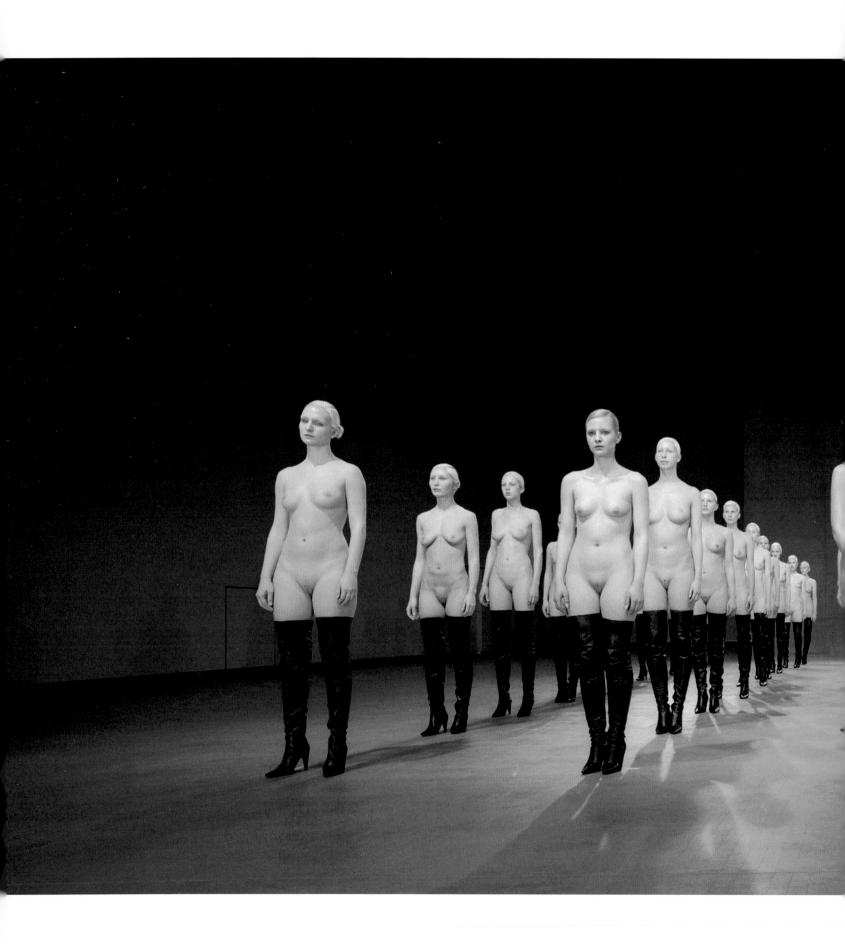

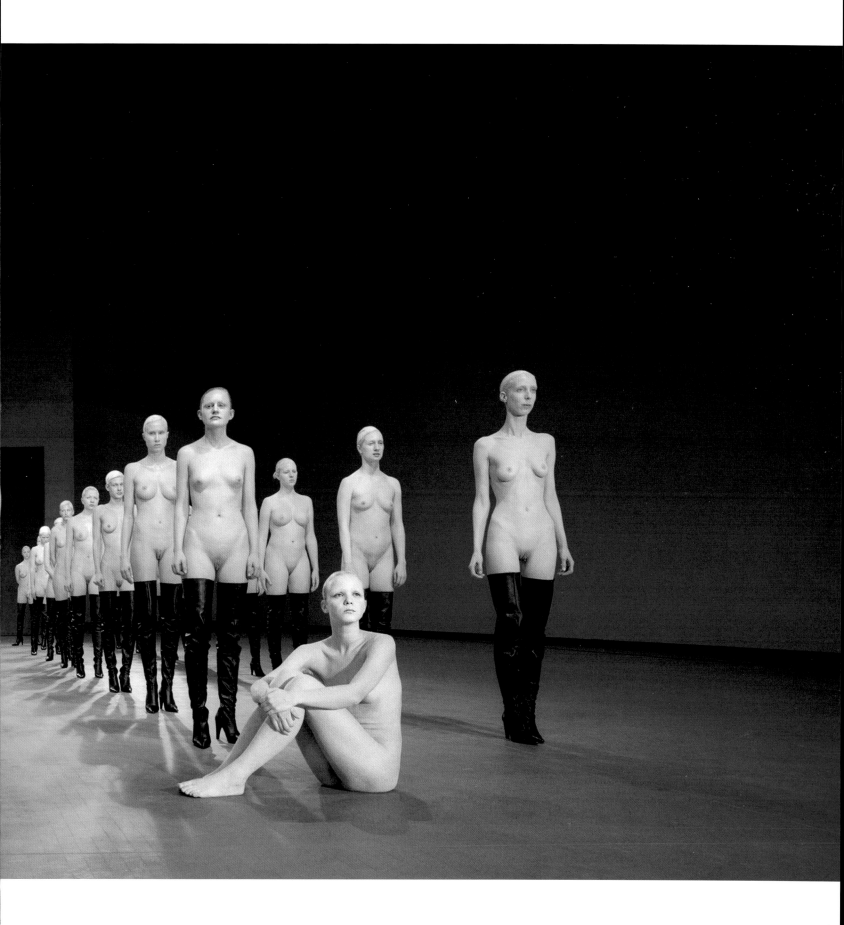

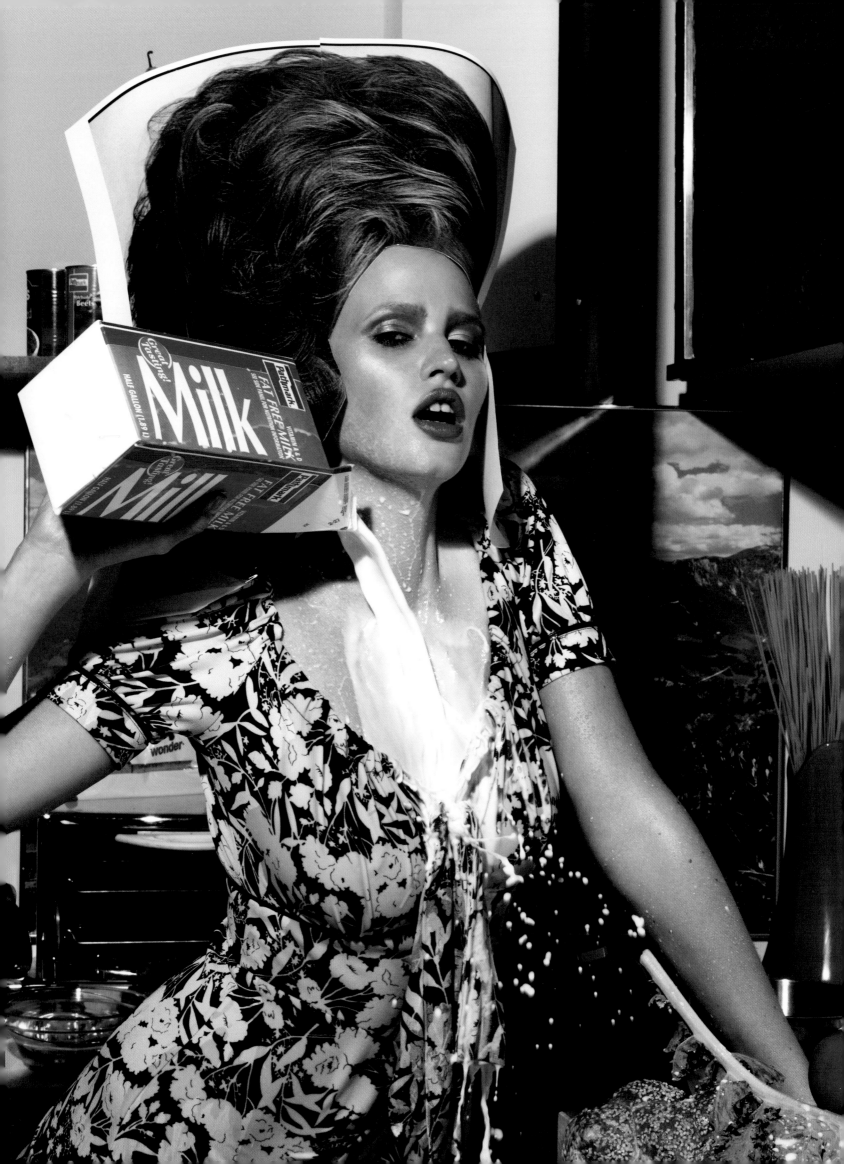

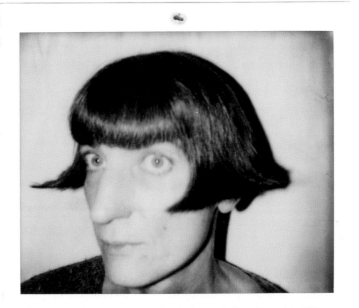

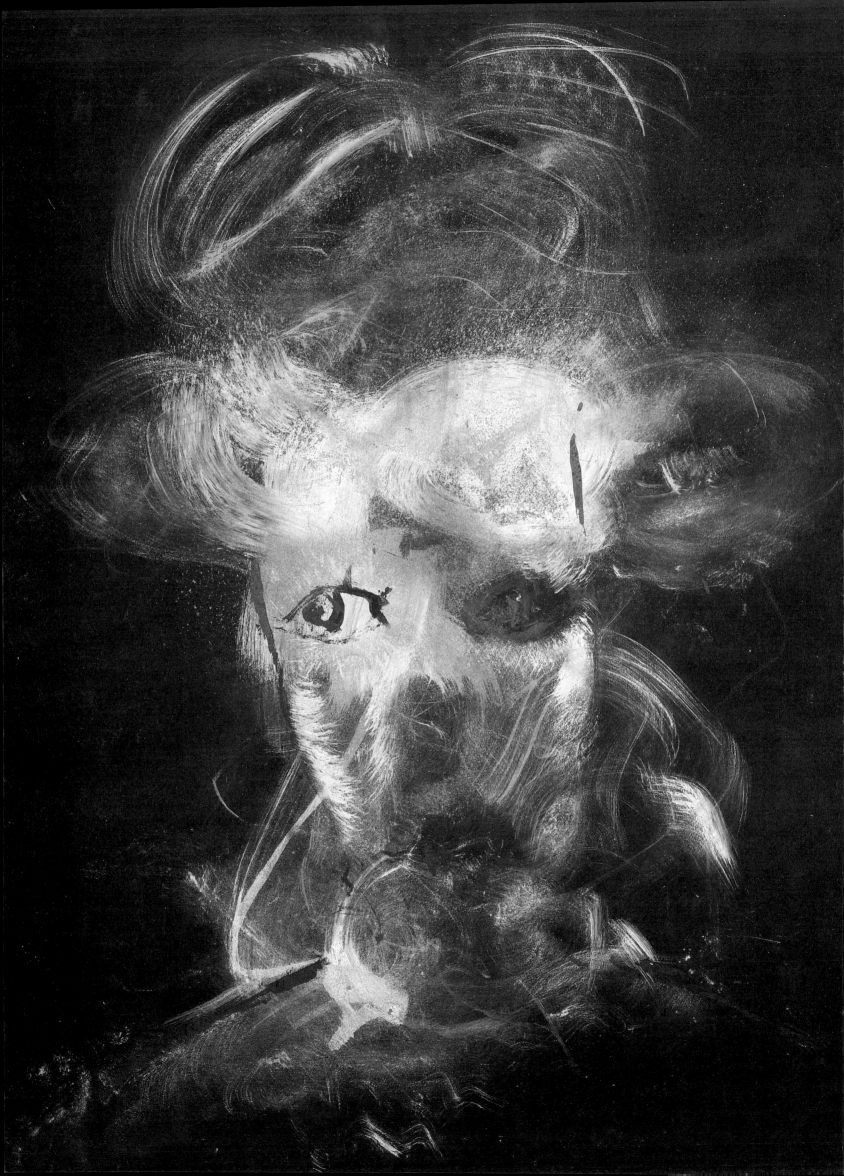

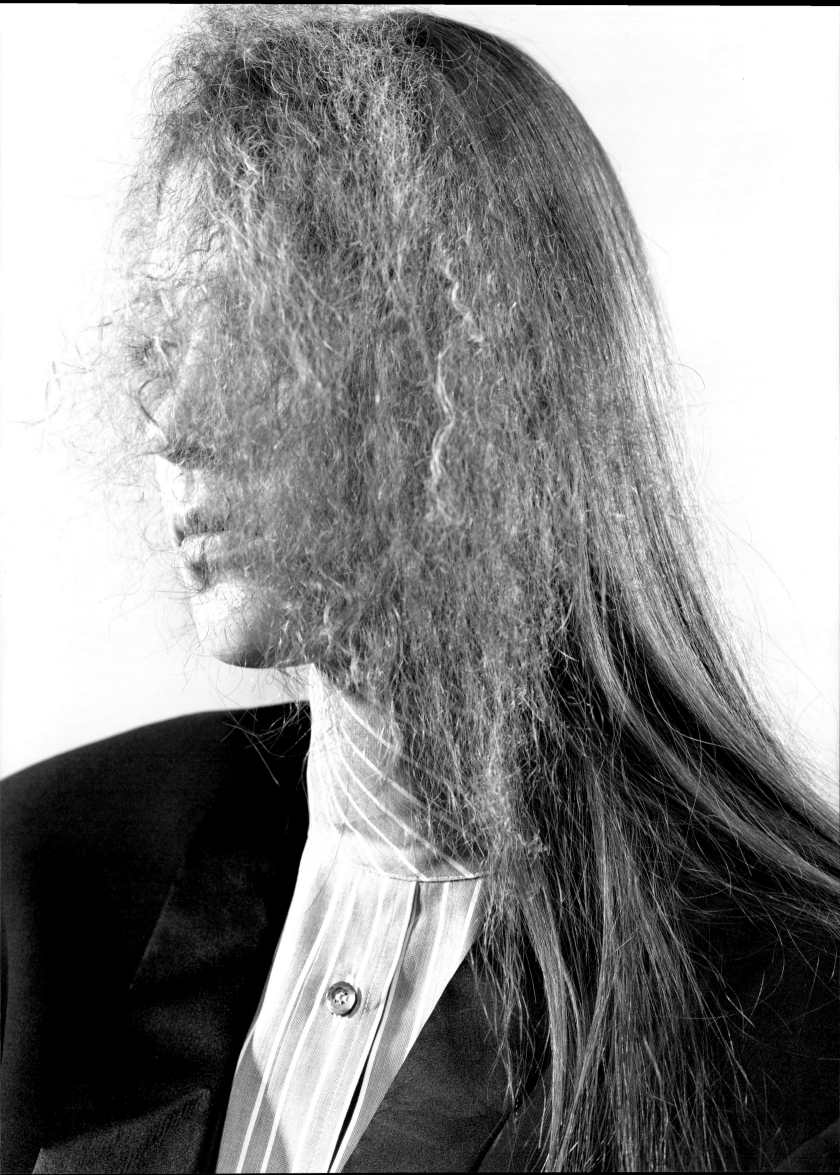

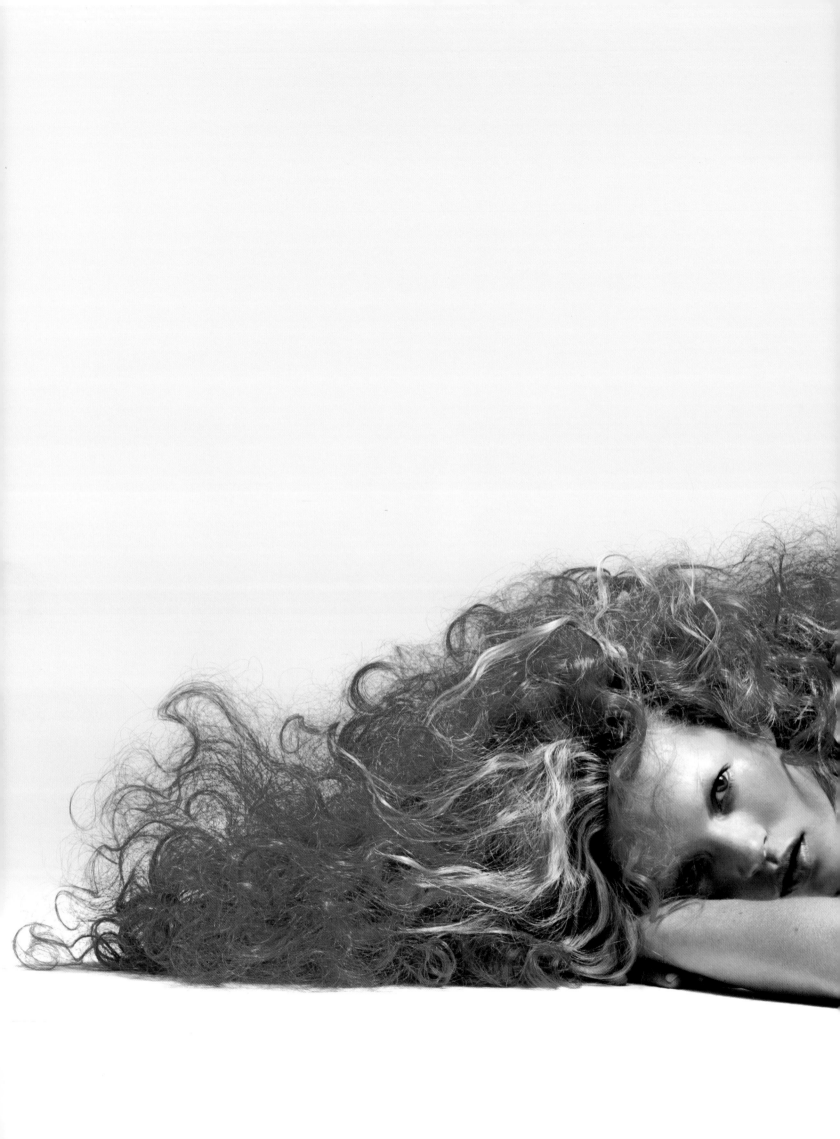

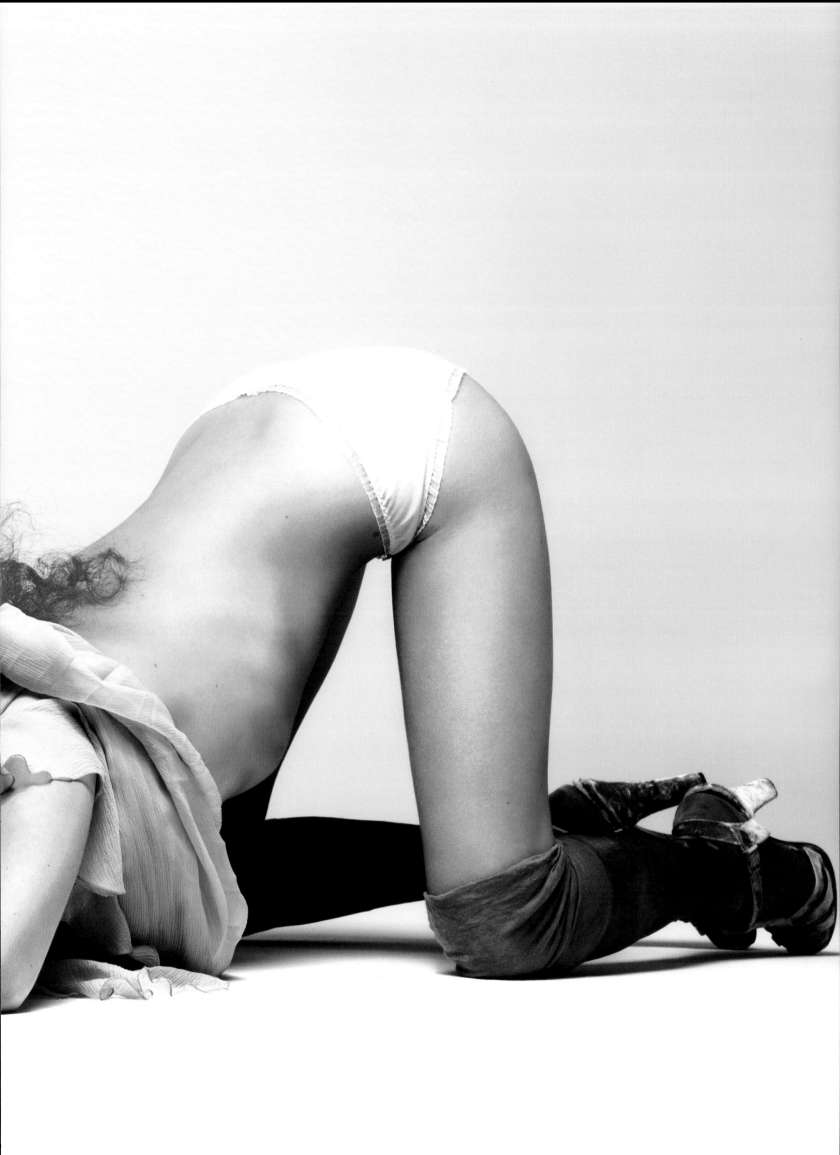

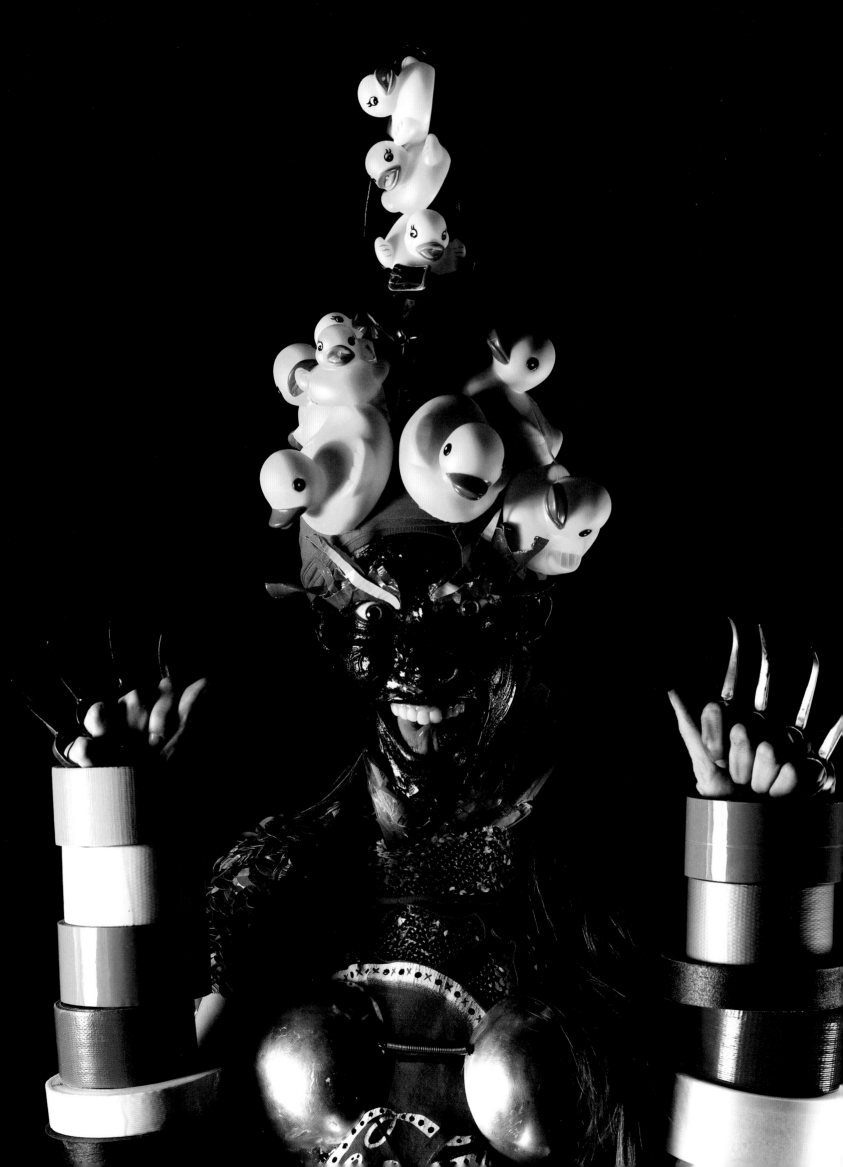

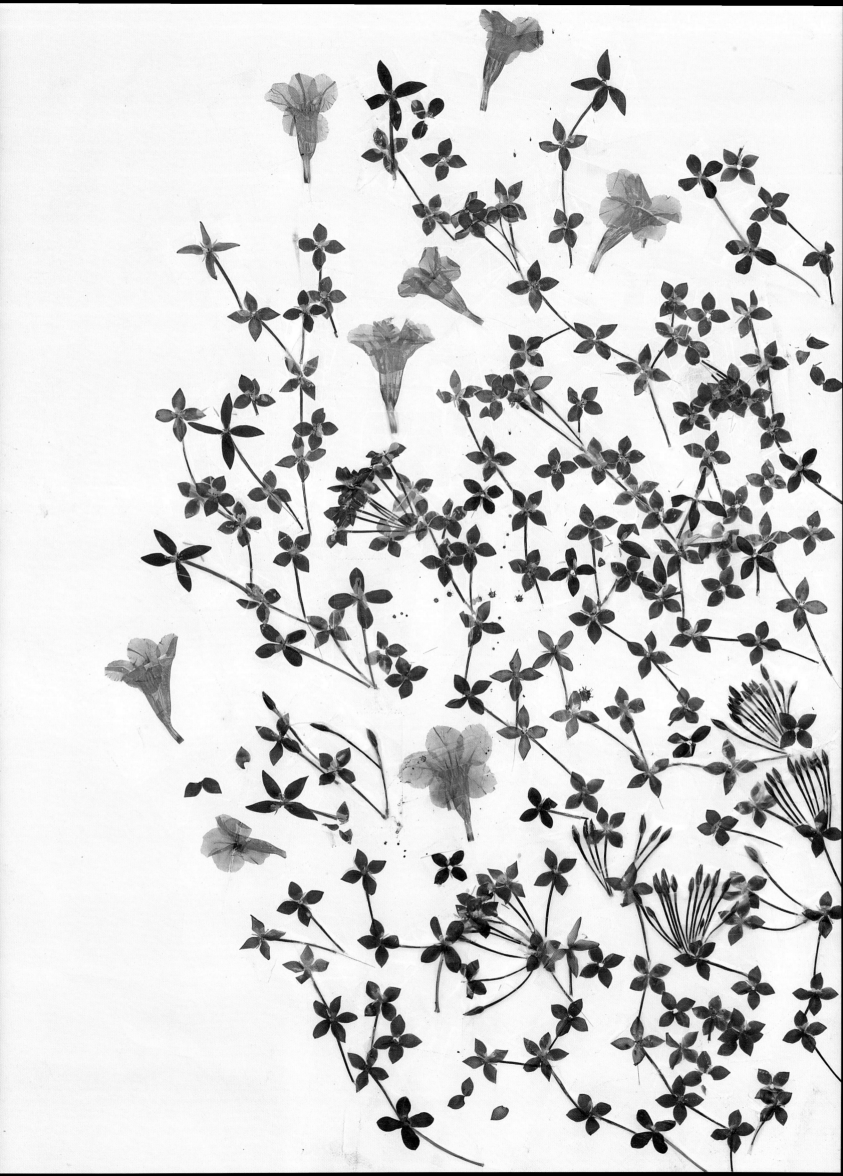

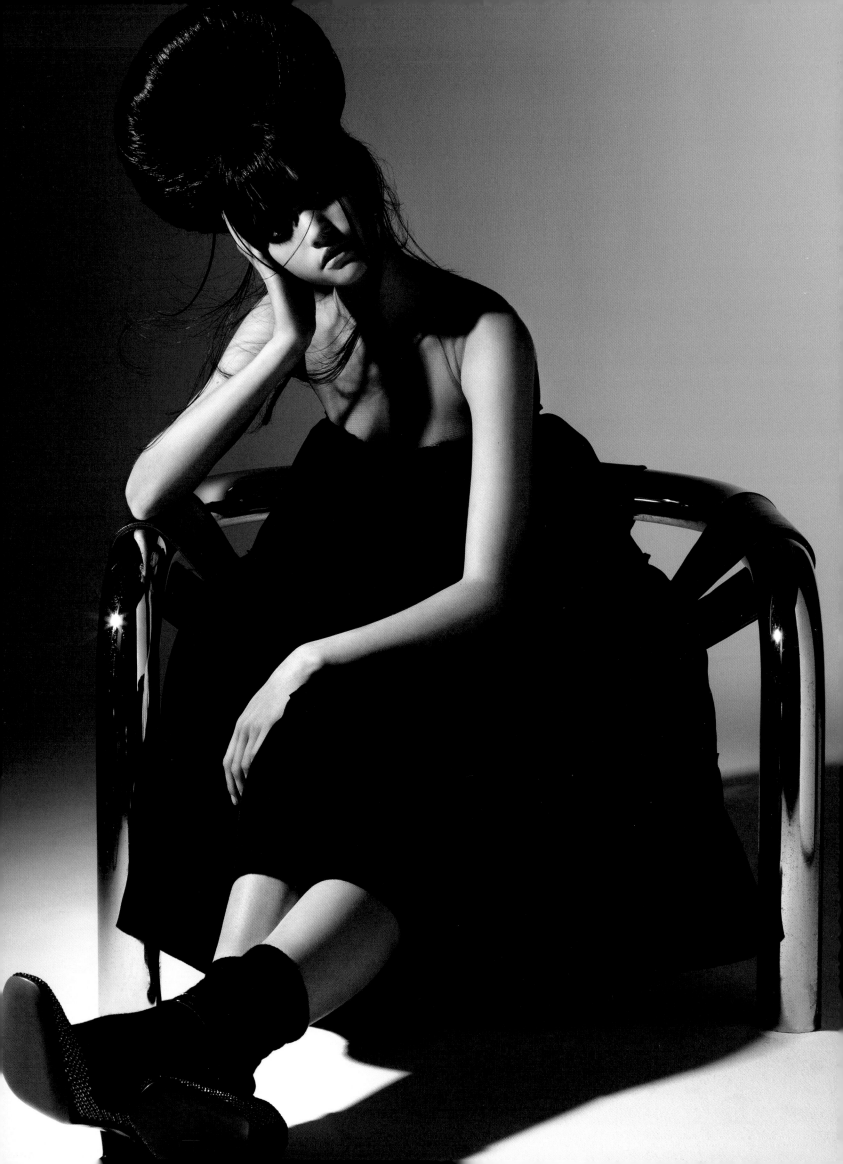

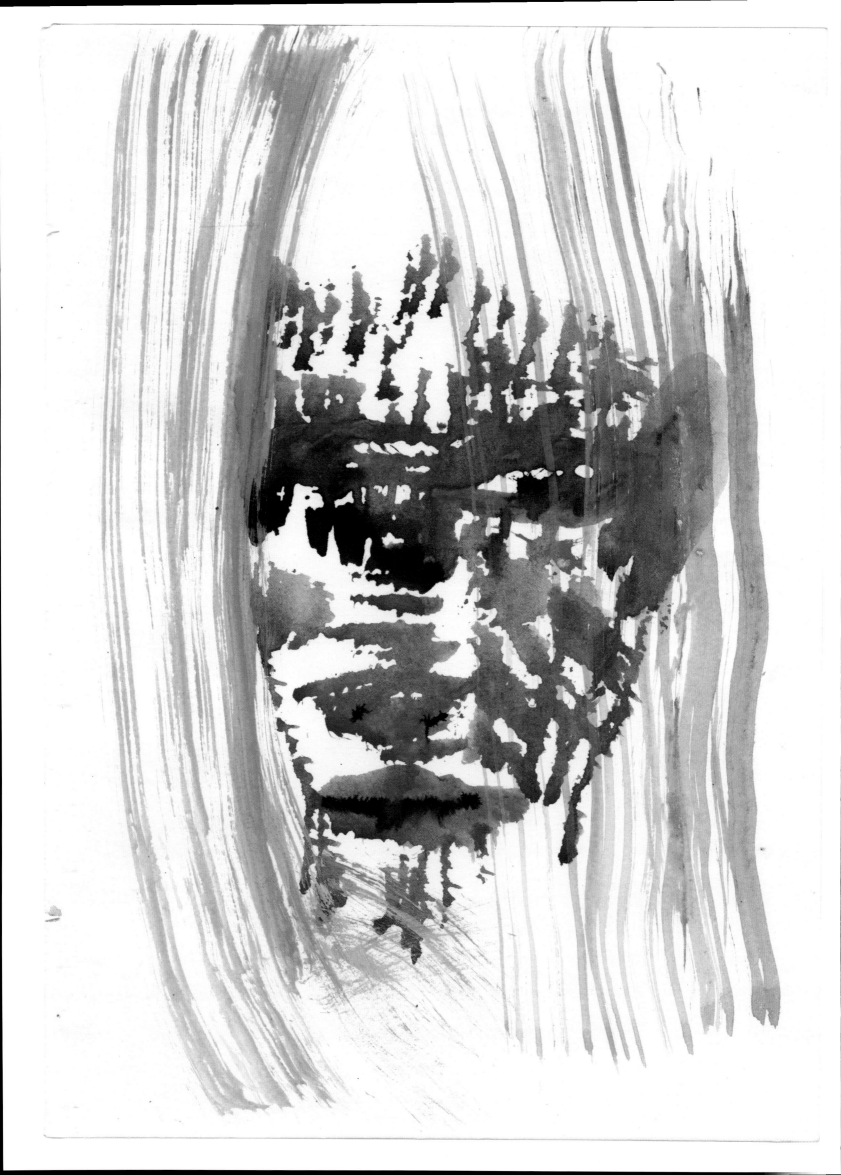

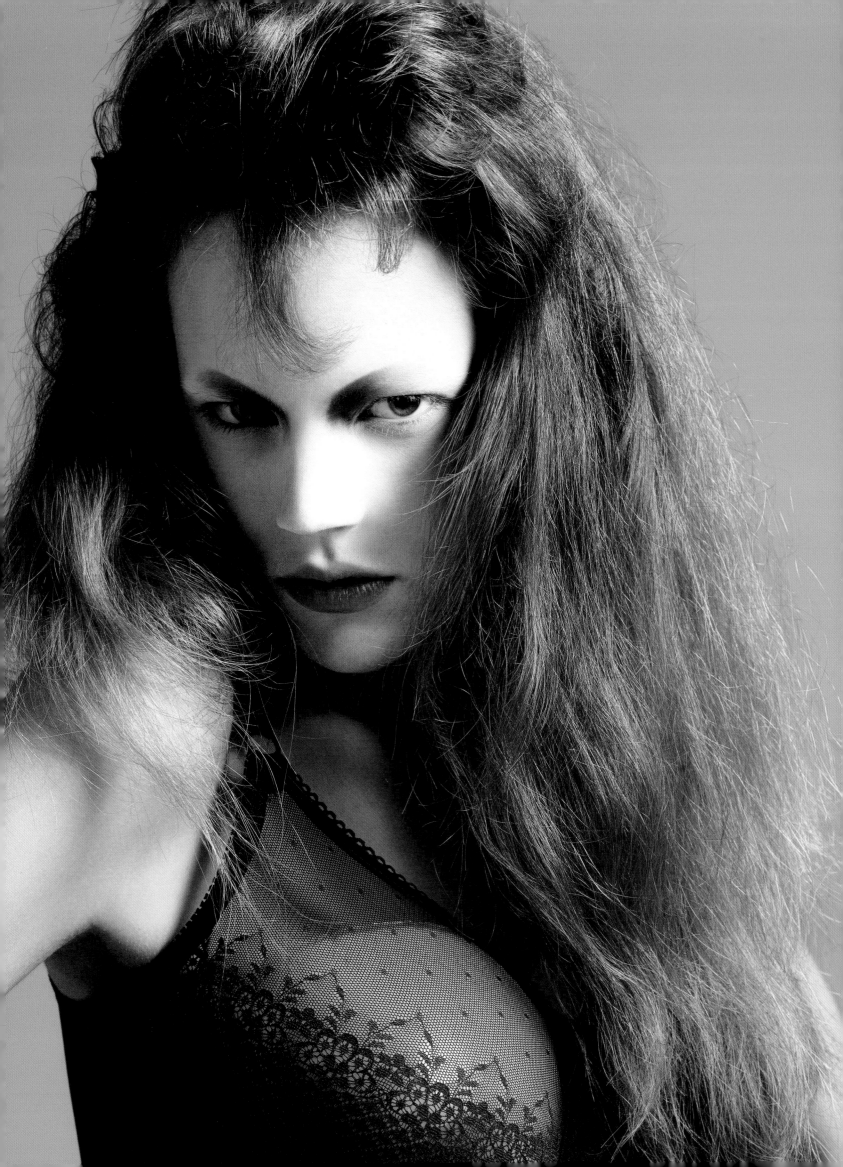

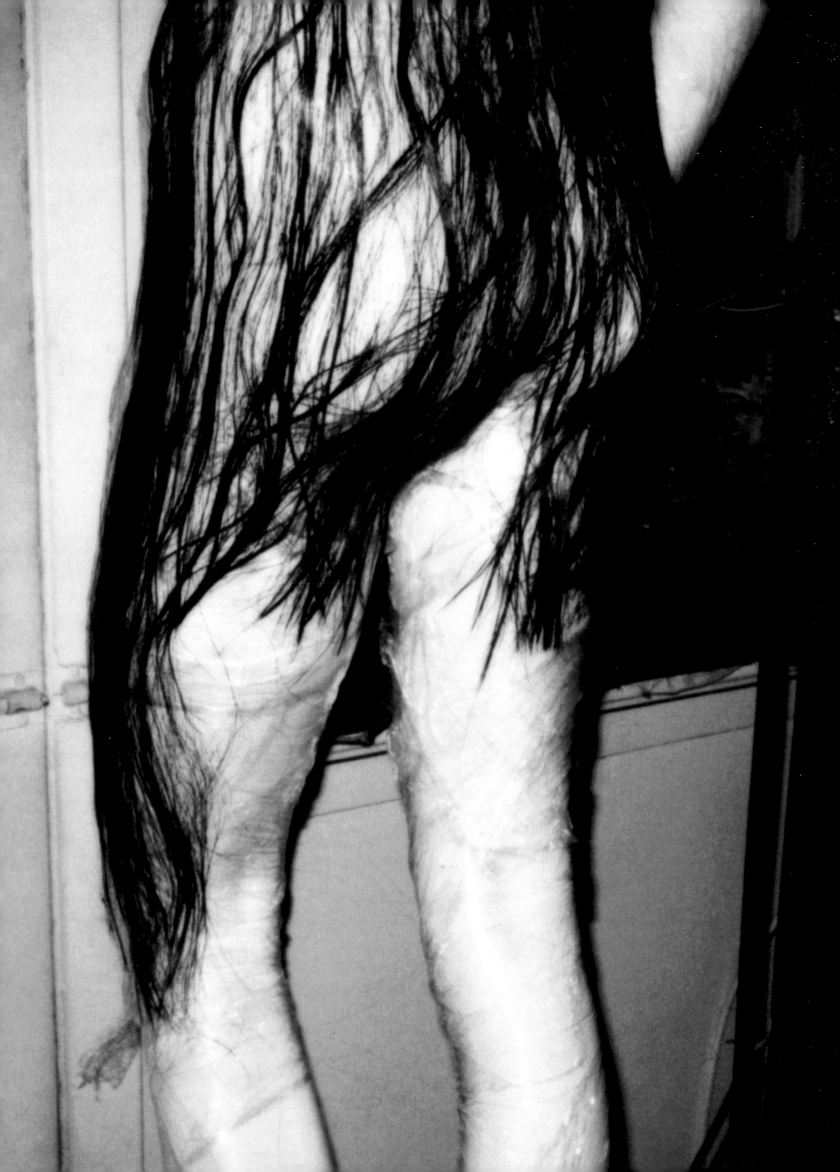

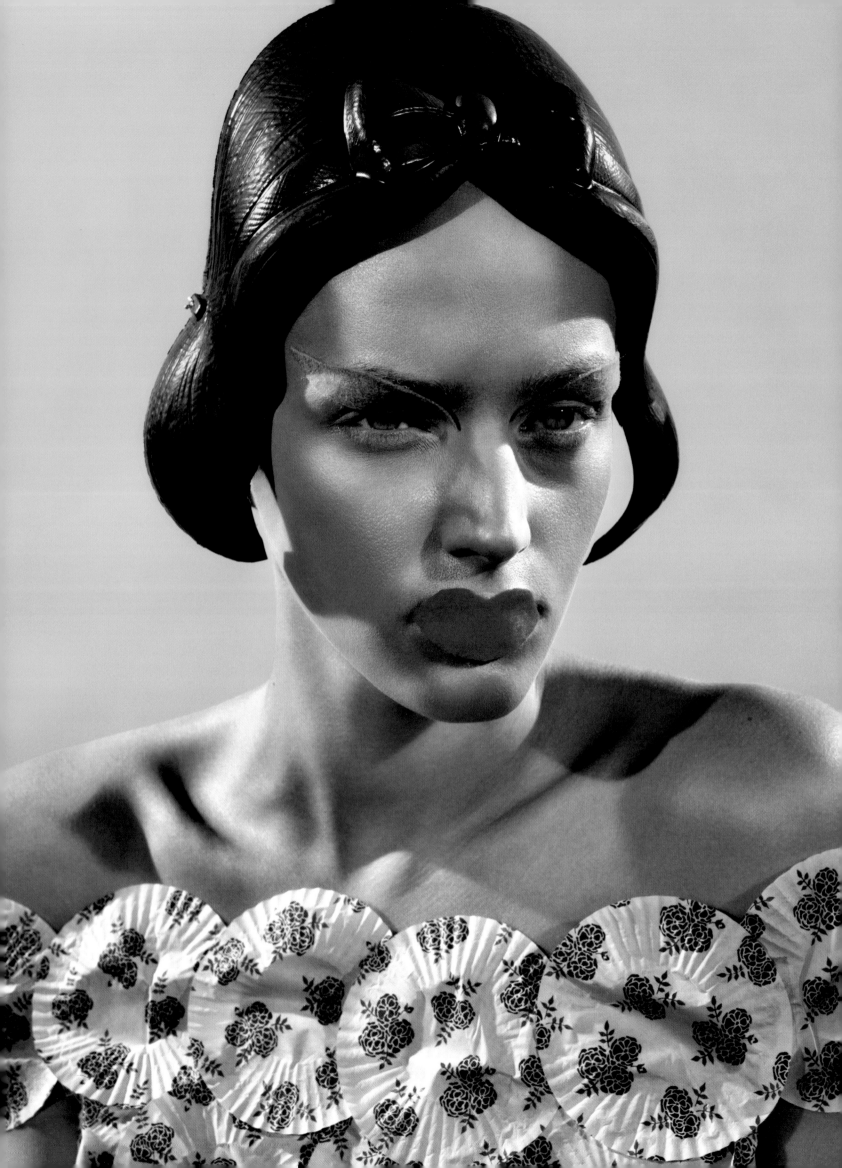

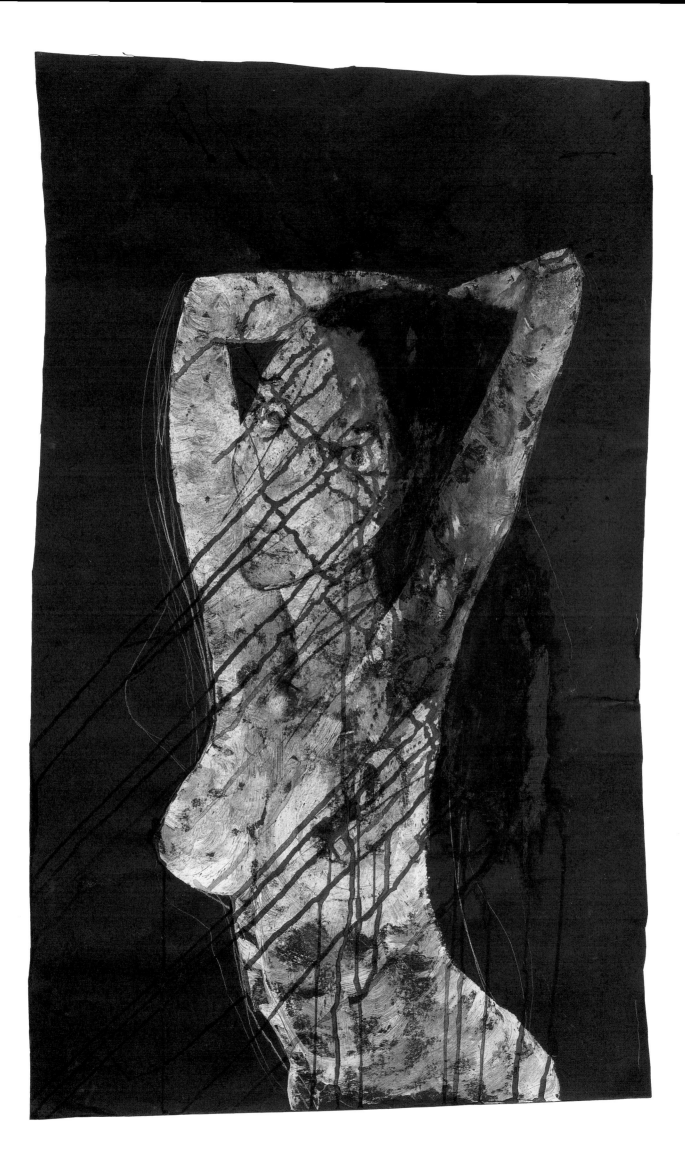

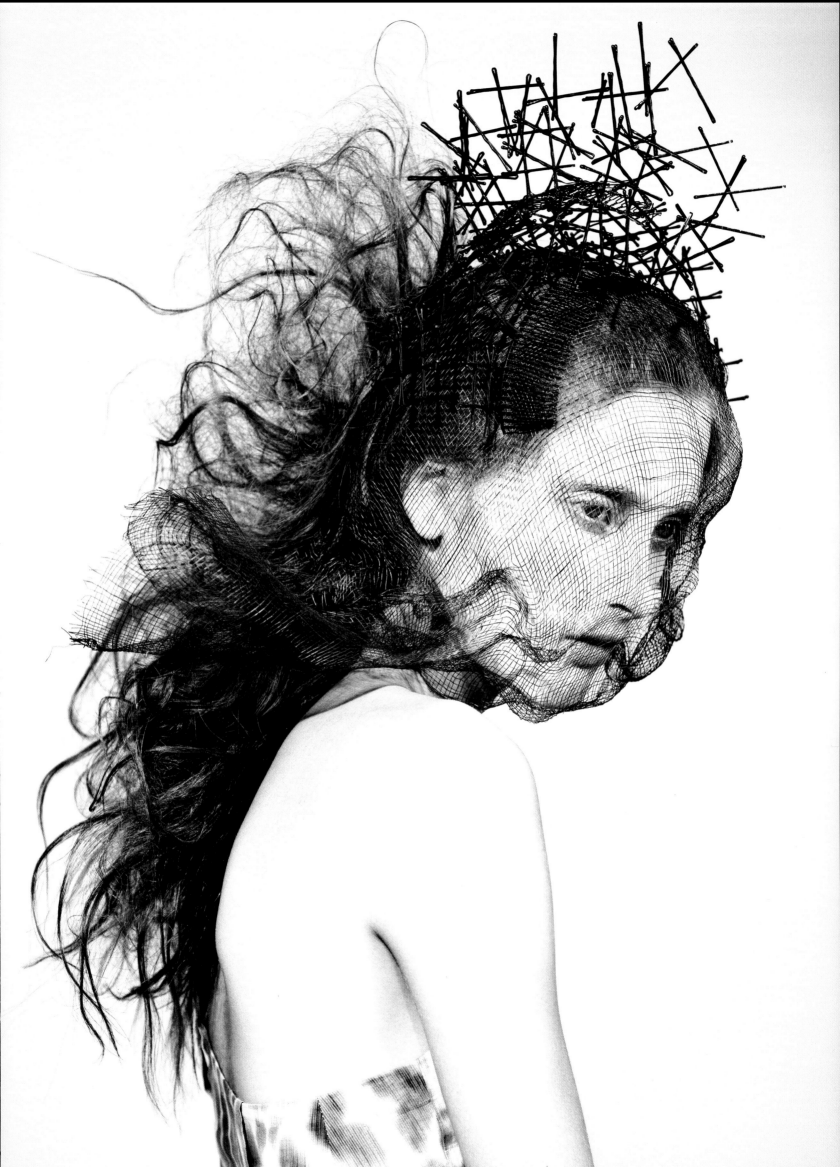

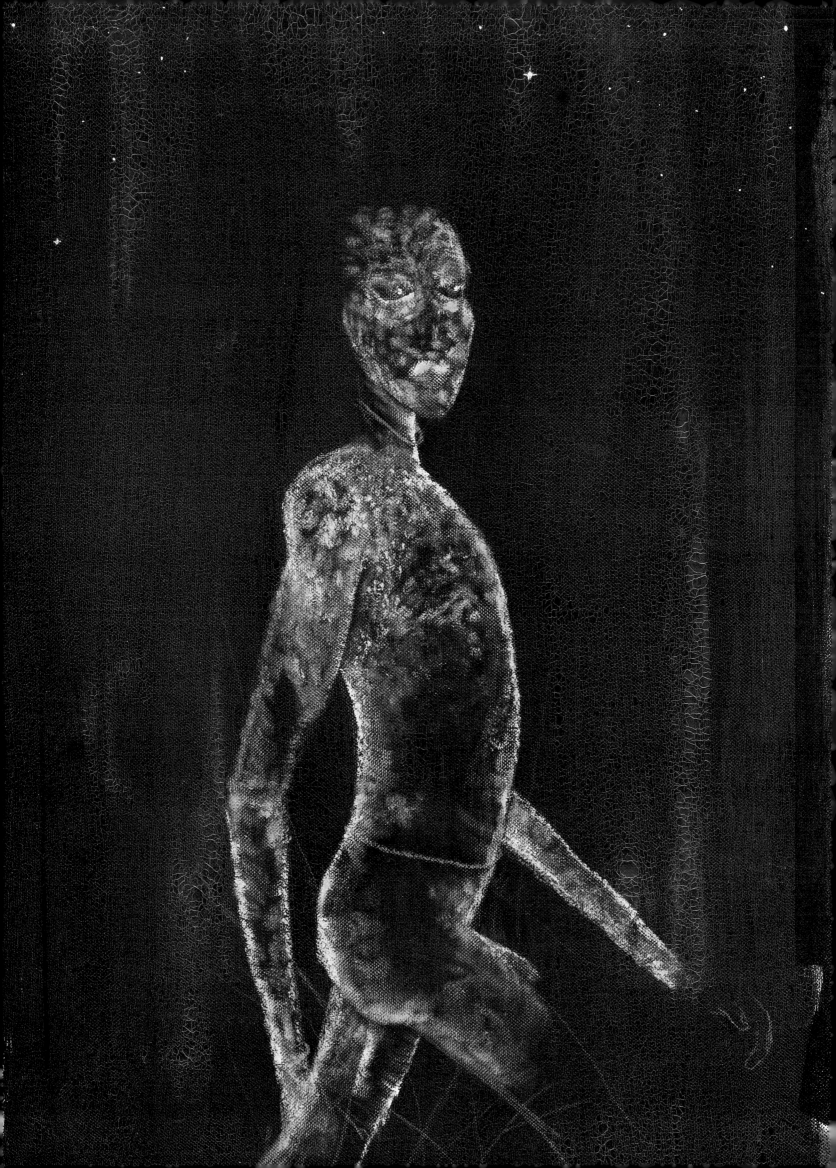

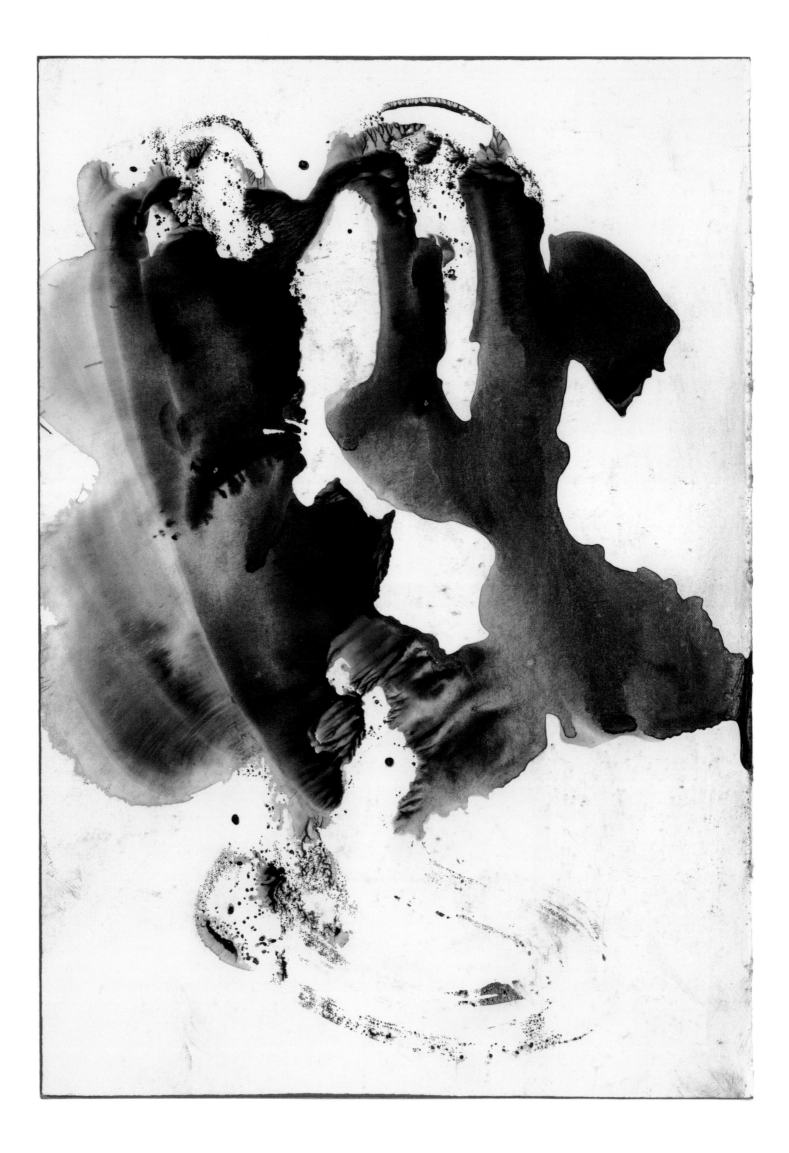

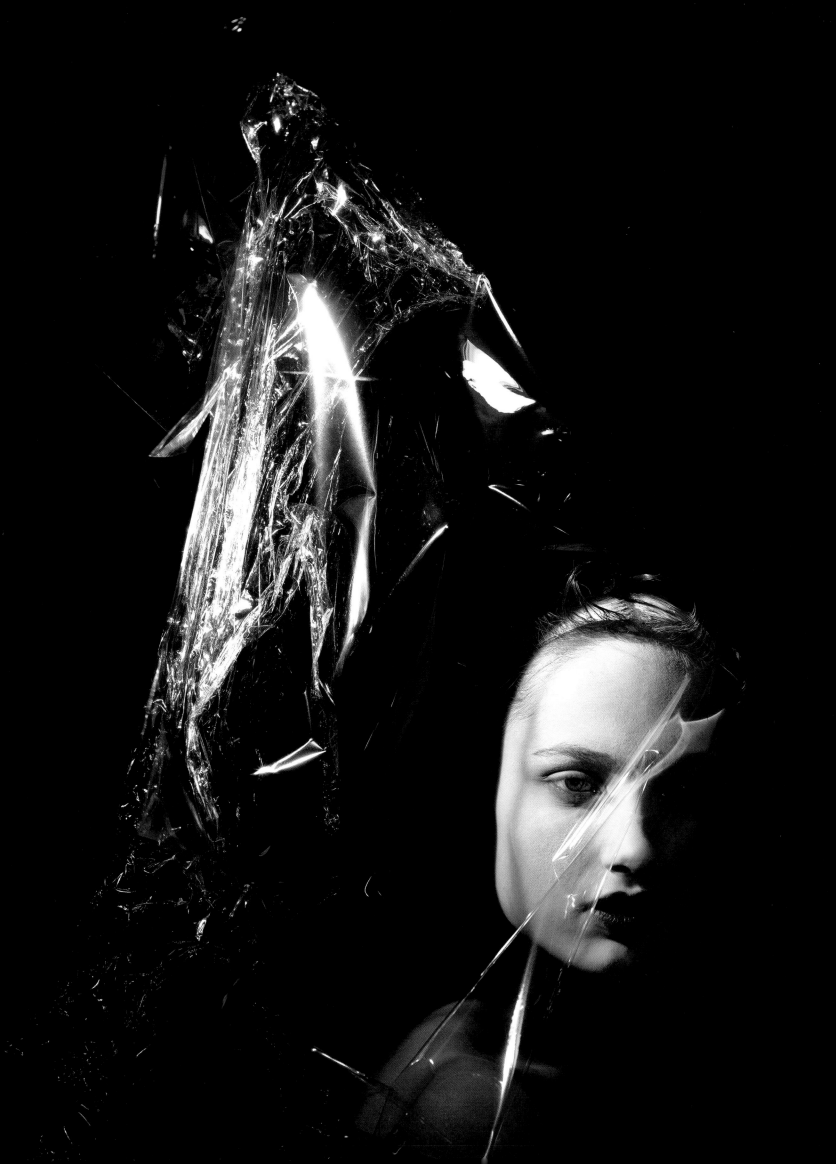

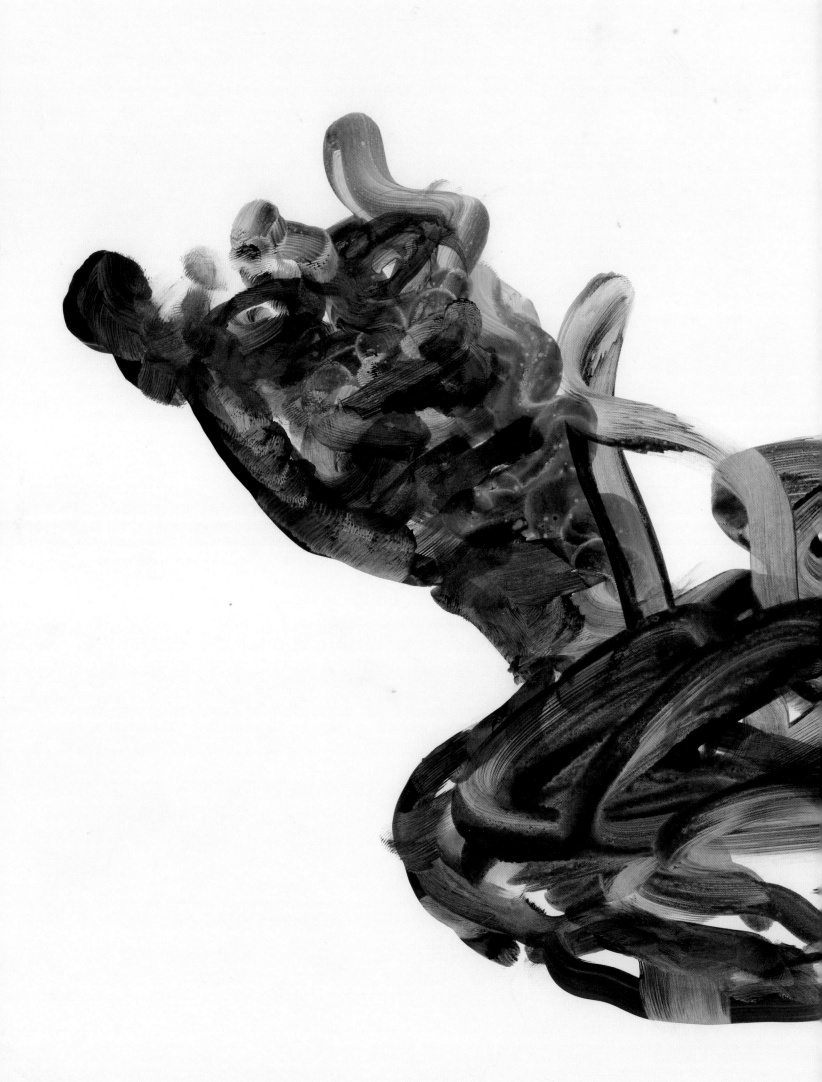

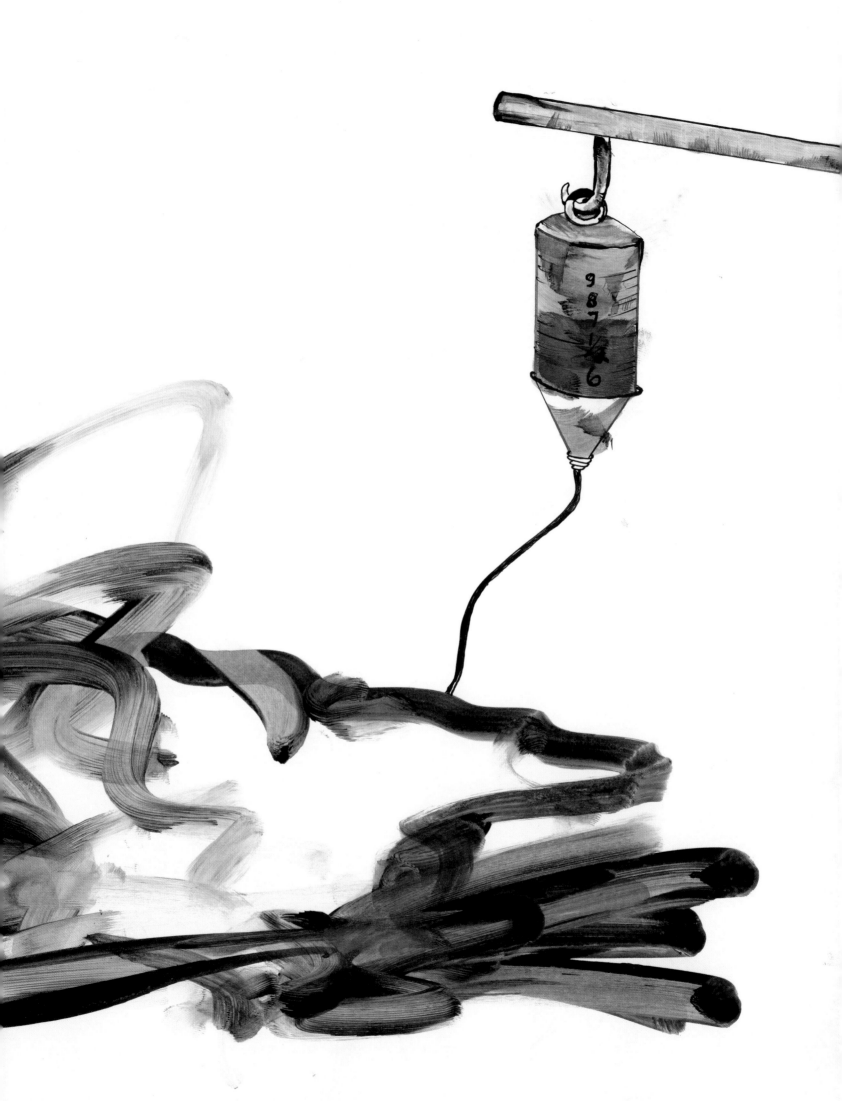

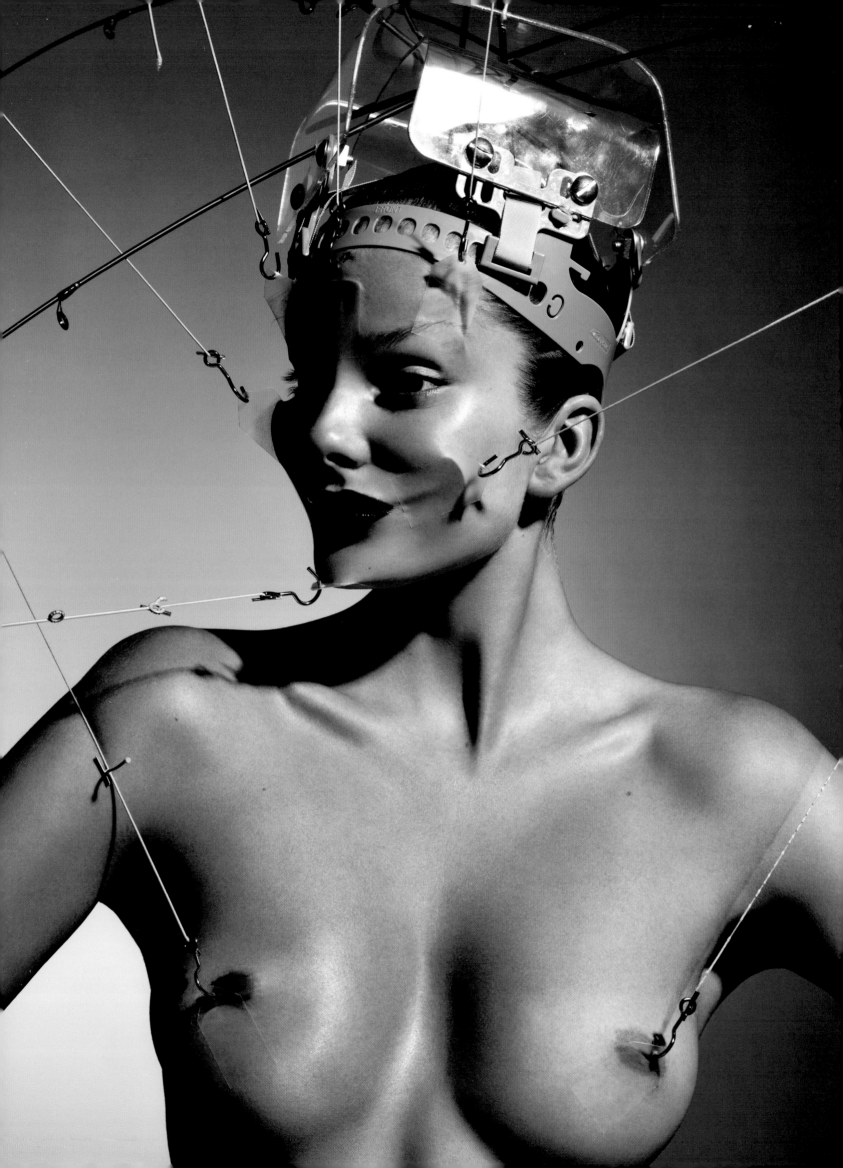

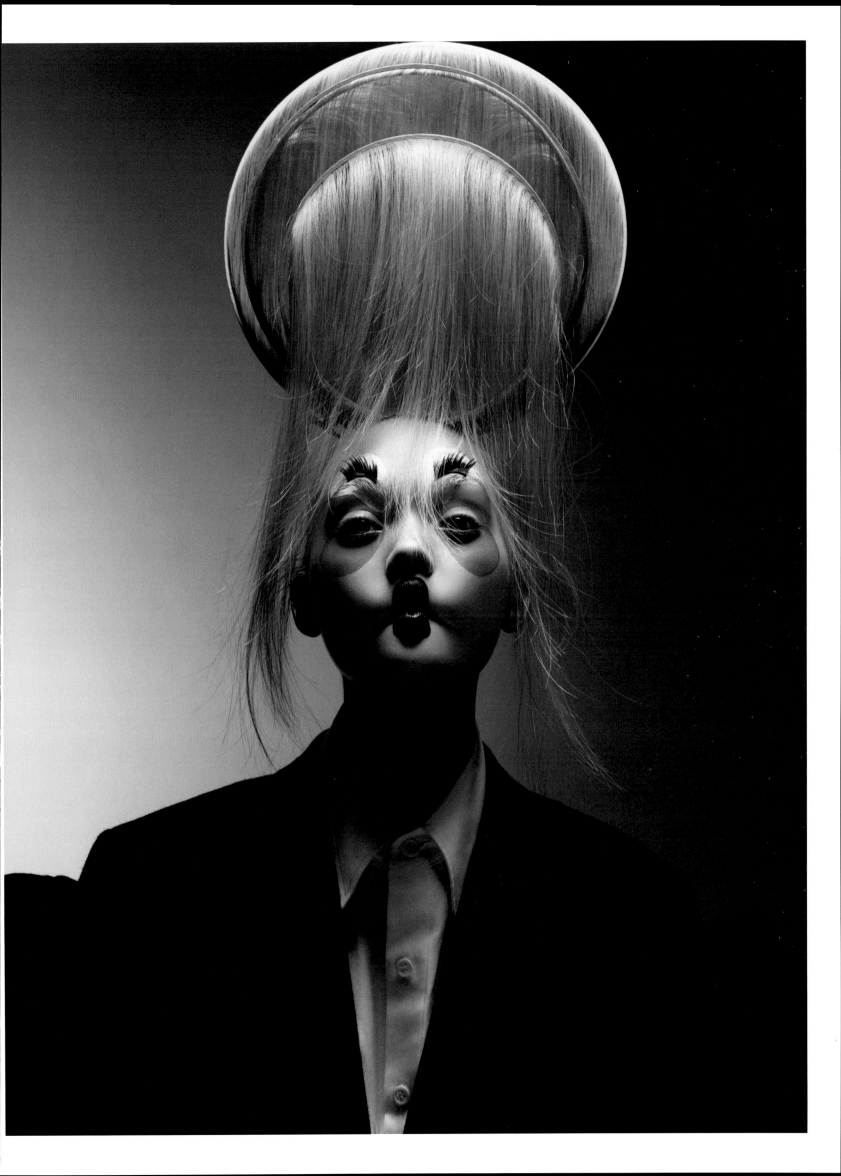

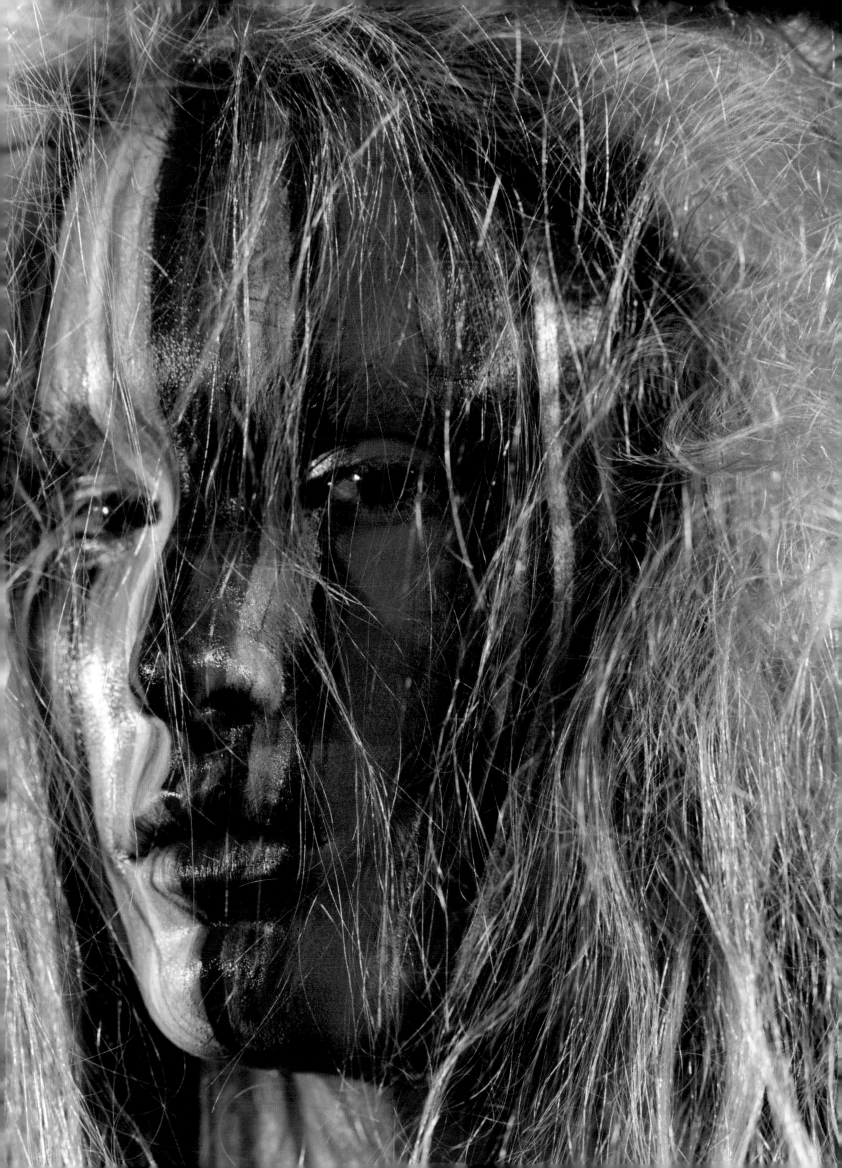

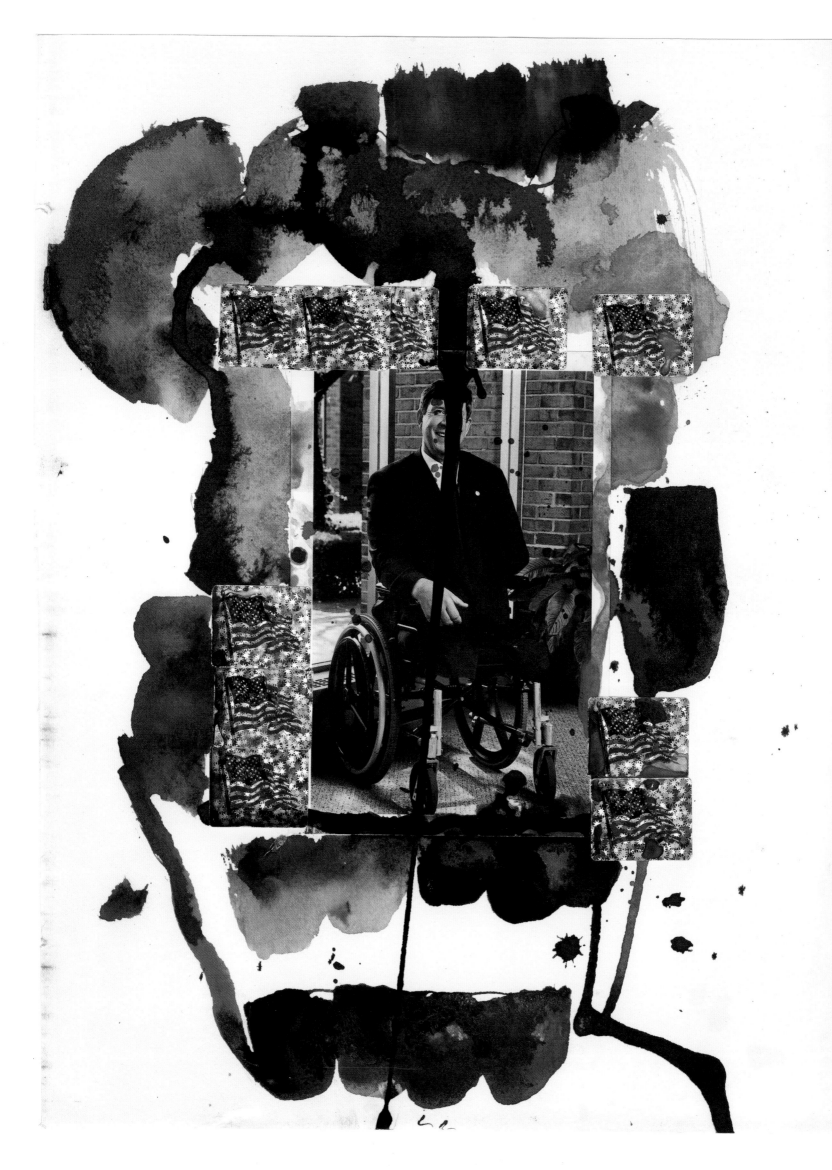

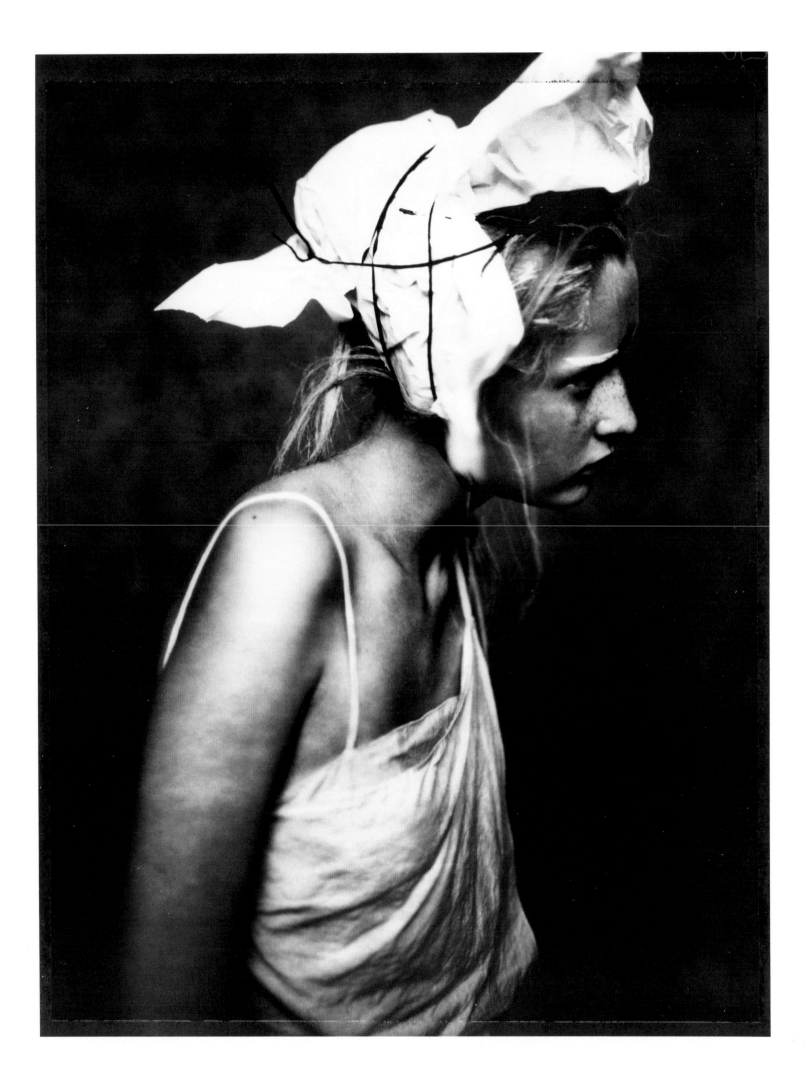

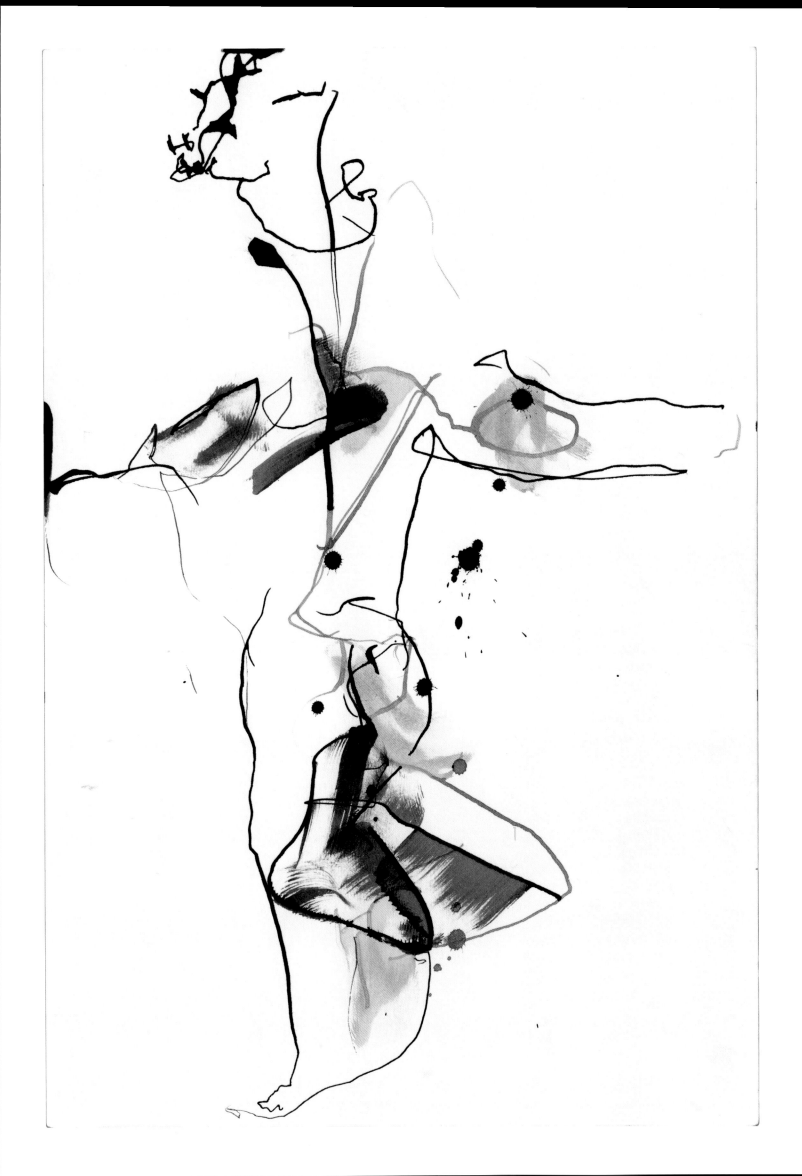

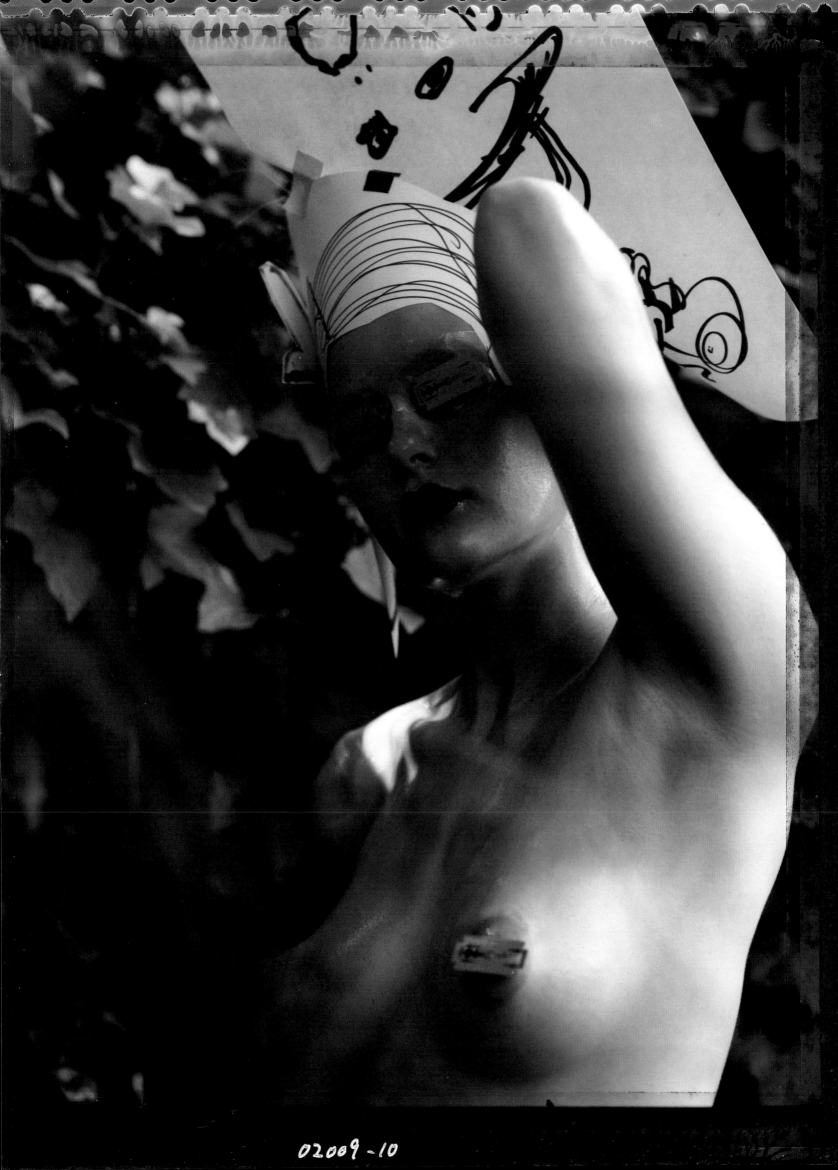

02009-10

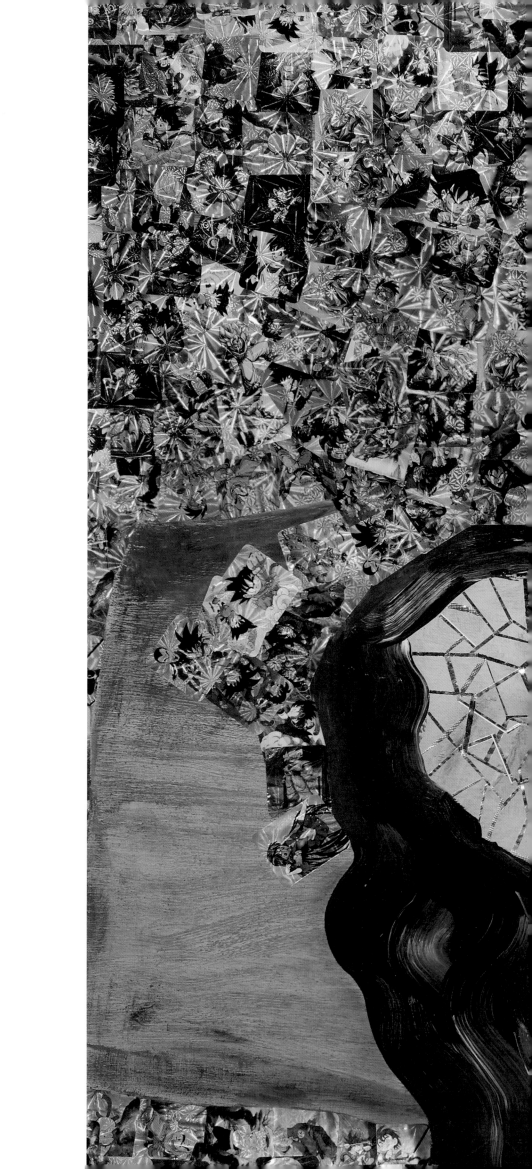

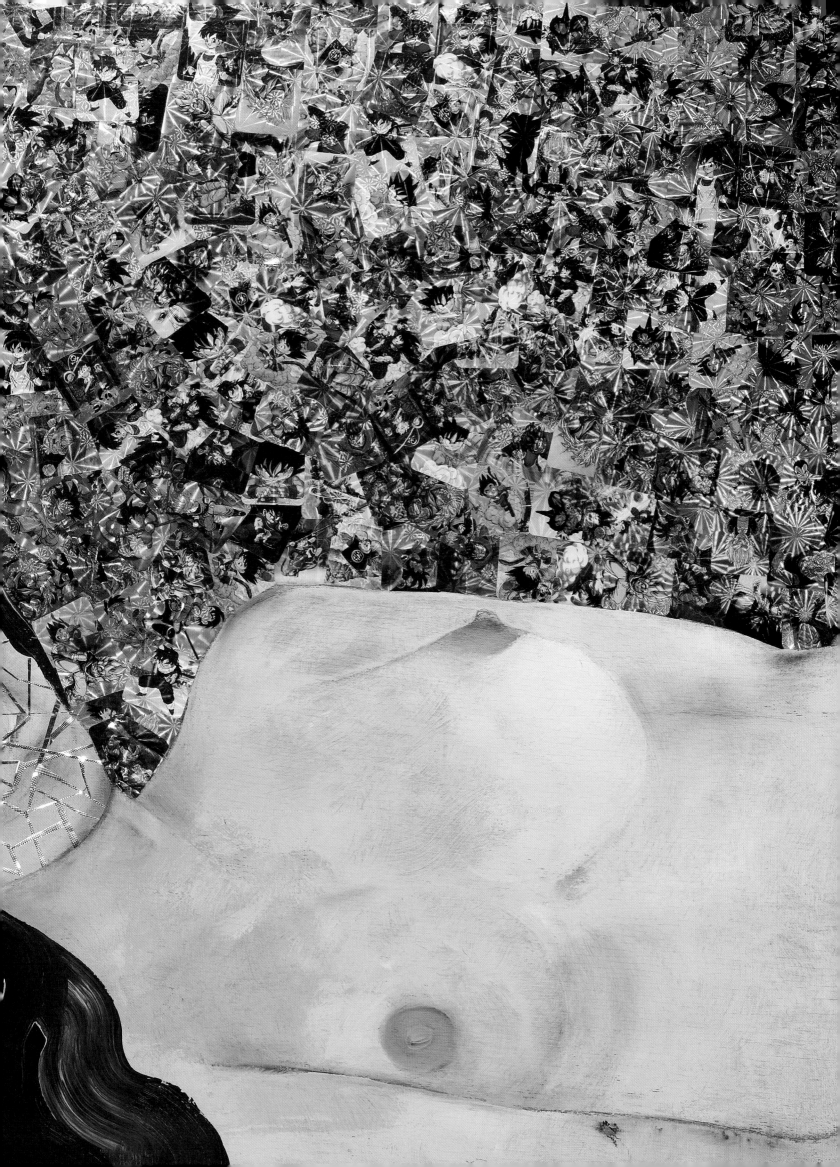

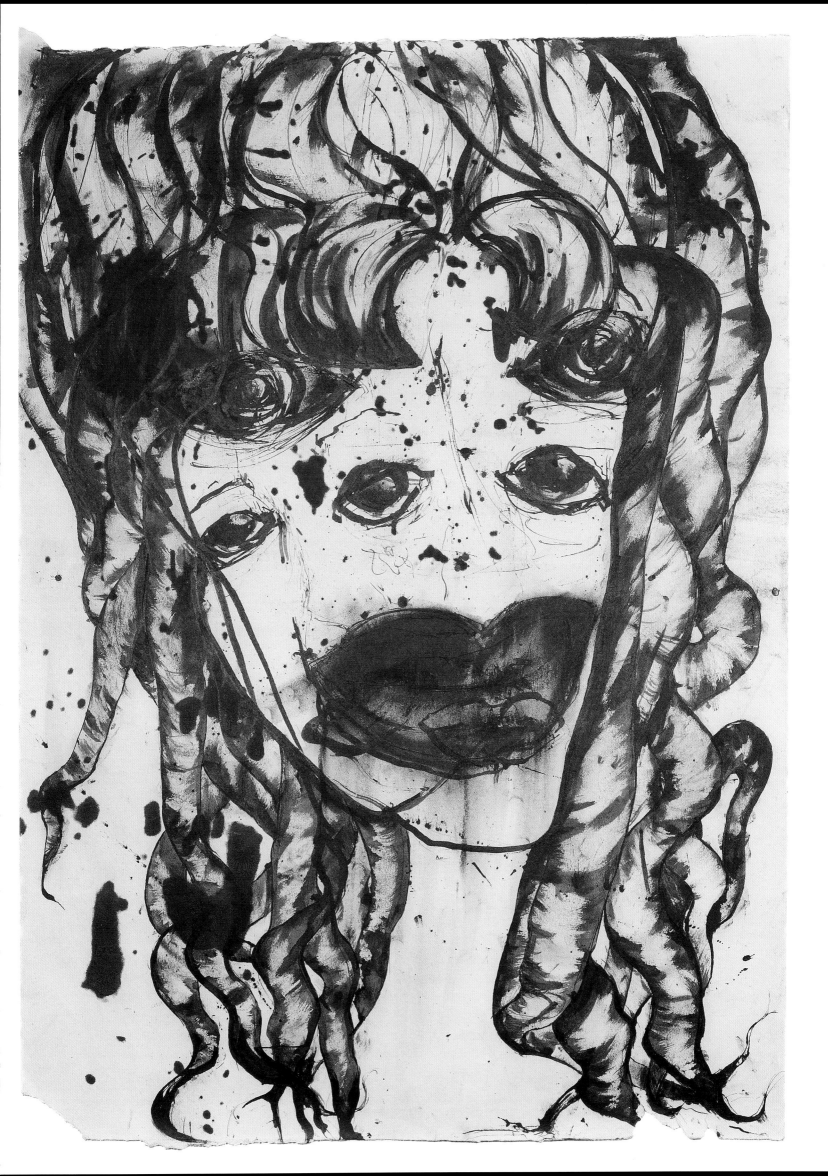

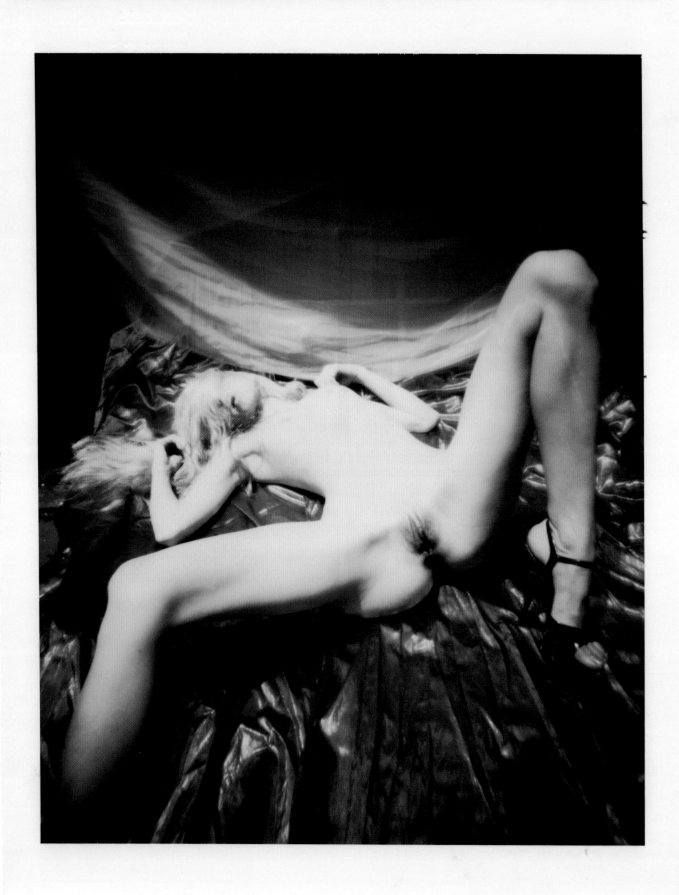

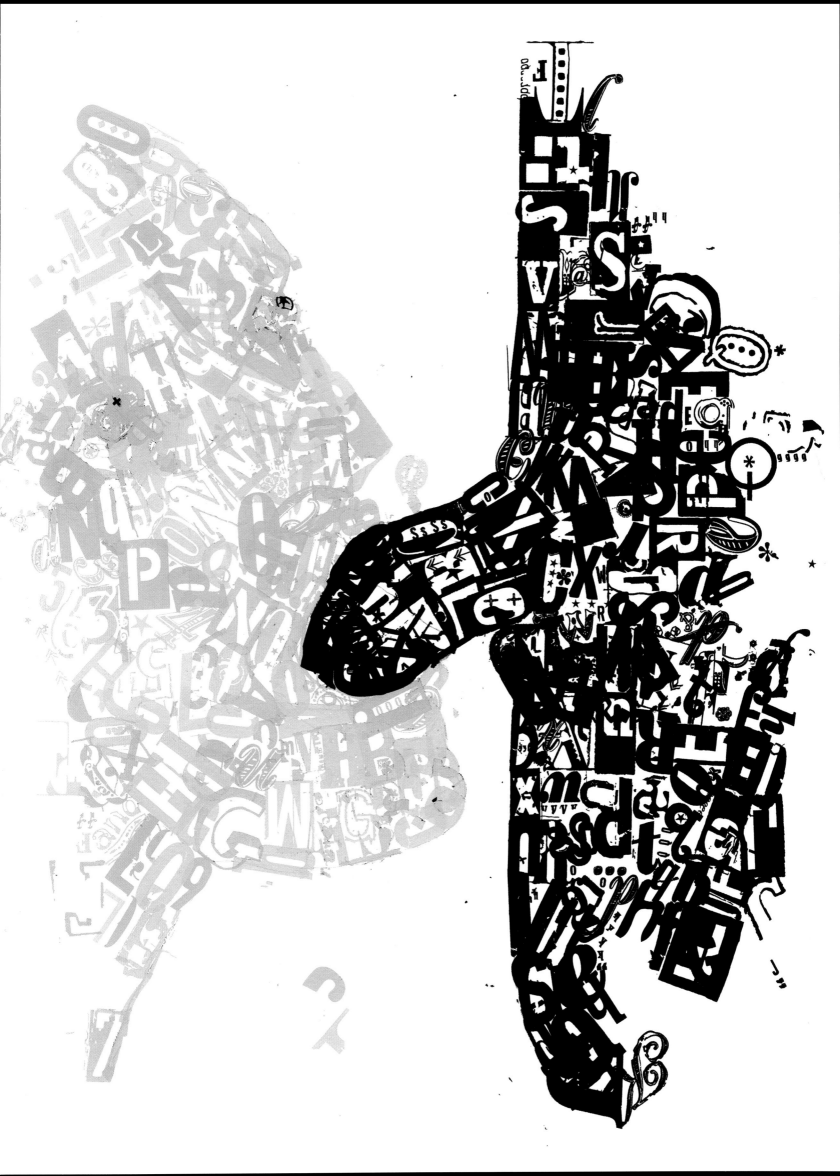

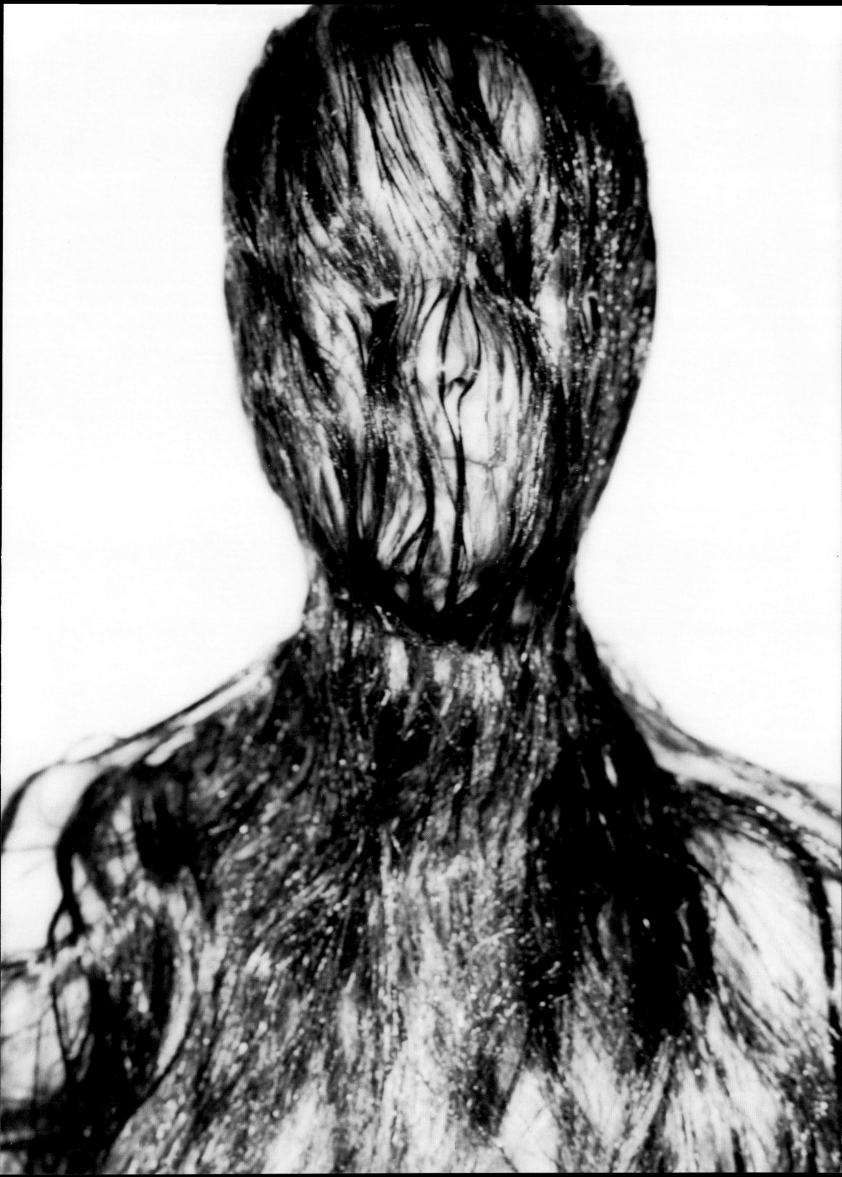

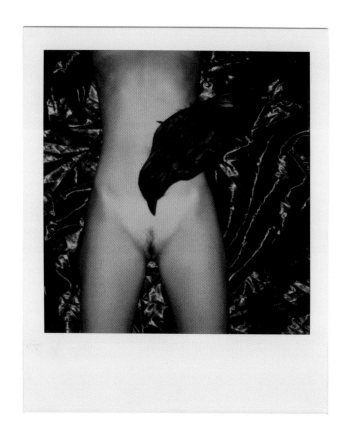

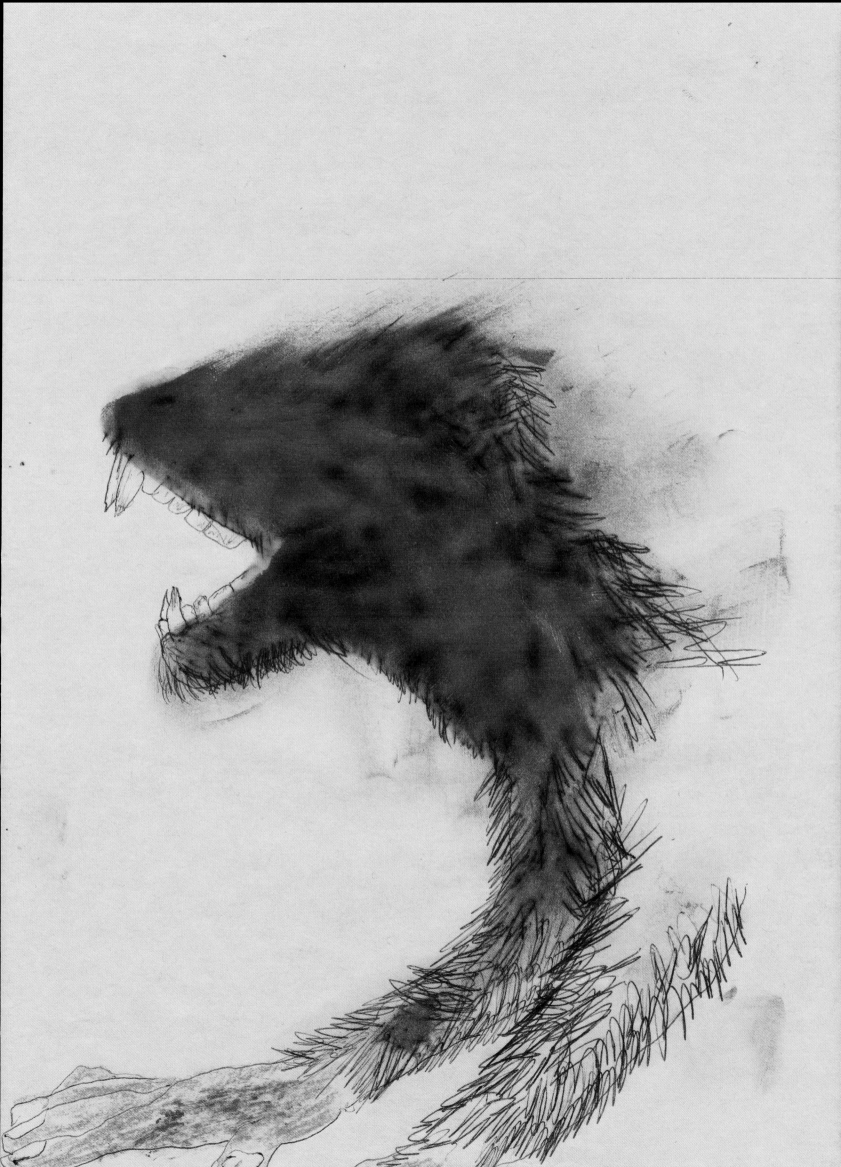

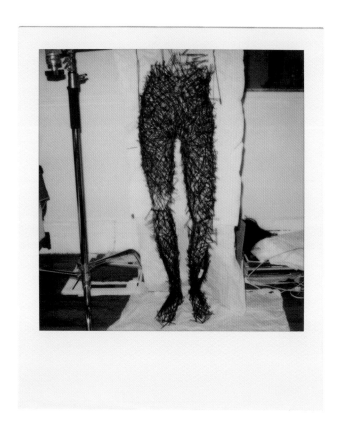

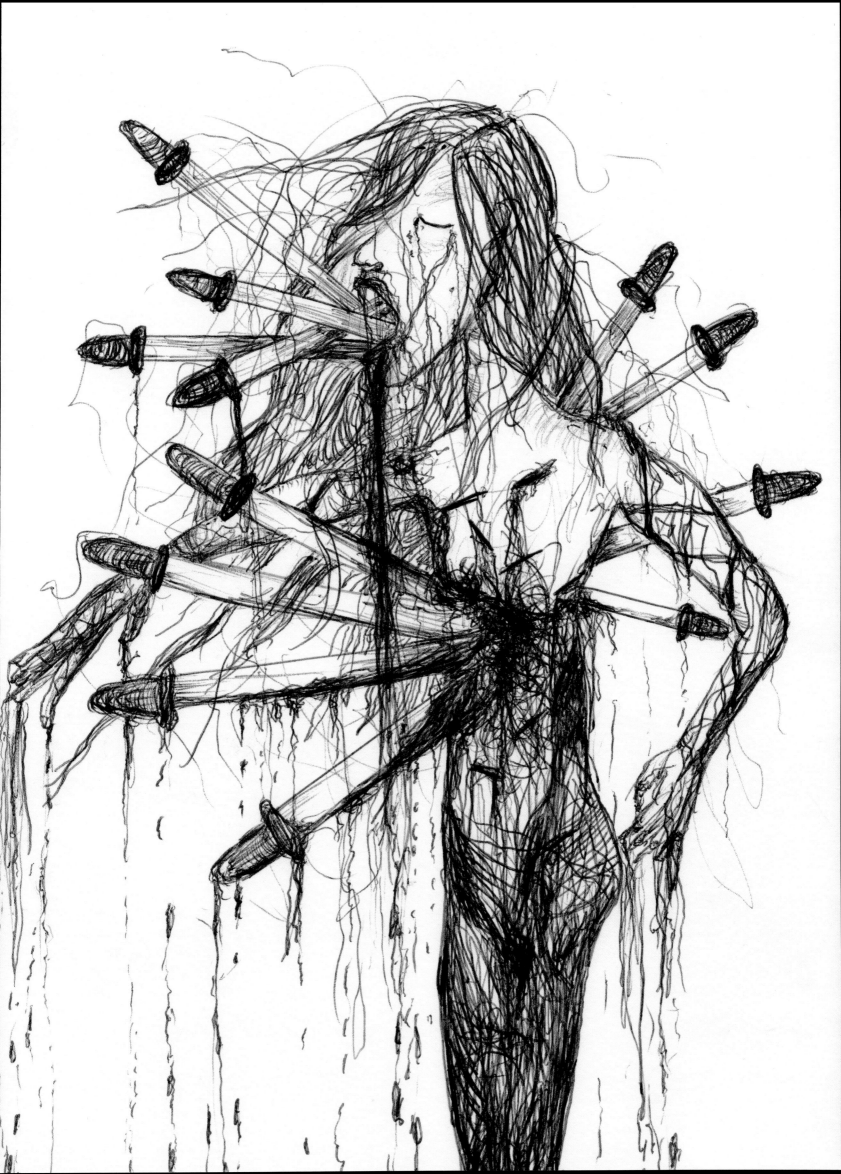

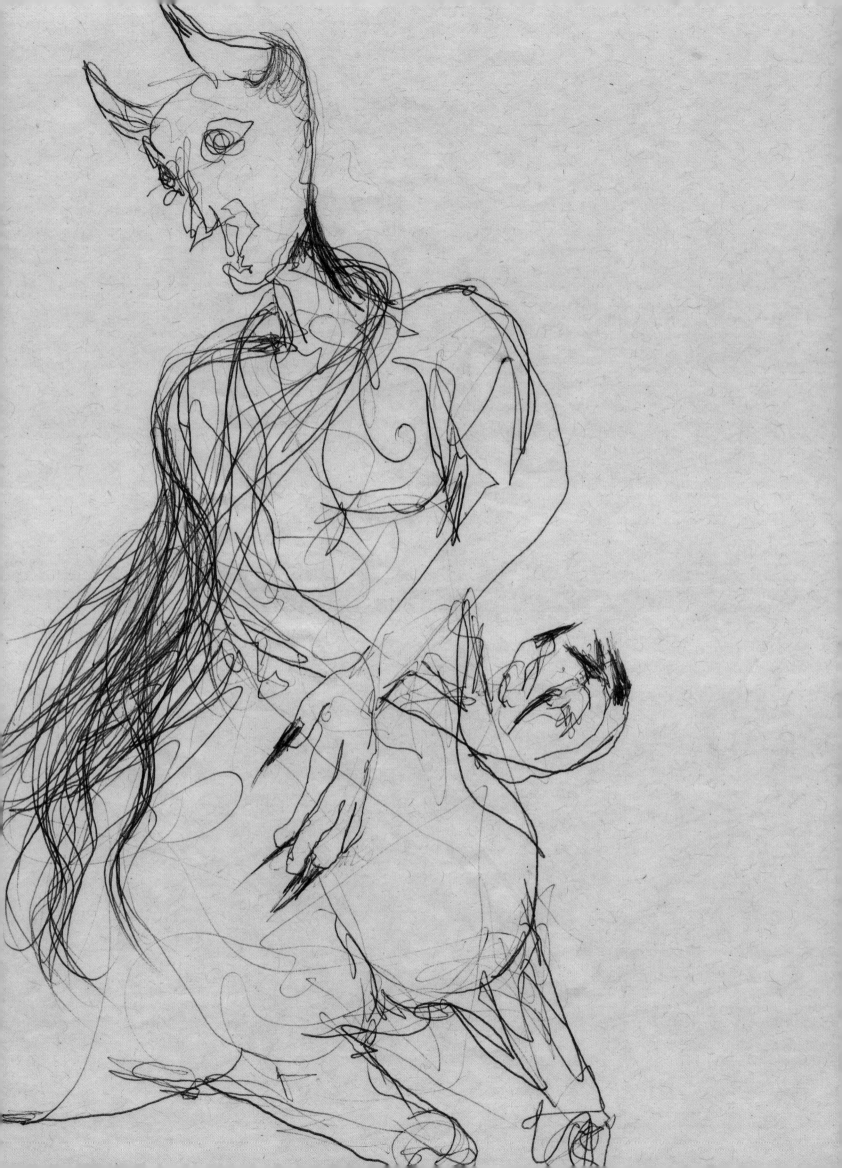

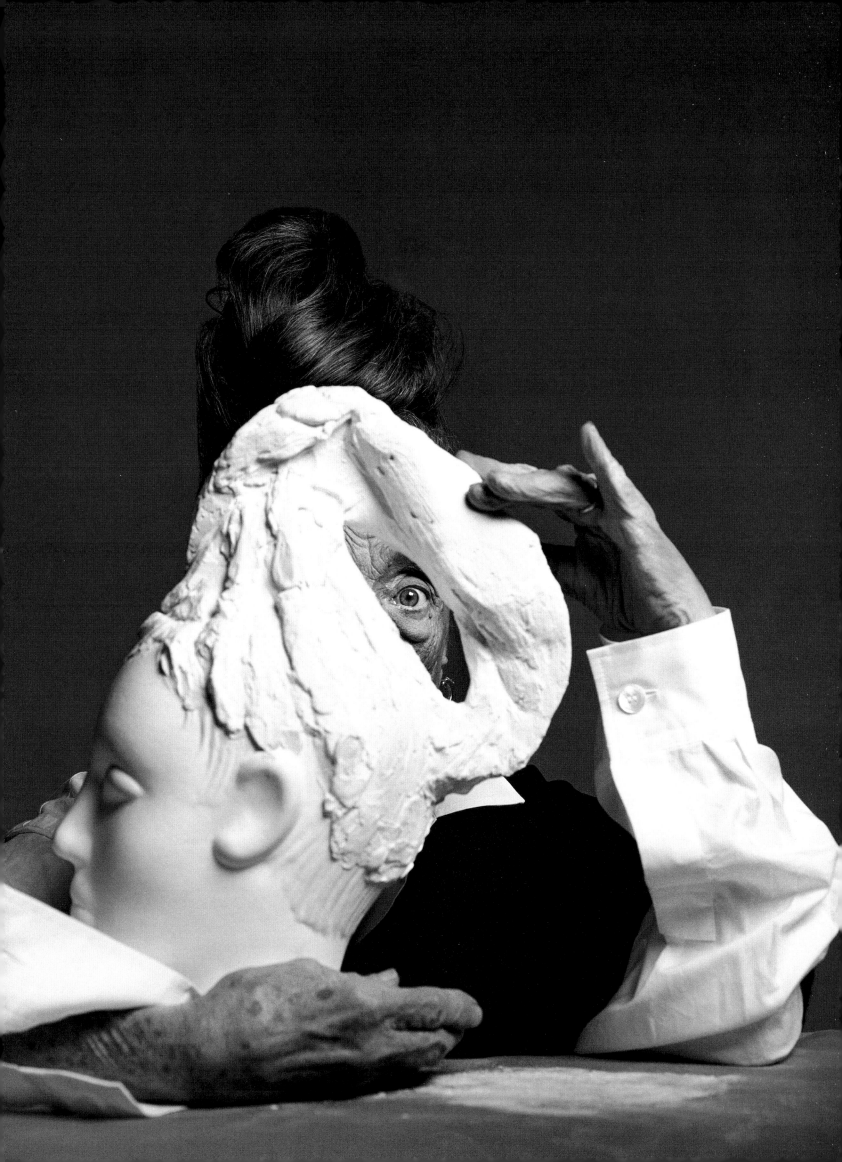

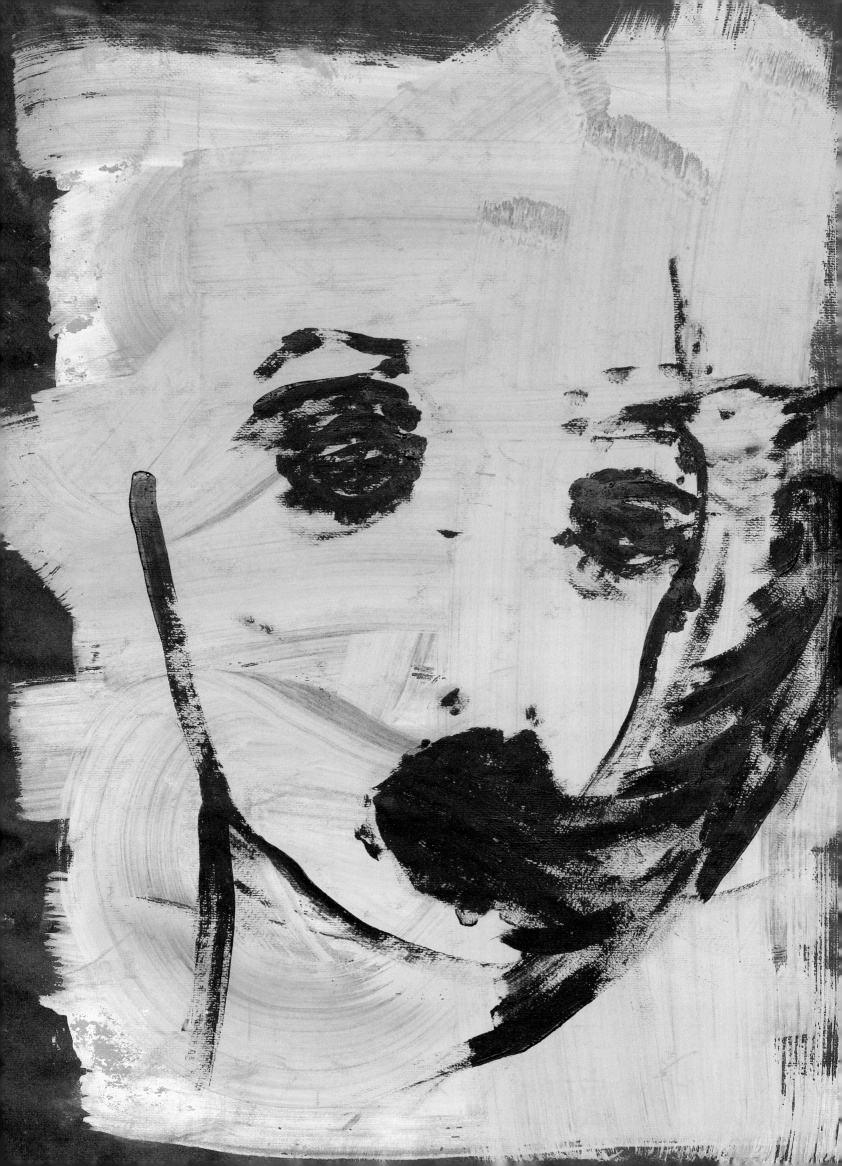

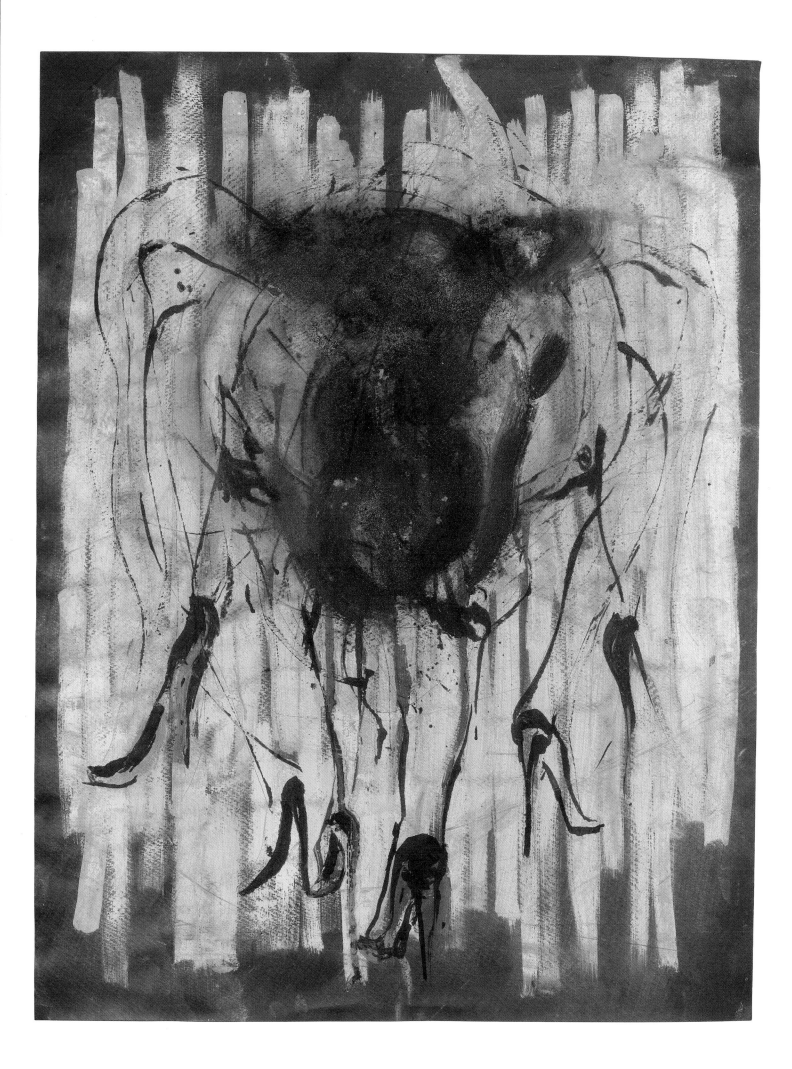

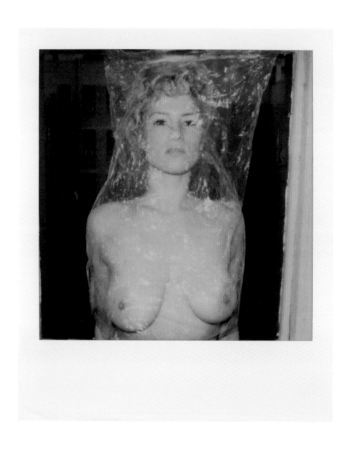

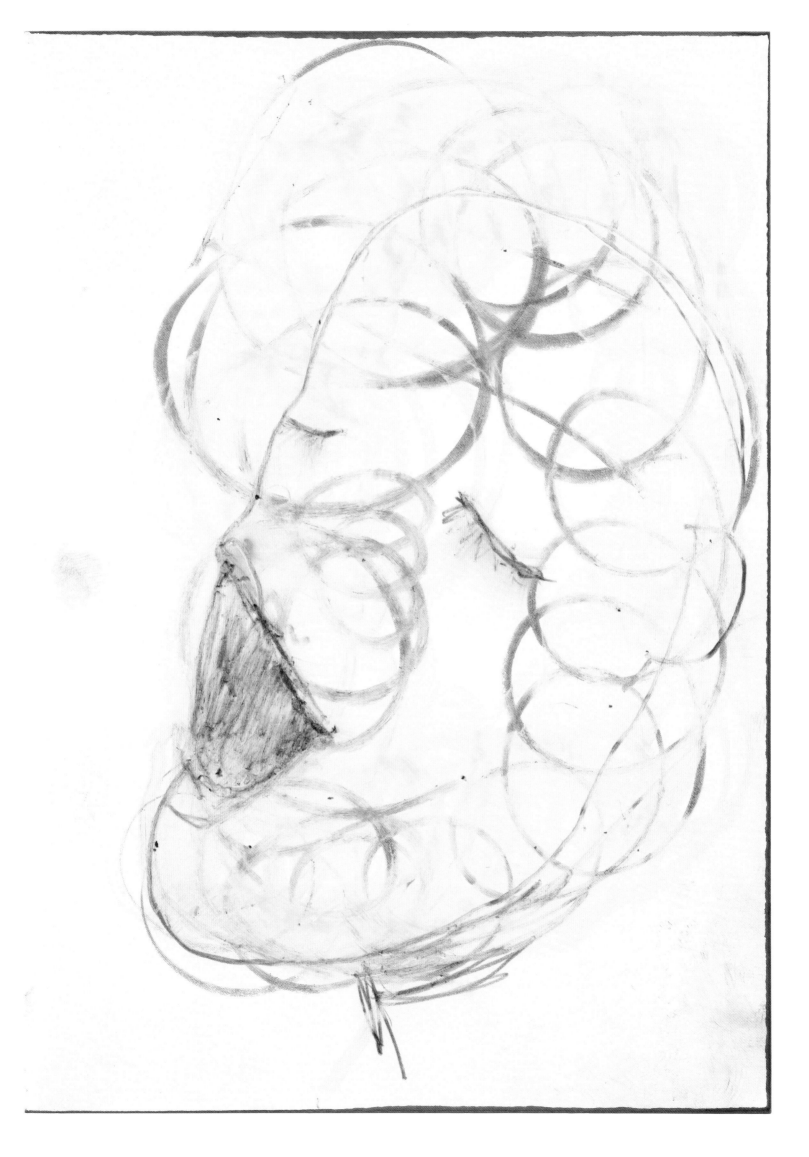

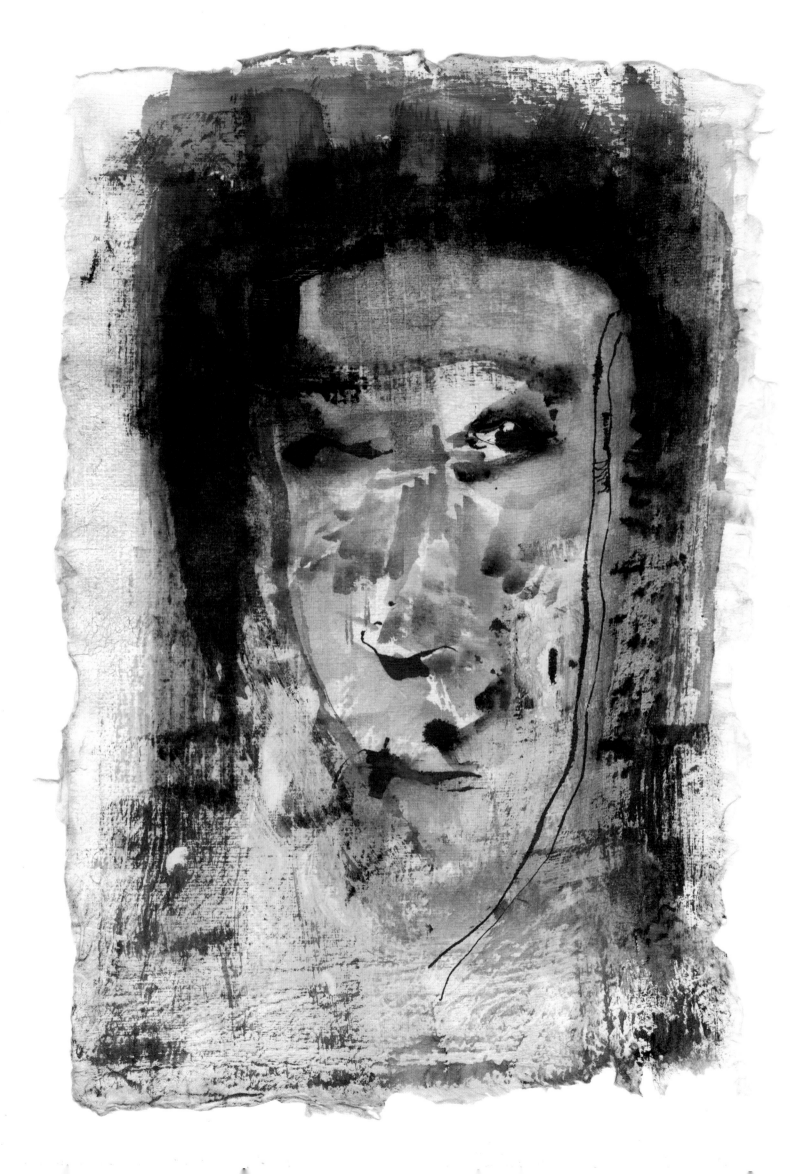

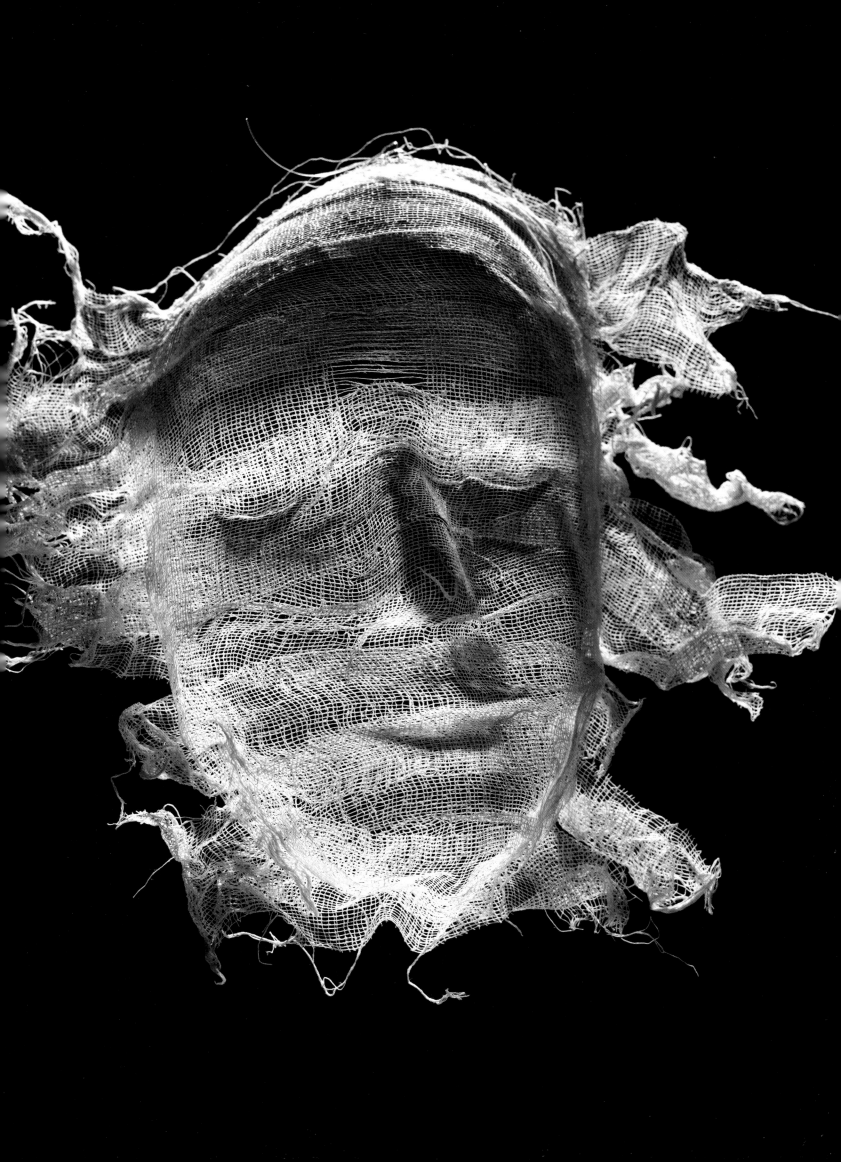

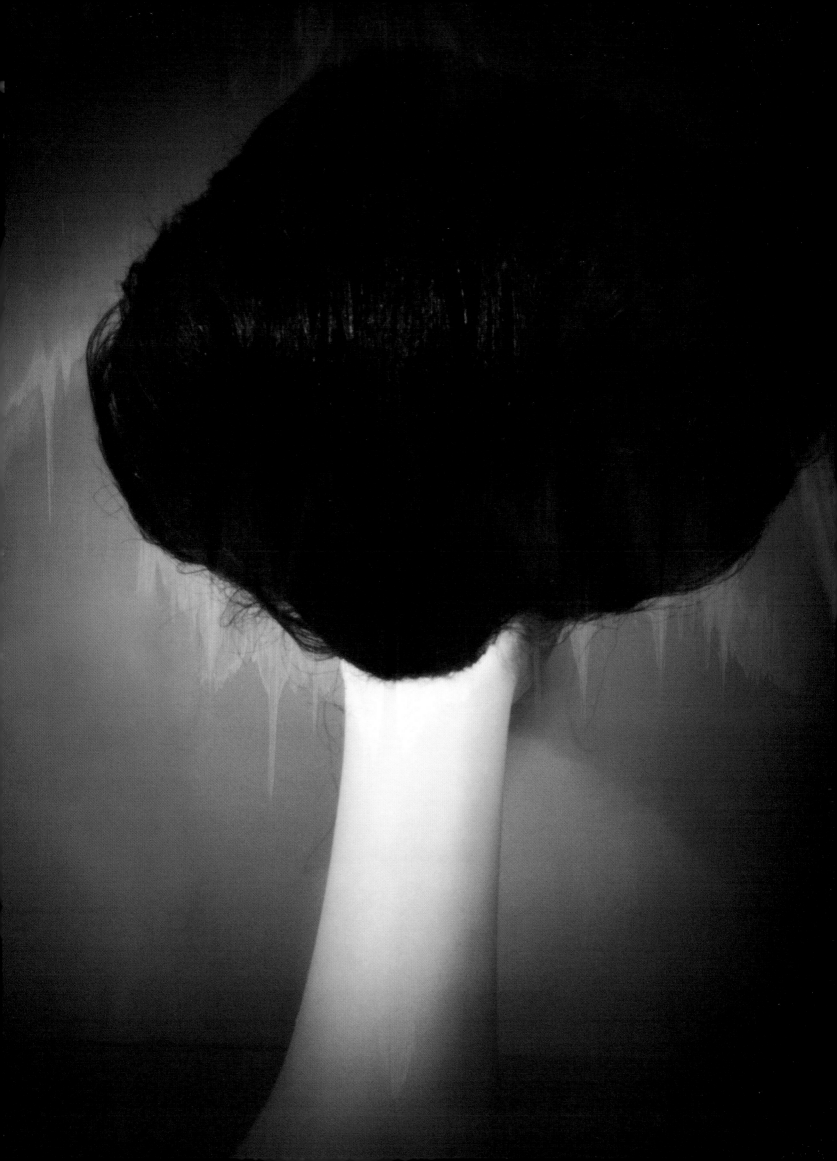

This book is dedicated to Mom and Dad...

I would like to thank the following:
Susan Günther, Heather Sommerfield, Ali Bird, The Wall Group,
Hest Inc., Brian Hetherington, Baron & Baron, Maria Fimmano,
Aaron de Mey and Linda Cantello.

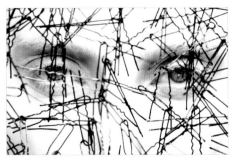

Hair Sculture by Recine, Photo by Robbie Fimmano, April 2008.

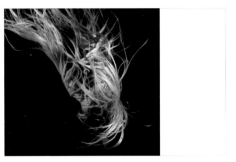

Pamela Anderson, *Another Magazine*, Photo by Mario Sorrenti
Fall/Winter 2002

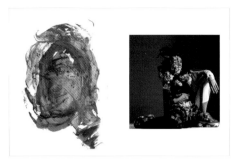

Untitled, Tempra on Paper 8 X 11 ¾ in. 2006 / *Another Magazine*, Elise,
Photo by Mario Sorrenti, March 2003

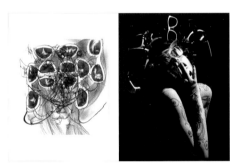

Untitled, Ink on Paper 7 ½ x 7 ½ In. 2007 / *V Magazine*,
Tanya Dziahileva, Photo by Mario Sorrenti, Spring 2007

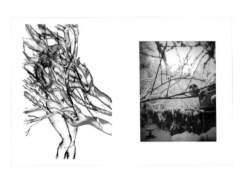

Untitled, Ink on Paper 8 x 5 ½ In. 2006 / Untitled, 8 x 10 in. Polaroid
Photo by Recine, 2005

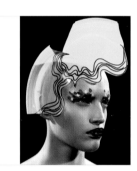

Numero, Vivien Solari, Photo by Mario Sorrenti , 1996
Also the cover credits

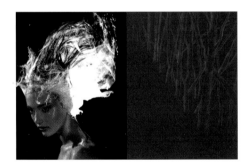

Karmen Perdue, Photo by Robbie Fimmano, 2009 / Untitled,
White Pencil on Paper 10 1/8 x 13 ½ in. 2008

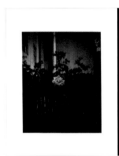

Untitled, 8 x 10 in. Polaroid, Photo by Recine, 2004 / *Exit Magazine*,
Grace Kelsey, Photo by Recine, Fall 2004

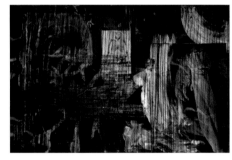

Untitled, Collage, Ink, Tape on Paper, 20 x 13 ½ In. 2009

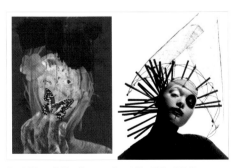

Untitled, Butterfly, Tape, Tempra on Paper 10 ¼ x 13 ½ in. 2008 / *Numero*,
Gemma Ward, Photo by Mario Sorrenti, July 2006

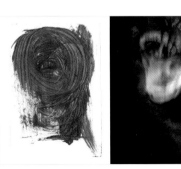

Untitled, Tempra on Paper 7 ¼ x 10 ¼ in. 2003 / Untitled, 4 x 5 in. Polaroid,
Photo by Recine, 2006

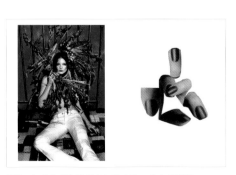

W Magazine, Eniko Mihalik, Photo by Mario Sorrenti, April 2009 /
Untitled, Collage on Paper, 10 x 13 ¼ in. 2008

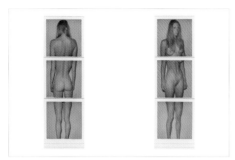

Laura, 690 Polaroid 3 ½ x 4 ¼ in. each, 1998

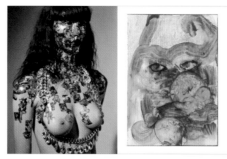

Exit Magazine, Rebekah Davies, Photo by Recine, Fall 2004 / Untitled, Tempra on Paper 3 ¾ x 6 ½ in. 2004

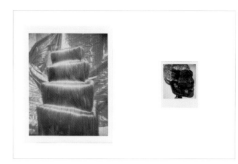

Untitled, 8 x 10 in. Polaroid, Photo by Recine, 2000 / Untitled, 690 Polaroid 3 ½ x 4 ¼ in. 2004

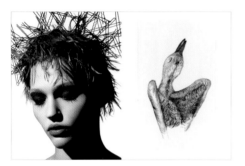

Vogue Italia, Sasha Pivovarova, Photo by Mario Sorrenti, April 2008 / Untitled, Ink on Paper 5 ¼ x 8 ¼ in. 2007

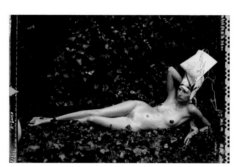

Untitled, Grace Kelsey, Black and White Photograph Photo by Recine, 1998

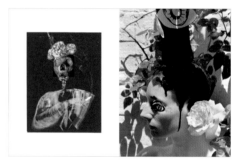

Untitled, Collage, Tempra on Paper 10 ¼ x 13 ½, 2008 / *Another Magazine*, Grace Kelsey, Photo by Recine, Fall 2004

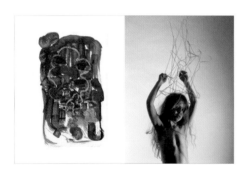

Untitled, Crayon, Ink, Tempra on Paper 6 ¾ x 10 in. 2005 / *V Magazine*, Lua Beaulieu, Sculture by Recine, Photo by Mario Sorrenti, 1999

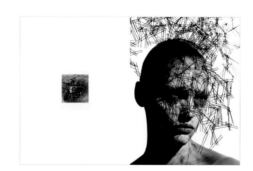

Untitled, 690 Polaroid 3 ½ x 4 ¼ , Photo by Recine, 2009 / *Vogue Italia*, Sasha Pivovarova, Photo by Mario Sorrenti, August 2007

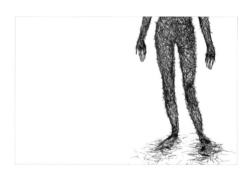

Hairpin Sculpture By Recine, Photo by Mario Sorrenti, 2008

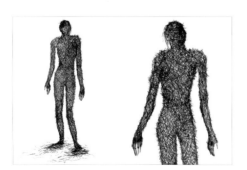

Hairpin Sculpture By Recine, Photo by Mario Sorrenti, 2008

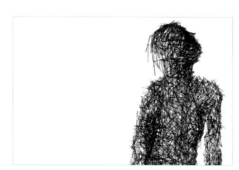

Hairpin Sculpture By Recine, Photo by Mario Sorrenti, 2008

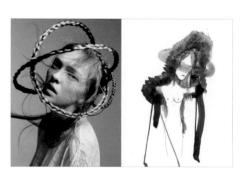

Photo Mario Sorrenti / Untitled, Tempra on Paper 10 x 13 ¼ in. 2007

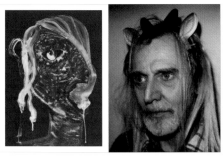

Untitled, Tempra on Paper 14 x 15¼ in. 1997 / Rene Ricard
690 Polaroid 3 ½ x 4¼ in. Photo by Recine, Spring 2008

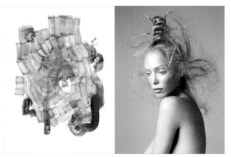

Untitled Ink, tempra on Paper 8 x 10½ In. 2008 / *V Magazine*,
Tanya Dziahileva, Photo by Mario Sorrenti, Spring 2007

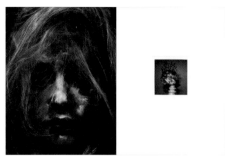

Another Magazine, Grace Kelsey, Photo by Recine Fall 2004 / Untitled
690 Polaroid 3 ½ x 4 ¼ in. 2004

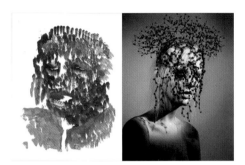

Untitled, Tempra on Paper 10 x 13¼ In. 2008 / Ingrid Mask,
Photo by Robbie Fimmano, 2007

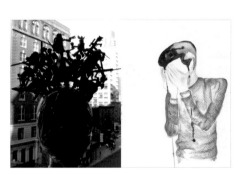

Untitled Photo by Susan Günthen 2009 / Untitled, Pencil, Ink, Crayon
on Paper 10 x 13¼ In. 2009

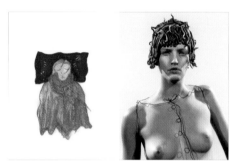

Untitled, Ink, Crayon on Paper 5½ x 8½ In. 2006 / *Numero*, Vivien
Solari, Photo by Mario Sorrenti 1996

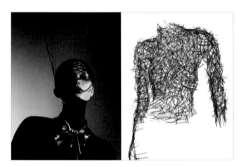

Vogue Italia, Gemma Ward, Photo by Mario Sorrenti, July 2006 /
Hairpin Sculpture by Recine, Photo by Robbie Fimmano, 2008

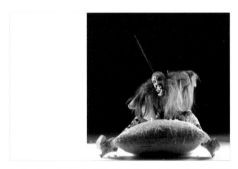

Another Magazine, Jessica Miller, Photo by Mario Sorrenti, March 2003

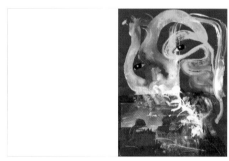

Untitled, Collage, Tempra on Paper, 10 ¼ x 13 ½ in. 2008

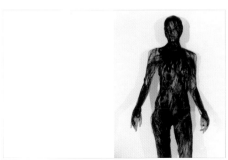

I-D Magazine, Grace Kelsey Photo by Recine, 2004

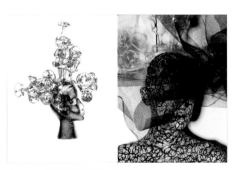

Personal Artwork, Sculpture by Recine, Photo by Robbie Fimmano
2009 / Guinevere Van Seenus, Photo by Robbie Fimmano, 2010

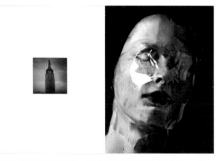

Untitled, 690 Polaroid 3 ½ x 4 ¼ in. 2004 / Photo by Mario Sorrenti,
2008

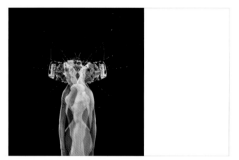

Christina Kruse, Photo by Robbie Fimmano, 2010

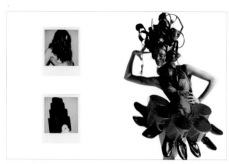

Untitled, 690 Polaroid 3 ½ x 4 ¼ in. 2004 / Untitled, 690 Polaroid 3 ½ x 4 ¼ in. 2000 / *V Magazine*, Tanya Dziahileva, Skirt Created by Philipp Haemmerle, Photo by Mario Sorrenti, Spring 2007

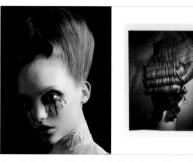

Vogue Italia, Gemma Ward, Photo by Mario Sorrenti, Sept 2005 / Untitled 8 x 10 in. Polaroid, 2008

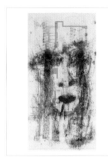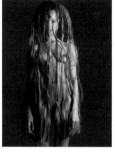

Untitled, Lipstick, Powder, on Draft Paper 12 ¼ x 24 in. 1996 / Natalia Vodianova, Photo by Mario Sorrenti, 2007

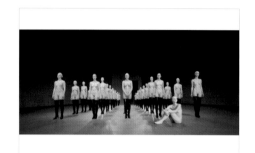

Vanessa Beecroft Installation, VB45, 2001

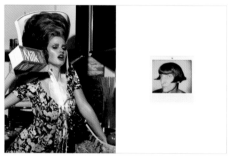

V Magazine, Lara Stone, Photo by Mario Sorrenti, Fall 2007 / Untitled, Edit Deak, 690 Polaroid 3 ½ x 4 ¼ in. 1995

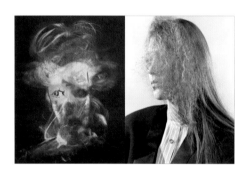

Untitled , Tempra on Paper 19 ¾ x 25 ½ in. 1998 / *W Magazine*, Anastasia, Photo by Mario Sorrenti

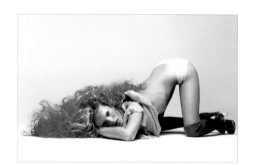

Kate Moss, Photo by Mario Sorrenti, 2005

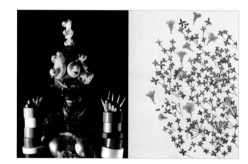

Another Magazine, Jessica Miller, Photo By Mario Sorrenti, March 2003 / Untitled, Flower, Tape on Paper, 13 ½ x 21 in. 2008

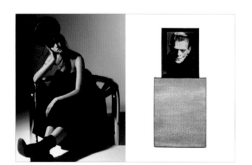

Harper's Bazaar, Gemma Ward, Photo by Mario Sorrenti, July 2006 / Untitled Collage, Oil Paint on Canvas 11 x 24 in. 2005

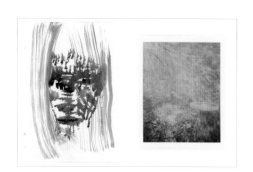

Untitled, Ink, Tempra on Paper, 7 ¼ x 10 in. 2006 / Untitled, Polaroid 8 x 10, Photo by Recine, 2006

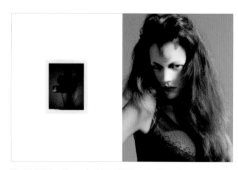

Untitled, Polaroid 4 x 5 in. 2003 / *W Magazine*, Freja Beha Erichsen, Photo by Mario Sorrenti, Oct 2005

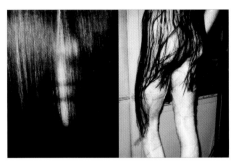

Untitled, 690 Polaroid 3½ x 4¼ in. 2004 / Untitled, 690 Polaroid
3½ x 4¼ in. 2004

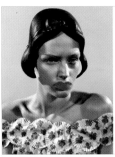

Numero, Vivien Solari, Photo by Mario Sorrenti, 1996 /
Untitled, Tempra on Paper 25 x 40½ in. 1998

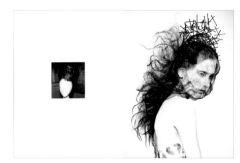

Untitled, 690 Polaroid 3½ x 4¼ in. 2009 / Iekeliene Stange,
Photo by Robbie Fimmano, 2008

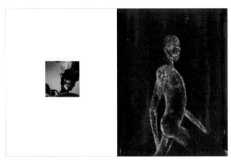

Untitled, 690 Polaroid 3½ x 4¼ in. 2006 / Untitled, Tempra on Canvas
18 x 24 in. 2008

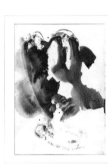

Untitled, Personal Work, 2004 / Karmen Perdue,
Photo by 2009

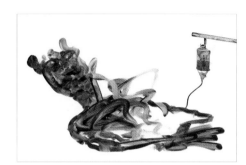

Dad, Ink on Paper, 10¾ x 16½ in. 2003

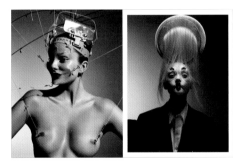

French Vogue, Eniko Mihalik, Photo By Mario Sorrenti, March 2010 /
Vogue Italia, Gemma Ward, Photo by Mario Sorrenti, July 2006

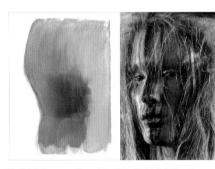

Untitled, Tempra on Paper, 8½ x 12 in. 2006 / *Exit Magazine*,
Photo by Recine, Fall 2004

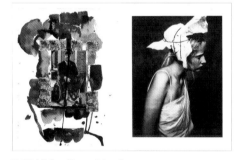

Untitled, Collage, Tempra, Ink on Paper
10 X 13¼ in. 2007 / Photo by Paolo Roversi, April 1998

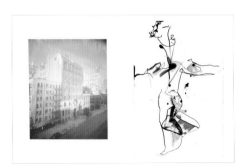

Untitled, Polaroid 8 x 10, 2007 / Untitled, Ink on Paper,
5½ x 8 ¾ in. 2004

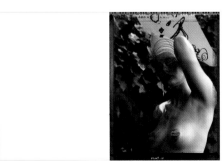

Sarah Schalk, Photo by Recine, 1998

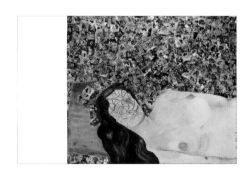

Untitled, Collage, Tempra on Wood Panel 23½ x 27 in. 2007

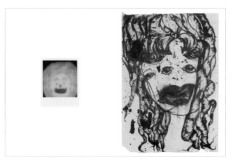

Untitled, 690 Polaroid 3 ½ x 4 ¼ in. 2008 / Paris, Ink, Lipstick on Paper
22 x 30 ½ in, 1998

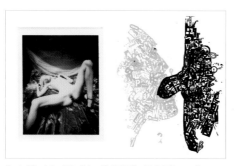

Crystal Byrd, 8 x 10 in. Polaroid, 1998 / Untitled, Collage on Paper
12 x 14 in. 2007

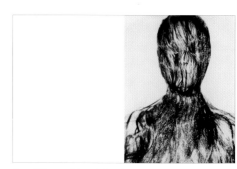

Grace Kelsey, 690 Polaroid 3 ½ x 4 ¼ in. 2004 Photo by Recine 2004

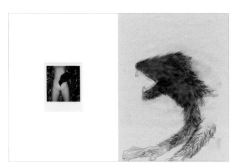

Untitled, 690 Polaroid 3 ½ x 4 ¼ in. 2006 / Untitled, Ink, Lipstick on
Paper, 8 ½ x 11 in.

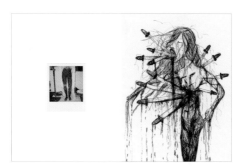

Untitled, 690 Polaroid 3 ½ x 4 ¼ in. 2004 / Untitled, Ink on Paper,
5 ½ x 8 ¼ in. 2005

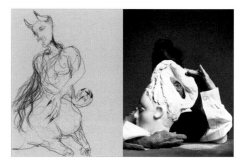

Untitled, Ink on Paper, 8 ½ x 11 in. / Harper's Bazaar, Louise Bourgeois
Photos by Mark Hom

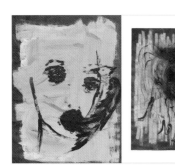

Untitled, Tempra on Paper 18 x 24 in. 1998 / Untitled, Tempra on
Paper 20 x 26 in. 1998

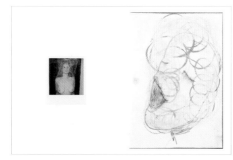

Kim, 690 Polaroid 3 ½ x 4 ¼ in. 2009 / Untitled, Pencil, Crayon on
Paper 4 ¾ x 6 ½ in. 2004

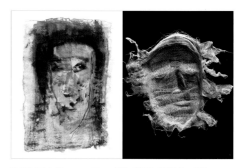

Untitled, Ink, Tempra on Paper, 18 ½ x 12 ¾ in. 2008 / *French Vogue*,
Gauze Mask by Recine, Photo by Mario Sorrenti, April 2010

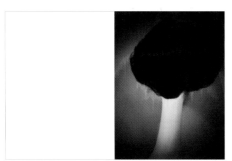

Untitled 8 x 10 in. Polaroid, 2008

Bob Recine
Alchemy of Beauty

Creative Director
Fabien Baron

Art Director
Maxime Poiblanc

© Damiani 2011
© Photographs, Mario Sorrenti and Robbie Fimmano
© Texts, Rene Ricard

Published by Freedman | Damiani

Damiani editore
via Zanardi, 376
40131 Bologna, Italy
t. +39 051 63 56 811
f. +39 051 63 47 188
info@damianieditore.it
www.damianieditore.com

Printed in November 2011 by Grafiche Damiani, Bologna, Italy.

ISBN 978-88-6208-212-9